THE DOODLE REVOLUTION

UNLOCK THE POWER TO THINK DIFFERENTLY

PORTFOLIO / PENGUIN

WRITTEN AND ILLUSTRATED BY

SUNNI BROWN

PORTFOLIO / PENGUIN
Published by the Penguin Group
Penguin Group (USA) LLC
375 Hudson Street
New York, New York 10014

USA | Canada | UK | Ireland | Australia | New Zealand | India | South Africa | China
penguin.com
A Penguin Random House Company

First published by Portfolio / Penguin, a member of Penguin Group (USA) LLC, 2014

Excerpt on page v from *Future Shock* by Alvin Toffler (Random House, 1970).

Illustration credits appear on page 242.

ISBN 978-1-59184-588-1

Printed in the United States of America

1 3 5 7 9 10 8 6 4 2

Set in Archer, Gotham, Inside Out, Dancing in the Minefields, and Lipstick
Designed by Kristin Moses, DesignGood Studio

DEDICATIONS

To six men who give me
courage, clarity, creativity, and compassion:

Rocky Brown, the prankster

Eddie Vedder, the voice

Chet Hornung, the thinker

Georges St-Pierre, the martial artist

Flint Sparks, the teacher

Geoffrey Canada, the visionary

The *illiterate* of the 21st century will not be those who cannot read and write, but those who cannot LEARN, UNLEARN, and RELEARN.

—Alvin Toffler

CONTENTS

INTRODUCTION

X

CHAPTER ONE

DOODLING IS THINKING IN DISGUISE

2

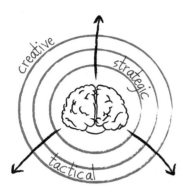

CHAPTER TWO

THE DOODLE'S RADICAL CONTRIBUTIONS:
Power, Performance,
and Pleasure

CHAPTER THREE

DOODLE UNIVERSITY:
Exploring the Foundations
of Visual Language

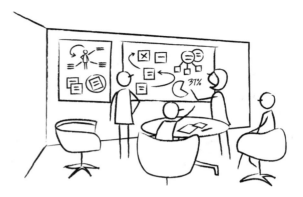

INTRODUCTION

There is no singular definition of a Doodle. There is only insight that comes from what you make of it.

—Sunni Brown (a.k.a. Dr. Doodle),
the Founding Mother of the Doodle Revolution

Dear Revolutionary,

In our first interaction, I'd like to make you a promise and it is this: This book will matter deeply in both your life and your work. I did not write this book to entertain myself or even, to be honest, to entertain you. I wrote it because every single one of us can make use of what it offers. And I don't mean you can use it like makeup to decorate or frosting to sweeten. I mean you can use this book like a submarine or a sword. You can use it like an X-ray or a deep-ocean drill. You can even use it like a hammock on a sunny day. This book is designed—forgive the cliché—to change your life. It will help you expand what's available to you as a weapon against ignorance, a tool against complexity, a meditation in search of insights, and a game in search of discovery. All of these possibilities are idling just within reach in the universally known device called the Doodle. That, my friends, is why this book exists. It's part of a global campaign for visual literacy called the Doodle Revolution. And you are an essential part of it.

Love!

Sunni

WHY THE REVOLUTION?

There are five reasons why the Doodle Revolution must exist and why its Revolutionaries must find each other and learn from each other.

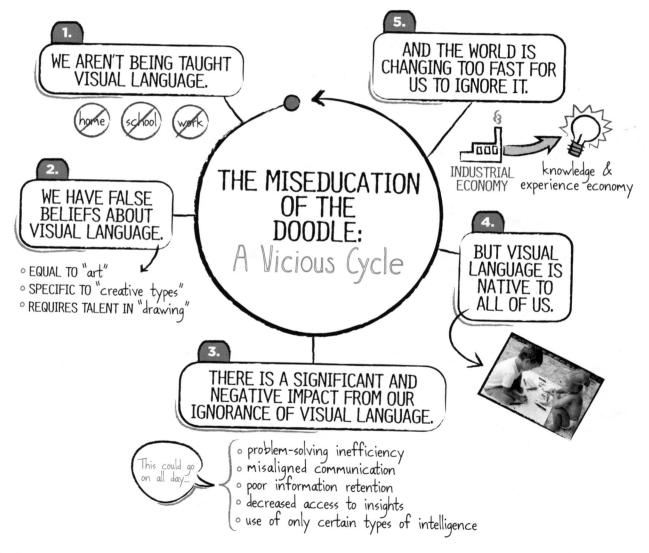

1. WE AREN'T BEING TAUGHT VISUAL LANGUAGE.

home school work

2. WE HAVE FALSE BELIEFS ABOUT VISUAL LANGUAGE.

- EQUAL TO "art"
- SPECIFIC TO "creative types"
- REQUIRES TALENT IN "drawing"

THE MISEDUCATION OF THE DOODLE: A Vicious Cycle

5. AND THE WORLD IS CHANGING TOO FAST FOR US TO IGNORE IT.

INDUSTRIAL ECONOMY → knowledge & experience economy

4. BUT VISUAL LANGUAGE IS NATIVE TO ALL OF US.

3. THERE IS A SIGNIFICANT AND NEGATIVE IMPACT FROM OUR IGNORANCE OF VISUAL LANGUAGE.

This could go on all day...

- problem-solving inefficiency
- misaligned communication
- poor information retention
- decreased access to insights
- use of only certain types of intelligence

#1 WE AREN'T BEING TAUGHT VISUAL LANGUAGE.

We are not being adequately taught to use visual language in schools, at home, or at work. Until we make a deep impression on even one of these institutions, we must choose to teach ourselves.

#2 WE HAVE FALSE BELIEFS ABOUT VISUAL LANGUAGE.

We have cultural stereotypes about "art," about "drawing," and about "doodling" that are obstacles to learning and growth. We have misinformation about being "creative" that is blocking us from embracing visual language. We need to suffocate these false beliefs. They're doing nothing for us.

#3 THERE IS A SIGNIFICANT NEGATIVE IMPACT FROM OUR IGNORANCE OF VISUAL LANGUAGE.

There are serious cognitive performance effects of our inability to use visual language. This crippling of our innate capacity to explore, learn, remember, and think more effectively is unacceptable. We deserve better.

#4 BUT VISUAL LANGUAGE IS NATIVE TO EVERYONE.

We already know how to use visual language—it's native to us all. Rarely is such a powerful tool placed in our hands with so little effort. All we need to do is unleash this skill and train it. We're all standing at the doorway of the Doodle, and inside is a world of possibilities.

#5 AND WE CAN'T AFFORD TO NOT LEARN IT.

We cannot afford to hold hands with our oblivion any longer. Information density is too high, and the marketplace, headed rapidly toward knowledge and experience economies, is too unforgiving. Our competition—internal or external—isn't sleeping. And nations of educated but visually illiterate adults do nothing to address the challenges of the future.

THE DOODLE REVOLUTIONARY'S JOURNEY

This book takes you on a journey to visual literacy, and you may choose your entry point using the arc below. It's important to note that this journey isn't concerned with whether you're smitten with doodling or vehemently opposed. Either way, the path will offer you something of value.

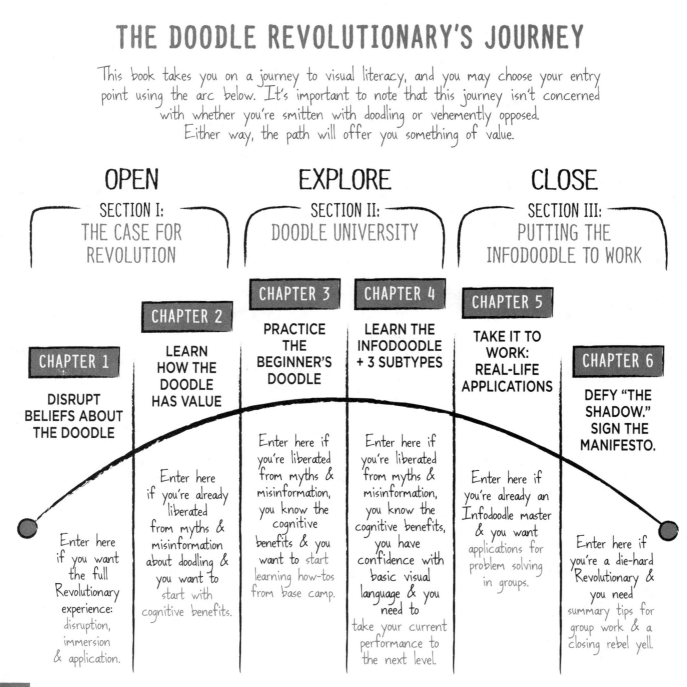

OPEN

SECTION I:
THE CASE FOR REVOLUTION

EXPLORE

SECTION II:
DOODLE UNIVERSITY

CLOSE

SECTION III:
PUTTING THE INFODOODLE TO WORK

CHAPTER 1

DISRUPT BELIEFS ABOUT THE DOODLE

Enter here if you want the full Revolutionary experience: disruption, immersion & application.

CHAPTER 2

LEARN HOW THE DOODLE HAS VALUE

Enter here if you're already liberated from myths & misinformation about doodling & you want to start with cognitive benefits.

CHAPTER 3

PRACTICE THE BEGINNER'S DOODLE

Enter here if you're liberated from myths & misinformation, you know the cognitive benefits & you want to start learning how-tos from base camp.

CHAPTER 4

LEARN THE INFODOODLE + 3 SUBTYPES

Enter here if you're liberated from myths & misinformation, you know the cognitive benefits, you have confidence with basic visual language & you need to take your current performance to the next level.

CHAPTER 5

TAKE IT TO WORK: REAL-LIFE APPLICATIONS

Enter here if you're already an Infodoodle master & you want applications for problem solving in groups.

CHAPTER 6

DEFY "THE SHADOW." SIGN THE MANIFESTO.

Enter here if you're a die-hard Revolutionary & you need summary tips for group work & a closing rebel yell.

THE
DOODLE
REVOLUTION

UNLOCK THE
POWER TO THINK
DIFFERENTLY

DOODLING IS THINKING IN DISGUISE

ADULTS CAN'T DRAW: A REPORT FROM THE FRONT LINES OF VISUAL LANGUAGE

I have spent the last few years staring adults in the eye and hearing them lie to my face. Literally thousands of adults have lied to me, and no end seems to be in sight. Perhaps the worst part about this is that all of these adults *believe* their own lies—they actually consider their misinformed blather to be accurate. These ever-present lies come in various forms—and trust me, adults are very creative liars—but the central tenet can be summed up in three words:

There are multiple reasons why I know this assertion to be preposterous. The first is because I'm standing in front of perfectly functional sets of eyes and hands, all of them backed by perfectly functional visual cortices. The second is because I have not yet met an adult who skipped childhood—a period in which most of us are happy to draw—and went straight to being a forty-year-old. The third is because I, too, was raised in a culture that placed virtually no value on visual language, so I've had to overcome my own lies, which makes me very good at recognizing them. And the last reason is based on experience. As an author, business owner, and professional Infodoodler, I've witnessed throngs of people with a firm conviction in their genetic inability to draw later send me full-blown, hand-drawn information graphics, complete with characters, process maps, and their own unique letterforms. By the time I receive these gifts, there's no need for me to expose the previous lie. It has been completely and marvelously revealed.

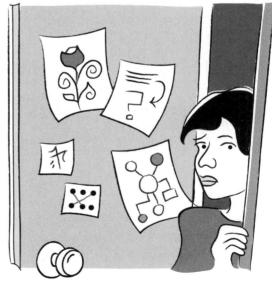

What happened to us?
All we have left are numbers and words.

After witnessing this pervasive I-can't-draw syndrome in organizations and teams around the world, my curiosity (and frustration) finally got the better of me. Something is seriously wrong in a system when a preponderance of grown-ups believe they're incapable of visually articulating something in the world. I would call this an epidemic of visual illiteracy, and any kind of illiteracy as a standard in adults does not sit well with me. To understand what I mean by visual illiteracy, let's peer into the word "literacy" for a second.

When we understand how literacy affects people's potential, it becomes urgent to increase it throughout the world. And I believe that *visual* literacy is also urgent. It's the currency of a more economically stable society—let's make no bones about that—but it, too, affects the potential of people to achieve their goals, develop their knowledge, and participate more fully in shaping the world. Visual literacy could be defined as the ability to do all of the things associate with traditional literacy, while using visual language and materials.

LITERACY = ability to...

- IDENTIFY
- UNDERSTAND
- INTERPRET
- CREATE
- COMMUNICATE
- COMPUTE

...using printed and written materials associated with varying contexts

That makes sense, right? But there's another major aspect of literacy to acknowledge: Literacy involves a continuum of learning that enables individuals to achieve their goals, develop their knowledge and potential, and participate fully in their community and wider society.[1]

cheep

BIRD HORSESHOE
chick magnet

VISUAL ILLITERACY IS UNACCEPTABLE.

Now, because humans are physiologically primed for visual intelligence, our visual literacy skills are nowhere near unsalvageable and we're mostly set up for success. The vast majority of seeing people are comfortable identifying and recognizing visual information. (Look, Grandma! A hyena!) Our skills get slightly less impressive when we're asked to interpret visual information.[2] (What is that hyena's stance telling me?) But we start to stink notably when we try to create, compute, and communicate using visual language. In those areas we find ourselves universally challenged, but they're pretty substantial areas since they afford us complex thought. I'm thankful that I can see and recognize a hyena, but I may need a plan more sophisticated than "RUN!" if this hyena decides to make regular raids on my camp. And once I've calculated a plan addressing that future uncertainty, I'd like to be able to communicate that plan to others and recruit them for insights and action. Create, compute, communicate. You see?

Unfortunately, at this juncture in history our relationship with visual language is seriously compromised. I dare say it's shabby at best, and this spate of visual illiteracy elicits all sorts of questions.

How do we drop like rocks off of the visual language learning curve? When and why does this insidious phenomenon start?[3] I've seen children of all ages ooze doodles and drawings onto paper as if they were vines growing from their hands.[4] They do this easily, without prompting or training; it's as natural as walking and talking. Then, without warning—and, worse, without adults generally noticing or caring— they seem to lose their visual language capacity as they embrace numbers and letters. Out go their loose, easy sketches, and in come the supposedly "real" tools, the power tools of numbers and words that will likely dominate their attention for the rest of their lives.

LITERACY

- IDENTIFY
- UNDERSTAND
- INTERPRET
- CREATE
- COMMUNICATE
- COMPUTE

not too shabby

using printed and written materials in various contexts

VISUAL LITERACY

- IDENTIFY
- UNDERSTAND
- INTERPRET
- CREATE
- COMMUNICATE
- COMPUTE

not too shabby

shabby

using visual materials in various contexts

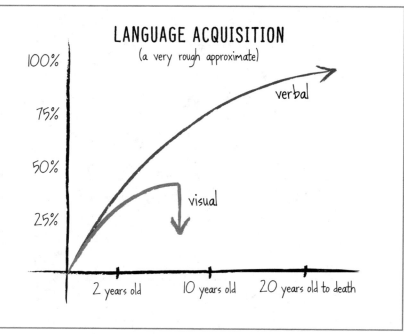

LANGUAGE ACQUISITION
(a very rough approximate)

100%

75%

50%

25%

verbal

visual

2 years old 10 years old 20 years old to death

Like most adults, you may be thinking: So what? Who cares if we all forget how to doodle and draw? What do those things have to do with adult life and work? I hear you. I myself am an unapologetic word lover, obsessed with linguistics and harboring a deep respect for numbers and data.[5] But given what I've seen working with crowds of adults, I cannot ignore this elephant-sized question:

Why do most of us abandon visual language and exchange it for numbers and written language when
WE COULD MAKE USE
OF THEM ALL?!!

Why, when we are perfectly capable—indeed genetically capable—of generating visual language, would most of us rely almost exclusively on symbols that have to be taught? Why would we put down one tool and pick up two others rather than use all three? If a tool makes me smarter, faster, clearer, and better at communicating, why on earth would I discard it?

I'll give you a tickler on my main theory: I don't think most of us know what to DO with visual language outside of certain fields. We expect visuals in architecture, engineering, design, and art. We're okay with doodling outside of the classroom or the office. We think napkin sketches at restaurants are fine (and we even enjoy them after margaritas). We'll play Pictionary among friends. But I don't think we recognize a place for visual language in most other fields. Our modern cultures and institutions don't make any systemic connections between visual language and critical thinking, visual language and problem solving, visual language and comprehension, or visual language and innovation. In these areas, my friends, we're in the Dark Ages. But there is so much intellectual and creative power to be unleashed from visual language that this oblivion can no longer stand. This bubble has got to be burst. We need to shake the dust off our perceptions of and abilities in doodling and drawing and put those skills to WORK. This is what the Doodle Revolution is all about.

DOODLE MOMENT

You'll be invited to participate in all sorts of activities throughout this book. They'll get more sophisticated and intellectually rich as you add layers to your understanding. So here's the first one. Grab a pen or marker, and try this simple exercise. Start with the following two design parameters: The line must go unbroken—don't lift your pen from the page for about ten seconds—and the line should cross over itself multiple times, creating enclosed forms. Other than that, let the line have any quality or color you desire and let it drift around your page like a plastic bag in the wind. (Apologies for the sad reference to urban life.) After about ten seconds, stop and spend some time shading in the forms created by the intersections. Pay attention to what effect this exercise had on you. Did you feel calm? More relaxed? Did you want to keep going? Whatever sensation you had, congratulations are in order. You just delivered glucose and oxygen-rich blood to the many strongly networked areas of your brain responsible for imagination and visualization. You also reminded yourself that you already know how to doodle, and it's kind of fun.

WHY WOULD AN ADULT LEARN TO DRAW, ANYWAY?

I teach adults how to sketch and draw for the same reason that other people teach adults how to write. Visual language is a *language*, and being fluent in that language gives us a mind-boggling power to articulate thoughts, communicate those thoughts, and solve problems in ways we otherwise wouldn't be able to.

But before I start detailing the abundant amount of science and sense-making that support this assertion, let me tell you a secret about how I've learned to coax adults into moving past their ever-present Resistance to drawing.[6]

I DON'T ASK ADULTS TO "DRAW."

I learned through trial and error in working with businesspeople that "drawing" is much too loaded a word. If you ask adults if they can draw, they interpret it to mean "Can you create lifelike representations of reality?" When I say "drawing," people instantly picture something by da Vinci or Picasso and then have a panic attack. The poor creatures exhibit all sorts of fight-or-flight responses, and understandably so. If we think drawing requires a skillful visual reproduction of some object in the world, then, sheesh, by that standard I can't draw either. I couldn't draw a picture of a wombat if it posed patiently on my desk for two days. (But I can definitely doodle a wombat. And so can you.)

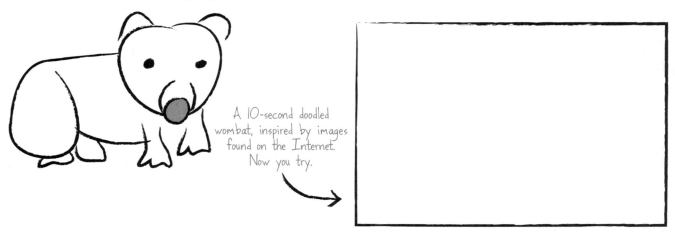

A 10-second doodled wombat, inspired by images found on the Internet. Now you try.

To be crystal clear, however, learning to draw is NOT what this book, or this Revolution, is about. There will be sections within where you'll swear you're drawing (and if you're comfortable going there, carry on), but this book is about educating on and advocating for the use of a simple visual language referred to as "doodling."

We'll get to the semantics shortly, so just calm your inner language police.

It's about applying doodling—and its more advanced partner, "Infodoodling"—as accessible and potent techniques to any ferocious challenge to make it go away.

Now, I already know what some of you skeptics are thinking: *Doodling? Really?* You may not be good at drawing, but you are, in fact, an educated grown-up and you are too sophisticated for doodling. I mean, *children* can doodle. Any schmuck with a chalk rock can doodle. Well, thank you for making my point. Doodling requires no artistic talent, no expensive art supplies, no formal training, no "innate" visualization talent. Doodling is easy; it is instinctive; it is universal. People around the world are comfortable with doodling. In fact, doodling as a concept and a practice is so universal that it's almost up there in frequency with singing and dancing. This makes it a very nice teaching word for reintroducing skittish adults to their native ability to *show* rather than just tell. And once we accept that, the remarkable powers of the doodle just keep expanding.

Consider this reality: Doodling, even in its most simplistic form, has given society huge, game-changing innovations. A staggering number of scientific, mathematical, and business breakthroughs have come about via the act of making inelegant marks on paper.[7] Doodling has given corporations unimaginable insights into their businesses. It's given individuals new leases on life. An outside observer can't detect the synaptic crackles happening in the brain of a doodler, but, my friend—doodlers are *lit up*. We can no longer perceive doodling to be a trivial act because to do so is to ignore the genesis of hundreds of inventions sparked by the symbiotic relationship between visual language and thinking. I wouldn't beguile you. Doodling can transform the way you think. You are so very close to making it possible.

My niece and nephew, unapologetically doodling

EXCUSE ME, DID YOU SAY "DOODLING"?

People all over the world have experience with and preconceptions about the word "doodle."[8] This can work both for and against our mighty visual friend, so in this section I'll present the definition of doodling that I believe in with the hope that the fog might lift from our eyes and we will start to see doodling in a whole new light. First, let's align on the currently accepted definitions of the verb "to doodle."

Merriam-Webster tells us that "to doodle" means "to dawdle or trifle." Its synonyms include "to fiddle or fool around," "to hang about," "to fribble," "to idle," and "to monkey around." (I find that last definition offensive to doodling AND to monkeys.) Wikipedia tells us that a doodle is "an unfocused drawing made while a person's attention is otherwise occupied." The *American Heritage Dictionary* defines doodling as "frittering away time."

This definition is why most teachers don't like doodling in the classroom.

17TH-CENTURY DOODLE DEFINITION:

a simpleton; a fool

19TH-CENTURY DOODLE DEFINITION:

a corrupt politician

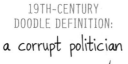

Hmm. None of those definitions is very flattering. Perhaps history has been semantically kinder than modern-day definitions? Let's see. In the seventeenth century, the word "doodle" was a noun only and it meant "a fool or a simpleton." Ouch. Now we know the roots of Yankee Doodle.

In the eighteenth century, "doodle" became a verb and it meant "to ridicule, swindle, or make a fool of"—a natural derivation of its previous unflattering counterpart.

In the nineteenth century, a "doodle" became a corrupt politician, one who may dawdle on the public's dime or otherwise take advantage of the perks of office. And that brings us full circle to our modern-day definition of the verb, which can be summarized simply as "doing nothing."

As you can see so far, we have not one appreciative, or really even tolerant, definition of the Doodle. Ruuu-uude.

While it's possible that you're snickering about the doodle's definitions and inventing fun phrases with its silly sound structure, these are pretty serious misnomers surrounding a real force of nature.

So here's the part where we revolutionize the definition. After working with and witnessing thousands of doodlers in action, I've found it necessary to advocate a different view on doodling, one that must be stated unequivocally.

18TH-CENTURY DOODLE DEFINITION:

to ridicule; to swindle

I don't believe that doodlers are unfocused. I don't believe that doodlers are monkeying around, nor do I believe that they're wasting time. Stated with crystal clarity:

There is NO SUCH THING as a mindless doodle.

There's a legitimate reason why billions of humans have been doodling in the snow, in the sand, on cave walls, and in journals for more than thirty thousand years. There's a legitimate reason why doodles show up in the notebooks of our most celebrated thinkers, scientists, writers, and innovators. And, surprise, it has nothing to do with doing nothing. There's too much evidence that suggests that what's really happening is that a doodler is engaging in deep and necessary information processing. A doodler is connecting neurological pathways with previously disconnected pathways. A doodler is concentrating intently, sifting through information, conscious and otherwise, and—*much* more often than we realize— generating massive insights. This reality, my friends, is why I want you to remember how to doodle. It is why, after you read this book, I hope that you seriously elevate your skill in doodling: because you'll be elevating your skill in thinking and problem solving, too.

Let's give the Doodle what's long overdue. From this point forward, when you read the word "doodle," I want you to think of it as **"making spontaneous marks (with your mind and body) to help yourself think."** Think of Doodling as the archnemesis of doing nothing. By the end of this book, its power and optimal use in your life and work will be abundantly clear.

TO DOODLE (modern, unfair defn.)
: ~~to dawdle~~
: ~~to dillydally~~
: ~~to monkey around~~
: ~~to make meaningless marks~~
: ~~to do something of little value, substance, or import~~
: ~~to do nothing~~

duh! 1+1 = 19 HUH?

FALSE.

TO DOODLE (Revolutionary's defn.)
: TO MAKE SPONTANEOUS MARKS TO HELP YOURSELF THINK WITH YOUR MIND AND BODY

OMG! ~~EUREKA!~~

TRUE.

DOODLING VS. SCRIBBLING, SKETCHING, AND DRAWING

Now that we've overturned a sizable misperception around the definition of doodling, many of you will naturally be asking this question: How is doodling distinct from sketching or drawing? Here's a loose explanation to ease your mind.

A SCRIBBLE: random, abstract lines generally made without lifting the drawing tool from the page; associated with children developing hand-eye coordination

A SKETCH: a quick, unrefined drawing

A DRAWING: a generally recognizable visual representation of an object or form

A DOODLE: spontaneous marks made to support thinking

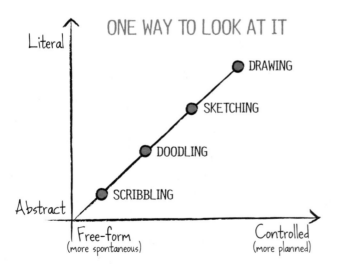

ONE WAY TO LOOK AT IT

My word-police readers may be scratching their heads. But can a doodle sometimes be a drawing?

The answer is yes.[9] Can a sketch be a doodle? Yes. Can a drawing be a doodle? Yes.[10] Can a scribble be a doodle?[11] Yes. Can a doodle be a sketch? Yes to all of the above.[12] Don't get caught in the semantic spiderweb. What matters here is that we are *uplifting the definition of the doodle* because it's something all of us are able to do, and then we will be *applying it together*. We're inviting the world to see the doodle in a positive and functional way and then to capitalize on its magnificent utility.

AN EVEN MORE EXPANSIVE DEFINITION OF DOODLING

We just overturned the standard definition of doodling, but here's the real cage-rattler.

There are hundreds of larger-than-life individuals who actually relied on doodling as a tool for repeat cognitive breakthroughs. One doesn't need to search far and wide to uncover vast numbers of these folks, but I want to take a closer look at three of them: Steve Jobs, Albert Einstein, and Nikola Tesla.

Keeping in mind our new definition of "making spontaneous marks to help yourself think," now imagine that those marks don't have to be just pen on paper. Imagine that those marks could be traces of any kind—footprints tracking through snow, musical notes emerging from an instrument, or electrochemical trails in the brain. Imagine that doodling can take something beyond a visual form, that its edges are not confined to being SEEN. Imagine that doodling can be kinesthetic, occurring through movement of the body; gestural, occurring through the movement of hands; musical, occurring through the manipulation of an instrument; or mental, occurring through the winding process of contemplation. Sounds wild, right? Stick with me. I've got examples.

Steve Jobs, Kinesthetic Doodler

Steve Jobs, the formidable CEO and disrupter of seven industries,[13] was famous for taking people on long walks as they talked over problems to be considered and decisions to be made. *Fortune* magazine referred to these as a "different kind of power walk"[14]—walks that Mark Zuckerberg, the Facebook CEO, is also known to take, some of them with Jobs himself before he died. Walter Isaacson's biography of Jobs cites many instances when Jobs was facing some sort of challenge and would sort through that challenge by taking long walks.[15] On these walks, it doesn't appear that Jobs's intention was to *clear* his head. Rather, his purpose seemed to be to align his thinking, to sift through the information known about the challenge in order to decide what action to take.

STEVE JOBS:
Class-A Doodler

According to people who worked with him, Jobs rarely sat down to think. He was like a lit fuse, and in meetings he used visual language naturally, drawing on whiteboards to show his concepts and strategies[16]—but he also *moved* a lot. Based on the fact that Jobs habitually considered and made decisions while in motion, I would call him a "kinesthetic doodler" (as well as an Infodoodler). He was a person who seemed to think better while making spontaneous marks with his physical body.

In this way, all of us have a little Steve Jobs in our nature. Dr. John Medina, the developmental molecular biologist who wrote *Brain Rules*, deliberately installed a treadmill in his office in order to "jog" his memory and tease out insights because he knows it works neurologically. For the human biological organism, moving while thinking—what we can refer to as "kinesthetic doodling"—facilitates ideas.

Albert Einstein: Musical Doodler

ALBERT EINSTEIN:
Class-A Doodler

For those of you who deplore long walks, there are other doodling options, one of them illustrated with exquisite perfection by Albert Einstein, known to be a great lover of music. According to one of his biographers, for Einstein,

> *Music was no mere diversion. On the contrary, it helped him think. "Whenever he felt that he had come to the end of the road or faced a difficult challenge in his work," said his son Hans Albert, "he would take refuge in music and that would solve all his difficulties." The violin thus proved useful during the years he lived alone in Berlin, wrestling with general relativity. "He would often play his violin in his kitchen late at night, improvising melodies while he pondered complicated problems," a friend recalled. "Then, suddenly, in the middle of playing, he would announce excitedly, 'I've got it!' As if by inspiration, the answer to the problem would have come to him in the midst of music."*[17]

This passage describes, unwittingly, the value of "musical doodling." The conditions needed for eureka are all there. Einstein's mind was saturated with the data he needed to solve a problem. He'd reached the limits of what writing equations and thinking alone could do. And when he hit those intellectual stumbling blocks, he brilliantly resorted to what any good musical doodler would do: thinking and playing at the same time. Improvising and imagining simultaneously through music.

Jazz musicians, of course, are also purveyors of musical doodling, which they refer to as improvisation. When one studies the philosophy of jazz, much ado is made about the distinction between repetition or classical training and jazz improvisation. According to Jacques Attali[18] and many academics who wholeheartedly agree, these methods represent two very different modes of *musical thought*. The first musical-thinking mode offers a road map, a template on which to rely and continuously improve, and it's valuable for keenly sharpening the established edges of a trail. But the second mode of musical thinking blazes entirely new trails, opening doors to creation and transformation, allowing the musician and the audience to discover something wholly unforeseen. This musical doodling has the potential to alter the very nature of the world in which we live. (Hello, theory of relativity!) By allowing the compositional process to leave the templates behind, the improviser becomes a pioneer, and the improvisational act of musical doodling gives dormant ideas the chance to spring to life.

NIKOLA TESLA: Class-A Doodler

Nikola Tesla: Mental Doodler

Until light once again shone on his work in the early 1990s, Nikola Tesla had been one of the world's most prolific but obscure inventors. The proverbial mad scientist, Tesla pioneered and patented a whopping seven hundred plus inventions in his lifetime, including wireless communication, remote control, X-ray technology, and fluorescent lighting. Despite his deep contributions to modern electrical engineering, Tesla died penniless and alone, and most people on the street don't know his name. I'd like to restore Tesla to our cultural consciousness by describing something intriguing about how he worked.

Based on historical accounts of his methods, I'm convinced that Tesla was an extraordinary "mental doodler." In the parlance of the Revolution, a mental doodler is a person who has an accelerated capacity to model multidimensionally using only his or her mind. Such a doodler does not require an external visualization of that model in order to see it, adjust

it, or improve it. Multiple scientists who worked with Tesla concurred that Tesla could almost instantly see a complex object in precise and realistic detail once he had heard its name. He rarely had a need to create drawings by hand. Instead, he rendered complete and final productions of a piece of equipment in his head!

For example, Tesla designed and tested electric turbines to generate power. He built the machinery entirely in his imagination, whirring and rotating the parts in his mind and correcting faults while it operated. Tesla was so adroit at this mental doodling that he actually considered Thomas Edison's method of invention to be clumsy and inefficient, requiring laborious experimentation and an excess of procedural steps.

For those of us less adept at mental modeling, it remains a buildable skill. Visualization is a muscle. It can be grown and strengthened, stretched and flexed. The reality is that we can teach our brains how to *see* more clearly and then we can teach them how to *show*. Fortuitously, we can use a wide array of doodling techniques—sophisticated and simple—to support that process.

So how does Doodling deliver on this promise? I'm glad you want to know. Let us welcome your new best friends, the Doodle's Three Ps: Power, Performance, and Pleasure. The Three Ps will answer your inevitable and legitimate question, "If I (suspend disbelief and) embrace the Doodle in all its forms, what's in it for me?"

THE DOODLE'S RADICAL CONTRIBUTIONS:
Power, Performance, and Pleasure

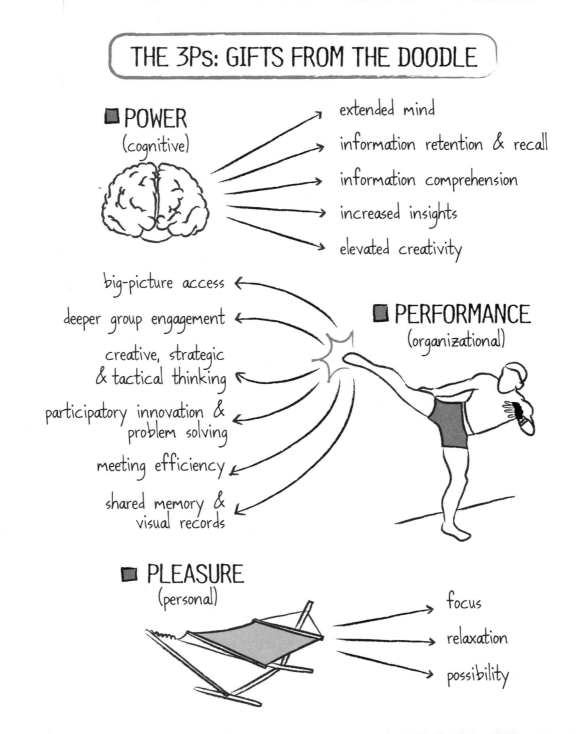

THE 3Ps: GIFTS FROM THE DOODLE

POWER
(cognitive)

→ extended mind
→ information retention & recall
→ information comprehension
→ increased insights
→ elevated creativity

PERFORMANCE
(organizational)

← big-picture access
← deeper group engagement
← creative, strategic & tactical thinking
← participatory innovation & problem solving
← meeting efficiency
← shared memory & visual records

PLEASURE
(personal)

→ focus
→ relaxation
→ possibility

POWER (COGNITIVE)

Power can have a negative connotation—Kim Jong-il, anyone?—but I'm talking about power as a force for good. I'm talking about Doodling as a form of enhanced thinking, as a device that's simply been in disguise, misunderstood by the casual observer for centuries. This diminutive technique offers dynamite cognitive power.

INFORMATION RETENTION AND RECALL

Scientists and educators have started to explore the effects of doodling in various settings, and some of their findings may surprise you. For example, did you know that doodling can actually increase information retention and recall? Rather than diverting our attention away from a topic (what our culture believes is happening when people doodle), doodling can serve as an anchoring task—a task that can occur simultaneously with another task—and act as a preemptive measure *to keep us from losing focus* on a boring topic. Dr. Jackie Andrade of the University of Plymouth, UK, conducted a study of participants who were asked to listen to a monotonous phone call, some doodling while listening and others just listening.[1] She discovered that on a surprise memory test, the doodlers retained and recalled 29 percent more of the content than their nondoodling counterparts. It appears that the reason we see doodling emerge in complex, uncomfortable, or lengthy discussions is because *people are relying on it to keep them present*, not to give them a way out.

To be fair, doodling *can* mean that someone isn't paying attention *to the topic at hand*. Unless doodlers actively choose otherwise, they can be giving energy to their personal thoughts rather than the content and conversation surrounding them. So Revolutionaries need to keep in mind that in order to give the doodle a good name, we must hone our skills at linking doodling with what's happening around us. We'll perfect this technique in later sections.

With respect to retention and recall, the bottom line is this: With the amount of information competing for our brains' attention these days, most of us need all the help we can get.[2] But we find reassurance from Dr. Andrade's work and from Simonides of Ceos, the Greek lyric poet credited with inventing two of our most popular memory techniques.[3] Simonides wrote that "anything can be mentally imprinted and kept in good order simply by converting it into a series of engrossing visual images and then arranging those images in space." The man must have been an avid doodler.

INFORMATION COMPREHENSION

We covered recall. Now let's talk comprehension. Let me tell you a story that may forever alter your perception about doodling in the classroom.

In the winter of 1969, Virginia Scofield, a friend of mine, was facing a daunting challenge: passing undergraduate organic chemistry. She had already failed miserably at her first attempt, and she was

on the edge of panic. At the time, Virginia was a biological sciences student at the University of Texas. Her career plan bumper sticker could have read "Ph.D. or Death!" because she had no alternate route to the title she desired and no plan B. She had to comprehend, retain, and assimilate organic chemistry's masochistic detail, and time was not on her side.

Being a diligent student, Virginia had tried and exhausted every traditional learning method she knew of—highlighting, standard note taking, and rote memorization—until finally she chose to unleash a powerful, primitive tool that ultimately turned out to be her savior: the Doodle. Virginia decided to create rudimentary visual representations of every concept in the infamous Morrison and Boyd textbook. She doodled, reviewed the image, and doodled again. She deployed a problem-solving technique that defied conventional wisdom and all the academic advice she'd ever received. This story has a triple happy ending. Not only did Virginia ace her organic chemistry final and eventually become Dr. Scofield, she also became a celebrated immunologist, earning accolades for an unexpected and significant breakthrough related to HIV transmission.[4]

Dr. Scofield never forgot the lesson she learned: Simple visualization is powerful and it is memorable, even if—heaven forbid!—it looks like chickens drew it. When she taught for decades at USC, UCLA, and the Claremont Colleges, Dr. Scofield used doodling as a transformative teaching tool. She asked her students (who were mostly taking strictly written notes) to sketch

what she sketched on the board and to use visuals in their notes in her classroom. Of course she also encouraged them to use labels, categories, equations, and abbreviations, but she asked that they focus on creating free-form imagery as much as possible during her lectures and stop trying frantically to capture all of the words. As a result, she significantly elevated the number of students making A's who had previously been in danger of failing altogether.[5] Scofield credits much of her success, as a researcher and teacher, to her world-changing decision to doodle.

Dr. Scofield's studies of *Botryllus*—a species of "sea squirts"—opened a new area of inquiry into one of this century's great biomedical dramas: the mystery of how the AIDS virus is transmitted, and how it might be stopped.

A recent article in *Science* reinforced Scofield's prescience.[6] Three researchers studying the effects of doodling and drawing on students' ability to learn science discovered that when students shift their focus from interpreting presented visuals to creating their own visual representations, they have a considerably deeper learning experience.

The doodling students in this study demonstrated heightened abilities to generate new inferences, amplify and refine their reasoning, clarify their conceptual understanding for other audiences, and engage at a profound and even "striking" level compared with students who were just reading or reading and writing summaries.[7] Based on these observations, the researchers advocated that drawing be recognized as a key element in education, right up there in value with reading, writing, and having group discussions.

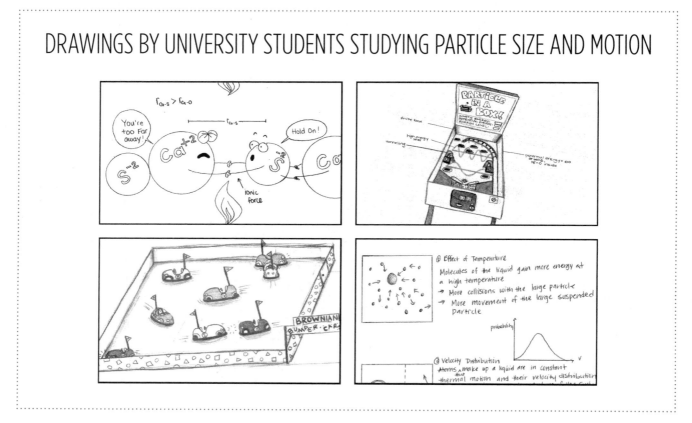

The moral of the story is that doodling and drawing as tools for learning complex subject matter yield big intellectual and creative payoffs. This makes these tools appropriate in situations where society often perceives them to be inappropriate—in settings where information density is high and the need for processing that information is high. It's not by accident that both Reagan and Clinton were famous for doodling during White House meetings—they were trying to think and make decisions in what were likely cerebral, high-stakes conversations. It's time we embrace the presence of the Doodle—as a device for enhancing comprehension—in the classroom, the boardroom, and even the war room.

IMMERSIVE LEARNING:
LEARNING THROUGH MULTIPLE MODES

visual

One *major* contribution of doodling, sketching, or drawing is that they open the doors to methods of learning that go beyond traditional learning techniques. This is hugely important, because I believe that learners should have access to any and all methods of learning that will get them to their goal. I don't mind if you choose to learn astronomy by way of interpretive dance. There shouldn't be limitations on the styles of learning available to us, and doodling accommodates every learning style I've read about. Don't believe me? Let's look at the Big Four.

VISUAL LEARNING

Visual learning could be described as a learning style in which ideas, concepts, data, and other information are processed and understood through images and visualization techniques.[8] The doodle's contributions here are obvious.

auditory

AUDITORY LEARNING

An auditory learner understands and processes information best through hearing and speaking. I've noticed from interacting with diverse sets of learners that doodling is appropriated as an auditory technique in two ways.

> I'd like to acknowledge that there are raging debates within the education community about what multimodal learning means and how it can be appropriately defined or measured. What's useful from these debates for our purposes is the overall recognition that people learn in a variety of ways—not just through reading, writing, and listening, which is what most schools and workplaces offer.

reading/writing

One: Doodlers often rely on doodling specifically when they're in a listening situation. In other words, the markers and pens come out when people are in a classroom or a meeting room, at a conference, or listening to the radio or television. These learners need doodling in order to focus more acutely on what's being said, and they demonstrate better recall when they're allowed to doodle than when they're not. These learners seem to enjoy the process of simultaneous sketching and listening (one might call this "visual translation"), whether what they draw is on- or off-topic. We all know at least one person whose pen operates like a sixth finger in meetings.

kinesthetic

The second way doodling becomes an auditory act is by involving humming, singing, or talking to oneself. Doodling appears to trigger in some people a tendency to vocalize or harmonize. Many adults I've worked with connect these activities—humming, singing, or self-talking and doodling—as if they are intricately linked, as if one doesn't precede the other but instead they come as a package. Together, these activities appear to amplify the experience of taking in and assimilating information for the doodler.

READING-AND-WRITING LEARNING

We're all very familiar with the reading-and-writing method because it continues to dominate the learning landscape around the world (not necessarily because it's ideal for learning, mind you). This style emphasizes text-based input and output or, more simply, information displayed as words. People who prefer this modality are comfortable with books, lists, journals, newspapers, and hellaciously designed PowerPoint presentations. Doodling relates to this learning style in the following ways.

Word Doodlers

"Word doodlers" are people who write one word on a page, say, "Kennedy," and then repeatedly rewrite or trace that word throughout the duration of a meeting or lecture. Often word doodlers write and trace the same word for months or even years, and if we meet in person, they ask me in a somber tone what it means about their personality (as if I have frontline access to Freud, who wouldn't know anyway). The answer is that I can't tell much about their personality from their word doodle (and what a dangerous game it would be to try). But what I do know is that our brains interpret letters as images, so the word they're tracing is supporting their focus and thinking just as if they were doodling an image or an abstract design.[9]

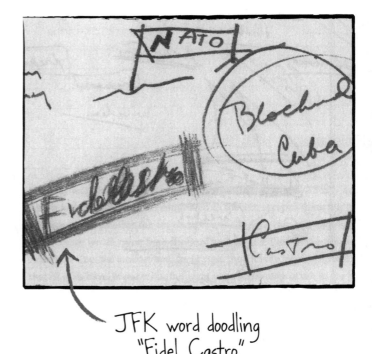

JFK word doodling "Fidel Castro"

Font Doodlers

Then there are the "font doodlers." These people are distinct from word doodlers in that they imbue their doodled words and letters with more elaborate typefaces, associated iconography, and elements of emotion. For example, these folks may write and trace the word "Kennedy," but they would enliven the word with a medieval font conjuring Camelot. However they choose to proceed, just like their word-doodling counterparts, font doodlers are actively engaging with visual forms in order to ground themselves in thinking.

Word Picture Doodlers

The font doodlers have a subgroup worth noting here, the "word picture doodlers." Word picture doodling overlaps with font doodling in that it embodies characteristics of the noun or verb it represents, but it's distinct in that the word is crafted using an image or images associated with the noun or verb itself. Visual examples make word pictures clearer, so I've included a couple below.

The reading-and-writing learning style involves a high-functioning cognitive capacity—what it takes to interpret and generate written language is impressive—but as a learning mode it's not as instinctive as doodling, and it has to be taught.[10] So it's important to acknowledge that reading and writing are profound tools of humanity, but they don't optimize the way our most ancient and powerful brain is wired, which is heavily in favor of spatial and visual input.

examples of font doodling

DRIVE
paradise
CONTENT
VIRAL

A thought exercise: Make up a story using the four words.

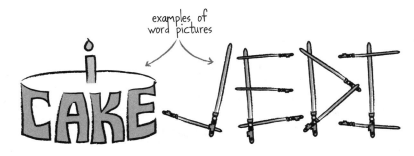

examples of word pictures

CAKE JEDI

KINESTHETIC LEARNING

Lynda Barry, the author and cartoonist extraordinaire, once said that the worst thing she can do when she's stuck is to start thinking and stop moving her hands. Doodlers know exactly what she means. The seemingly small act of using our hands to create something not only gets us reliably unstuck but also changes the way we look at and understand the world. It harnesses and directs some of the energy that would either be dispersed or made aimless through fidgeting or daydreaming, and the movement of the pen across paper or the marker across the whiteboard discernibly anchors the learner into the present moment. Even while the level of physical engagement in standard doodling is much less than, say, dancing, the fact that doodling enables important human functions—grip and movement—also positively impacts what's possible in the head of a thinker.[11] And an important heads-up: When you arrive at the doorway of Infodoodling, that's when you'll find that kinesthetic learning and the physical movement it allows may prove to be the most substantial of the Big Four learning styles.

Having learned about the Big Four learning modes and how doodling relates to each one, take a moment to reflect on the type of doodler(s) you have been, where you are now, and the type of doodler you want to become. Don't think you need to explore the depths of each technique right now—we'll get there as we move through the book. Just be aware of the doodler(s) you are when no one's watching, and appreciate that any native style can be a launching pad for the Infodoodle.

THE EXTENDED MIND

The last cognitive kick from the Doodle that I'd like you to consider is the idea of the "extended mind." It's a concept from philosophy that asserts that objects in the external environment are used by the mind to extend itself. So the mind isn't just sitting isolated inside the skull; it's seen to include every potential aspect of the cognitive process, including the use of environmental aids. Stated differently, in this view, objects and spaces within the environment function as *part* of the mind. Philosophically, I can't prove this. (I can barely make sense of Foucault.) Pragmatically, I know well that the sketches and doodles on sticky notes and whiteboards surrounding my desk are extensions of my thoughts on any given day. I know that the prototypes we build with teams are actually holding information so the group doesn't have to. I also know that we *need* these items because the typical human brain can contain and contemplate only four bits of information in working memory, the cerebral space allocated to manipulating information in the moment.[12] So creating a physical place in which to pour our thoughts and images permits our minds to release that information from short-term memory, thus letting us see it externalized and releasing us to organize, examine, and reflect on its deeper implications.

David Allen's wildly popular productivity method, Getting Things Done ("GTD" to its adherents), functions partially on this idea of the extended mind. He asserts that capturing and organizing to-dos in an intentional and systematic way—even in a form as simple as a list—can unleash a creative flood. He's right, and it works by releasing working memory from its obligations.

Larry Page, the cofounder of Google, seems to understand this sentiment, since he stated in an early TED talk that the only way he and his team could prioritize their top-100 projects was to write them all down and order them.[13] He explained that "as long as you keep the hundred things in your head, *which we did by writing them down*, then you could do a pretty good job deciding what to do."

It seems safe to say that extending the mind via surrounding white space (and various other office supplies) is often what makes the emergence of creativity and deeper analysis possible. Without it, we would spend volumes of energy juggling swirls of trivial details, and consistently fail despite our best efforts. We *need* the extended mind to give us room to build heartier insights. And inside of that extended mind, we need the Doodle, in all of its wondrous forms.

PERFORMANCE (ORGANIZATIONAL)

We've learned that the act of Doodling delivers clear cognitive impact for an individual. But there are reasons why the Doodle is of particular value when it's used by groups in organizations working together. When we incorporate simple visual language into a group thinking process, we instantly change what's possible en masse. And it's not just because Doodling awakens cortical networks typically uninvited to the thinking party.[14] It's because the act of visualization adds layers of relevance, functionality, and communication to a conversation. It deepens the exchange between people. I've witnessed groups applying the Doodle:

a) Invent something incredible where there was nothing special

b) Establish a team where there was only a loose band of haters

c) Reveal the nature of a product or service so they could better sell it

d) Discover the smartest move they could make for the next five years

e) Alter the course of their entire organization

a group making power moves with the Doodle

You heard it here, folks, and it's no hyperbole. When applied in a group setting, Doodling can unleash a plethora of unforeseen solutions to problems. This is in part due to its cognitive impact, and in part due to five additional gifts it brings when it's incorporated in a skillful way. Read on to discover how Doodling amplifies interaction within groups. Here's a sneak peek into what it can look like.

HOW DOODLING WITH OTHERS AMPLIFIES INTERACTION

THE BIG PICTURE

Group doodling lets multiple people see a more accurate and bigger picture, simultaneously. Rather than relying on words to understand each person's partial perspective, a shared doodle empowers the group to construct and build consensus around a single visual representation of a topic. And even when a topic is far too complicated to get universal agreement, *at least* we can center our discussion around the same details and avoid repetitive dialogue.

A personal story related to this: I once spent the better part of an evening arguing over the definition of "heroic"—Navy SEALs versus a variety of others—only to discover upon plotting these heroes visually that my husband and I were never going to agree. We were basing our arguments on values that were implicit and hard to pin down because they weren't visualized. Once we had them mapped, there was no point in defending our positions because we could see the differences in our thinking and recognize that no one was "right." We were just in a conversational hamster wheel, and doodling helped us get out of it. Below is a reproduction of the doodle we made that night to resolve our argument.

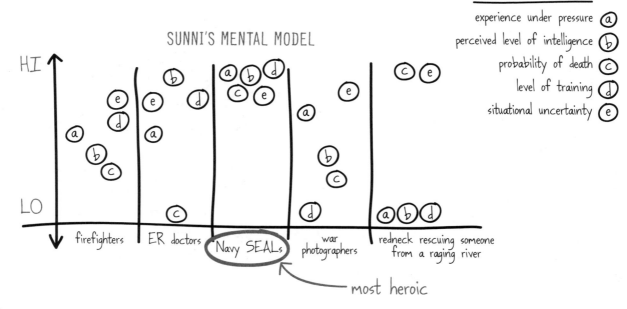

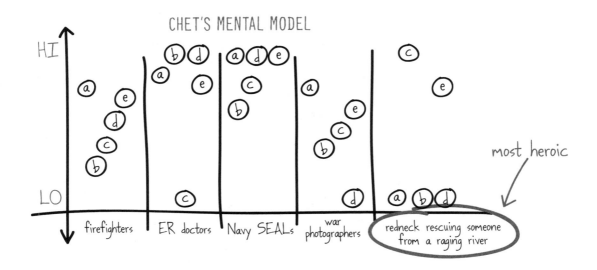

CHET'S MENTAL MODEL

most heroic

firefighters | ER doctors | Navy SEALs | war photographers | redneck rescuing someone from a raging river

HEIGHTENED ENGAGEMENT

Group doodling keeps people engaged in a problem-solving process because we are *biologically attracted* to information displayed visuospatially. Social proof: Our biological orientation to visuals and movement makes incorporating visual language into a group hugely relevant. Doodlers invite people to bring their whole selves, not just the parts that are trained to process auditory and text-based information.

Heightened engagement is a sight for sore eyes in almost every meeting culture. Having experienced

> QUESTION:
> Have you ever been in a restaurant with a television? It is next to impossible to stop turning toward it and focus on your dinner companion. Television has the visual and spatial allure of a Greek Siren (and a comparable level of danger).

and led a plethora of group sessions, I still find myself dazzled at the energetic effect on people when they're asked to stand up, interact, and map content with each other. They become whole participants at once rather than employees feigning interest in a meeting.

IMMERSIVE THINKING

Group doodling accommodates creative, strategic, *and* tactical thinking. Amazingly, doodling encourages innovation and creative thought by igniting various parts of the mind, but it can also *display complexities* visually, which supports quicker decision making and more informed ground-level action.[15] Being in a contextually rich environment, in a space ambient with visual language, gives us instant immersion into thinking with more layers. It is in complex circumstances that doodling really shines.

MEETING EFFICIENCY

Doodling with others also ensures that everyone is heard and that the ideas expressed have a "face" and a place to live. Content captured by the Doodle dramatically reduces repetitive conversation (yes, Mo, we understand your department is underfunded) and decreases the amount of time required to sort through and solve a problem. A study of visual language conducted by the Wharton School indicated that meetings using visual language are shortened by 24 percent.[16] I say we double its usage and shorten meetings by 48 percent. Who's with me!?

VISUAL RECORD & SHARED MEMORY

Group doodling also creates a visual archive of the conversation in a working session. It maps it. Rather than allowing insights to float off in the breeze—a common occurrence in standard group sessions—doodling gives those insights a visual "hook" and a record that's much more likely to be revisited (please don't pretend you read meeting minutes) because of its visual nature. Its "visuality" also supports the retention and recall of that mapped content and establishes a shared memory—one that persists well after a session has concluded.

LEVERAGING THE FIVE CONTRIBUTIONS: WHITEBOARD CULTURE

Those five contributions of the Doodle seriously change the group-work game, and it's important to acknowledge that there are organizational cultures that make those contributions really shine.[17] Before we examine the final P from the Doodle, Pleasure, let's consider a company context that makes heightened performance truly possible—a setting I refer to as "whiteboard culture."

I use the term "whiteboard culture" to describe an environment that encourages the large-scale visualization of thinking or ideation processes. The presence of large white space itself is the first physical sign of an organization's potential commitment to a Doodle-friendly culture.[18] That said, simply owning a whiteboard or flip charts isn't enough. In other words . . .

WHITE SPACE ALONE DOES NOT A WHITEBOARD CULTURE MAKE.

A vibrant whiteboard culture is a place in which employees are encouraged to use simple visual language—doodling, sketching, drawing, prototyping—and are capable, through training or experimentation, of doing so. Employees exposed to whiteboard cultures have learned, consciously or otherwise, about the extended mind. They know that the wall is the new desk, and they don't fear making Doodle-rich messes in service of generating ideas and mapping conversations. Real whiteboard cultures teach people to work beyond the boundaries of their desks and computer screens because they understand the effect it has on performance.

In a large majority of office cultures, however, white space remains a foreign concept. Some pay lip service to it on company walls or inside meeting rooms, but actually *doing* something meaningful inside that space remains as instinctive as decoding the Rosetta stone. To get the benefit of the five contributions we covered, an organization needs its commitment to have weight. Ideally, it would develop a culture that accommodates experimentation, transparency, collaboration, exploration, and creativity—all characteristics swirling around the skillful practice of "Doodle Thinking" in groups.

In Chapter 5, the Revolution will show you how to infuse your workplace with large-scale, simple sequences of visualizations. Applying these techniques can help you kick off a whiteboard culture, one that could look like this:

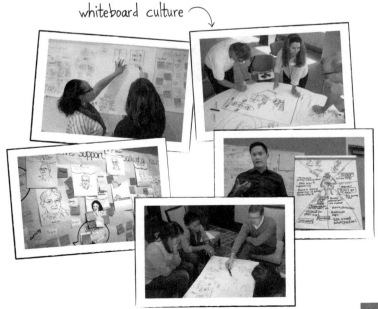

whiteboard culture

I think you're starting to see how the Doodle is the gift that keeps on giving. The knowledge you build over the course of this book will come together in spectacular fashion when you reach the final stage, where you'll find what we call "Infodoodle sequences"—visual-thinking actions that help solve common organizational problems. These sequences represent the most sophisticated form and function of Doodling, and they require a slow build. Be patient as we make progress and, by all means, enjoy the ride. High performance, here you come.

PLEASURE (PERSONAL)

In this world of up and at 'em, we often overlook the value of simple pleasures. While some of you über-cerebral readers will be baffled by this section, the book wouldn't be complete without it. We must acknowledge and celebrate three of the most satisfying gifts Doodling offers: focus, relaxation, and possibility.

FOCUS AND RELAXATION

FRIED: A PORTRAIT OF MODERN LIFE

Focus is a precious commodity in today's poke!-honk!-ping! life. We all experience the daily havoc of trying to attend to a flood of things at once. The reason so many of us have a creeping sensation of attention deficit disorder is because we're responsible for a multitude of tasks that we imagine we can do simultaneously. But multitasking is, for the record, impossible.[19] The human brain is not designed to pay attention to multiple attention-rich items simultaneously. It can only give them attention sequentially, one at a time,[20] and when we switch constantly among various tasks, we reduce our effectiveness at each task by a significant degree. (We also frustrate ourselves to no end.) Humans *can* do several things at once, but only if they are easy and nontaxing like (you guessed it) walking and chewing gum.[21] Trying to attend to multiple lush stimuli is just a recipe for crazy.

Now, I can't change your work environment. I cannot change the culture in which we live. I certainly can't change the Digital Age that's bringing bells and whistles to every living room across the country. What I can offer you is an invitation to doodle. To simply sit quietly with paper and drifting pen. As we'll continue to discover, doodles offer a welcome detour from our goal-driven, results-oriented focus. It's worthwhile to simply make meandering marks, allowing your mind to ebb and flow, to move and play without purpose and focus on just *that one thing* for however long you'd like.

One time I did that and it looked like this:

Another time I did it and it looked like this:[22]

When you try it yourself, you may be surprised (to remember) how relaxing doodling can be. Doodling facilitates that elusive "flow state." It can peacefully reverse the damage done by what the *New York Times* technology reporter Matt Richtel calls "screen invasion," which is the phenomenon of being plugged in and tuned out everywhere we go. Technology brings us a wealth of opportunities, but it also has its costs. Our attention is often fragmented, our presence with others diminished. We feel a constant sense of urgency without the accompanying sense of satisfaction that comes from being productive. In an odd twist on what the hippies meant, we "turn on, tune in, and drop out" of being connected, to others and to ourselves. Rather than relaxing us, this kind of behavior over a prolonged period of time can cause anxiety, isolation, and stress.[23] And stress, as you know, is not pretty. Stress contributes to many, many bad brain outcomes like a shrinking hippocampus[24] and potentially a one-way ticket to dementia.[25] Of course we'll continue to use technology—ideally in a way that optimizes its value for us—but we should consider using our low-tech options, too.

One Thing at a Time

Take a moment to enter the Doodle Zone. This Zone offers us a blissful haven from the incessant whirring of the mind. It provides an opportunity for the purposeful use of the basic, long-form doodle, thus resembling a Doodler's meditative practice. This Zone is quietly calming, it is a journey without a destination, and one can marvel at the experience after having observed where it led. In the Doodle Zone, the doodler's breathing slows; her heart rate decreases; her mind relaxes; her focus sharpens. She finds herself momentarily a picture of relaxed tranquility amid the hustle and bustle of daily life.[26] She also finds herself surprised at the insights that result from this seemingly insignificant endeavor. So here's your chance to relax and focus, right here, right now, in the pages of this book. Make a meandering doodle while listening to music or even while lingering on hold on the phone. Hum to yourself while you doodle in peace. Go on. What do you have to lose?

You are free to roam in *THE DOODLE ZONE.*

POSSIBILITY

I've asked you to stretch many of your established ideas as a part of this Revolution, and here's where I ask you to do it again. Let's consider what the Doodle offers in terms of *possibilities*. From personal experience, other people's stories, and a growing body of neurological research supporting this idea, I've come to believe something that I think you'd be interested to learn. Are you ready?

I BELIEVE
WE HAVE SIGNIFICANTLY MORE INFLUENCE OVER THE DIRECTION AND OUTCOMES OF OUR LIVES THAN WE REALIZE.

I believe that we contribute to our current situations more than we're often comfortable with accepting, and I believe that visualization through Doodling—by igniting what we can refer to as the brain's "knowing network"[27]—is one of the major ways we can influence what's actually happening or what's going to happen.

As odd as this may sound, the idea that we can and do alter our realities through visualization isn't radical at all when you consider the following:

· Professional athletes have long applied visualization techniques in their quests to gain an edge over their opponents. Some of my favorite examples include Georges "Rush" St-Pierre,[28] Michael Jordan, Michael Phelps,[29] and Chuck Norris, all of whom did and do use visualization to reach and sustain peak performance.

· Patients with a variety of injuries have managed their symptoms and have even healed themselves through the power of visualization.[31]

· People in horrific circumstances have kept themselves stabilized, sane, and even hopeful, sometimes during years of imprisonment, though visualization.[32]

Chuck Norris—yes, the man who has now become an Internet meme—was one of the first athletes in the United States to have discipline around visualization as a training technique. He referred to it as PMA, or "positive mental attitude." He said, "In my mind, I always saw myself winning. I would create fight scenes, visualize my opponents, analyze their weaknesses, and create visions of myself countering their attacks." He went on to state, "Whatever goal I set for myself, I will first get a mental image in my mind of exactly what it is I want to achieve." Marcus Wynne, the author of the article describing Norris's PMA technique, elaborated on the purpose of visualization in martial arts training. He wrote, "By conscientiously training the mind to see and hold a positive self-image, visualization shifts the self toward becoming that image."[30]

- Wildly successful careers have been imagined and manifested by the power of literally seeing (and then, of course, believing and pursuing) what we want.

I'd like to (hilariously) put myself, Celine Dion, and Arnold Schwarzenegger in the same category. We do have something in common: All of us have had visualizations of some kind of success that have guided us since we were children. Dion attributes many of her achievements to repeated visual, mental rehearsal of performing for throngs of appreciative fans. Schwarzenegger always envisioned himself as a champion bodybuilder and actor. As for me, I had no specific part I wanted to play, like an actress or a singer, but I spent years of my childhood imagining my way out of relative poverty. I imagined myself getting an extended education, traveling the world, meeting interesting people, and finding opportunities under any rock. Here's an example of how a visualization technique came to fruition in my recent life: Many times, I envisioned and doodled myself speaking on the TED stage in Long Beach, California. I held this in my mind as a five-year plan, but about a year after my visioning began, June Cohen, the executive producer of TED, invited me to give a talk. Does this mean my assertion is that we can all just imagine what we want and it appears? Of course not. As Jim Carrey—an actor well known for successful creative visualization—said, "You can't just visualize [what you want] and then, you know, go eat a sandwich."[33] We need a motivating vision, and we have to take the tactical steps necessary to fulfill that vision. We have to do the do. And it helps to do the Doodle. Ask Oprah if you don't believe me.

- Almost anyone can increase actual, physical muscle mass simply by visualizing an exercise routine.[34]

Having been exposed to those assertions, in hopeful defiance of your skeptical nature, I think you *feel* that what I'm saying is accurate. You and I know, on a gut level, something that the poet Virgil wrote more than two thousand years ago: Mind moves matter. To be more explicit, let me say it like this: Mind contributes powerfully to what it *sees*[35] and therefore to what it *experiences*, which then contributes to what it *knows*, which then changes what's *possible*.[36] Let's use a flowchart to examine this idea further.[37]

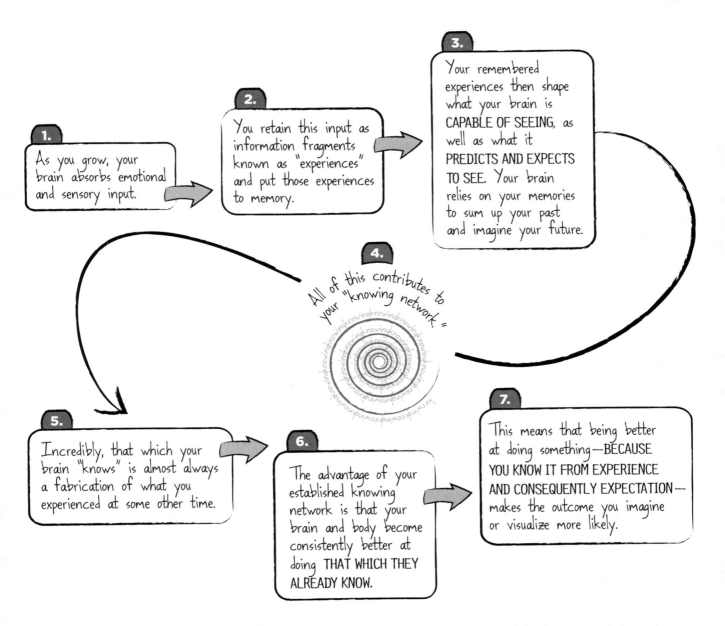

1. As you grow, your brain absorbs emotional and sensory input.

2. You retain this input as information fragments known as "experiences" and put those experiences to memory.

3. Your remembered experiences then shape what your brain is CAPABLE OF SEEING, as well as what it PREDICTS AND EXPECTS TO SEE. Your brain relies on your memories to sum up your past and imagine your future.

4. All of this contributes to your "knowing network."

5. Incredibly, that which your brain "knows" is almost always a fabrication of what you experienced at some other time.

6. The advantage of your established knowing network is that your brain and body become consistently better at doing THAT WHICH THEY ALREADY KNOW.

7. This means that being better at doing something—BECAUSE YOU KNOW IT FROM EXPERIENCE AND CONSEQUENTLY EXPECTATION—makes the outcome you imagine or visualize more likely.

This flowchart helps explain the phenomena in the list above. People can and do drive toward desired outcomes by picturing them repeatedly in their minds.[38]

The two-part question then becomes, how? First, how is visualization so effective in moving toward desirable outcomes?[39] Second, how do we as Doodlers practice this, using what we know about visual language? To answer the first question, let's talk about what I referred to earlier as the "knowing network."

In the brain, a network is a biological circuit of neurons that are connected and functionally related. Think of it as an electrochemical information highway connecting different regions that are responsible for performing various functions. Brain networks are important because they make distinct actions possible. For example, if I wanted to sing a song, I'd activate my auditory networks.[40] If I wanted to design a product, I'd activate my executive and imagination networks.[41] If I wanted to daydream, I'd flip the switch on my default network.[42] And what these networks would be doing for me is summoning and connecting the regions and parts of the brain that need to be enlisted to take that particular action.

Our *knowing* network, you may suspect, is that circuit of connected, functional areas in the brain that gives us the feeling that we *know* something. To do its job, this network draws on the regions responsible for

I SEE; THEREFORE I CAN.

memory, words and concepts, emotions, and higher-level meaning, all of which are necessary ingredients for knowing.[43] Doodlers need to understand that we can strengthen our knowing networks around realities *that we want to bring to life*—and, in doing so, directly impact our potential of moving toward those realities. Essentially, we can Doodle our way to better possibilities. This is true because the brain falls for visual mental practice in a major way.[44]

VISUAL, TO BRAIN, IS ALMOST AS GOOD AS REAL.

To Doodle is to engage in an intellectual, creative, and physical act that recruits *many neurological networks simultaneously*. This makes it a strong force for change and a portal for imagining and inventing preferred realities. To not use it as a tool would just be silly.

Now let's tackle that second *how* question. How do Doodlers use what we know about visual language to enhance what's possible? That process might look like this:

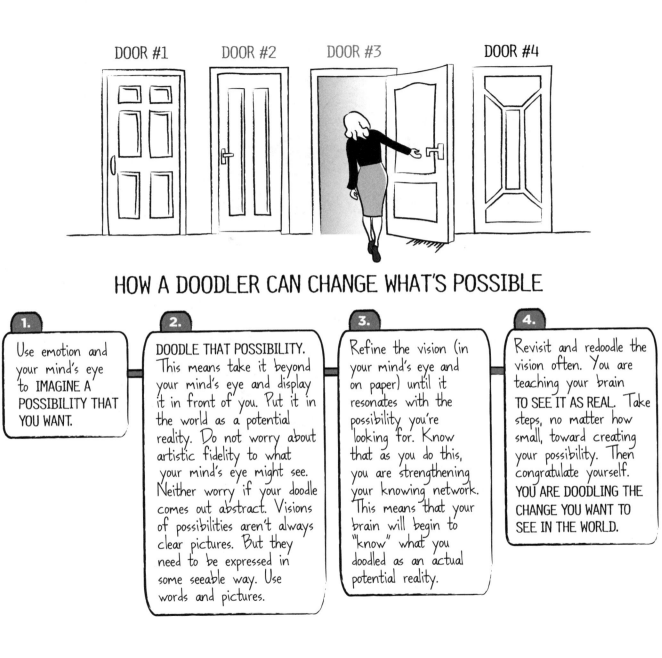

DOOR #1 DOOR #2 DOOR #3 DOOR #4

HOW A DOODLER CAN CHANGE WHAT'S POSSIBLE

1.
Use emotion and your mind's eye to IMAGINE A POSSIBILITY THAT YOU WANT.

2.
DOODLE THAT POSSIBILITY. This means take it beyond your mind's eye and display it in front of you. Put it in the world as a potential reality. Do not worry about artistic fidelity to what your mind's eye might see. Neither worry if your doodle comes out abstract. Visions of possibilities aren't always clear pictures. But they need to be expressed in some seeable way. Use words and pictures.

3.
Refine the vision (in your mind's eye and on paper) until it resonates with the possibility you're looking for. Know that as you do this, you are strengthening your knowing network. This means that your brain will begin to "know" what you doodled as an actual potential reality.

4.
Revisit and redoodle the vision often. You are teaching your brain TO SEE IT AS REAL. Take steps, no matter how small, toward creating your possibility. Then congratulate yourself. YOU ARE DOODLING THE CHANGE YOU WANT TO SEE IN THE WORLD.

In other words . . .

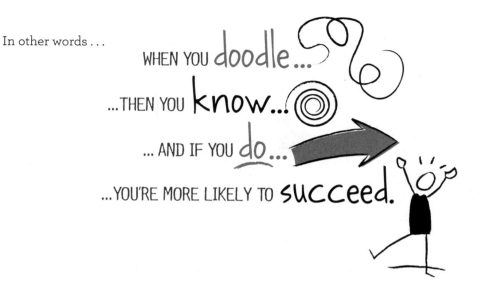

WHEN YOU doodle...

...THEN YOU know...

... AND IF YOU do...

...YOU'RE MORE LIKELY TO succeed.

Now listen, Revolutionary, I know this premise is extraordinary. I know it's hard to believe. You and I are on the cutting edge of neuroscience and behavioral psychology. Some people are going to think we're crazy. But we're in the business of exploding perceptions and beliefs—that's what Revolutions are for.

In closing this section, with respect to the third P offered by the Doodle—that sparkling promise of PLEASURE—what could you go forth and comfortably say to your colleagues about Doodling and its potential for work, school, and life?

You could say this: Visualization can have clear, tangible effects on outcome and performance. Doodling is an act of visualization.[45] Therefore, Doodling can have clear, tangible effects on outcome and performance. While I wouldn't make the promise that Doodling will take you *all the way* to your destination, it is a consistently contributing factor and one worth cultivating. This is one of the most powerful and expansive promises of the Revolution.[46]

DOODLE SPACE (to summarize something you've just learned)

DOODLE UNIVERSITY: Exploring the Foundations of Visual Language

RANKS IN THE REVOLUTION: THE DOODLER AND THE INFODOODLER

In some form or fashion, you are already a Doodler. (Revisit the section called "Excuse Me, Did You Say 'Doodling'?" if you're having any doubts.) And since you are already a Doodler, that means a person you live with is a Doodler, and so is your neighbor, and so is that lady from the homeowners association, and so is your boss (scandalous!). This means, without exaggeration, that there are billions of you, and all of you already have an important rank in this Revolution. You'll just get better from here on out.

The two ranks in the Universe of Doodling are Doodler (which you already are) and Infodoodler (which you will be). For your further edification, the Infodoodler category has three more specific ranks: Personal, Performance, and Group Infodoodlers. You'll be illuminated on all of these distinctions *after* we get a clear grip on the basic Doodle. We already know you're a Doodler (even if at this moment you're underutilized), but we still need to lay groundwork for the Beginner's Doodle, because only then will you be prepared for an encounter with the preeminent Infodoodle and its three formidable subtypes.

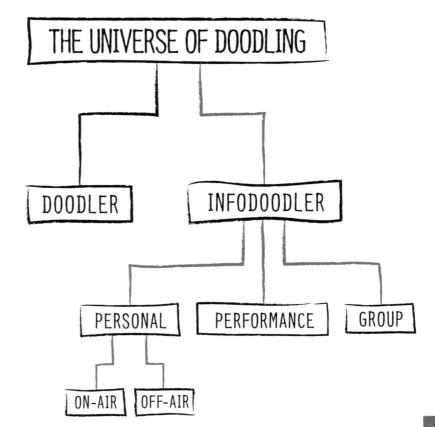

41

THE BEGINNER'S DOODLE

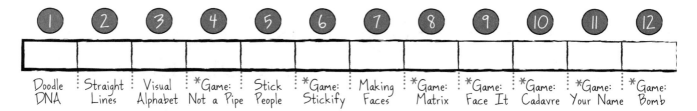

1	2	3	4	5	6	7	8	9	10	11	12
Doodle DNA	Straight Lines	Visual Alphabet	*Game: Not a Pipe	Stick People	*Game: Stickify	Making Faces	*Game: Matrix	*Game: Face It	*Game: Cadavre	*Game: Your Name	*Game: Bomb

During the ongoing construction of the Doodle Revolution, I encountered doodlers of all walks of life. I met doodlers who were shy and doodlers who were flashy. I met enthusiastic doodlers and traumatized doodlers. I met doodlers who used the tool simply—to relax, for example—and I met doodlers who had developed their own sophisticated techniques. Eventually, categories emerged when I started peering closely at the most basic Doodle—that Doodle we find when people are seated at a table with pen and paper, listening to someone speak. I found five consistent doodler "types" that I now call your Doodler DNA. It's worthwhile to know which is yours because it can be the foundation on which you build your Infodoodling skill. We'll take the Basic Doodle Assessment after you take a moment to discover your native Doodle DNA.

PROGRESS BAR

Since your visual senses are on alert in this book, you'll likely have noticed the presence of a progress bar at the top of this section, and you'll see them in other sections as well. This is a lo-fi game—a way for you to see what learning modules you're approaching and to show the advances you've made. As you complete each module, doodle in the corresponding area—fill it in entirely, draw a smiley face, check it off. Small victories give us shots of pleasure-laced dopamine, inspiring forward momentum (and it doesn't hurt that the progress bar encourages doodles from you in the meantime).

DOODLE GAME:
Discover Your Doodle DNA

You may already have an idea of your Doodle DNA, but it may have been a while since you experienced it. So, two options: either turn on talk radio or turn on some music (no television because you'll end up watching it). Settle down with a pad of paper and pen, and let your pen move along with the content you're hearing. Don't overly focus on it, and don't assume that the first thing that emerges is your Doodle DNA. Sometimes your pen is rusty, so to speak, so we need to push through the facade to let your native Doodle out. After five to ten minutes—or however long it takes for you to drift into a decompressed state—look at your creation. Did you doodle vertical lines, a checkerboard, a face? Does any of it look familiar, like a pattern or object you've doodled before? Close your eyes and remember when you used to doodle all the time. What do you remember? What do you see? The five doodler types are shown on the facing page. Which one are you? (It's important to note that you can be a combination of them all.)

Word Doodler

Remember: These are doodlers who write a word or words and then trace them repeatedly. Word doodlers include the subcategories of font doodlers and word picture doodlers. President Kennedy left us a variety of word doodles, one of which you saw in Chapter 2.

Nature/Landscape Doodler

Nature and landscape doodlers are preoccupied with natural elements. Their native doodle expressions involve trees, flowers, mountaintops, anything depicting the beauty of the great outdoors.

Abstract Doodler

These doodlers make geometric patterns reminiscent of the De Stijl artistic movement and/or visual flows that don't result in a recognizable object or form. Presidents Nixon and Washington were abstract doodlers.

People and Faces Doodler

This doodler type is preoccupied with figures and faces. President Reagan, who had dreams of becoming a cartoonist before he, um, settled for president, was a prolific doodler of realistic people and faces, often including characters in his love letters to Nancy (whom he referred to affectionately as "poo pants"). President Johnson also doodled people and faces, but his characters are more surrealistic, leaning toward alien life forms, some of which look either comical or disturbed. (No comment.)

Picture Doodler

Picture doodlers draw recognizable images. Submarines and hammers. Candy and corn. Mice and men. These doodlers are comfortable near the drawing end of the visual-thinking spectrum. President Eisenhower was a notable picture doodler, producing images of broken fingers, broken pencils, and misguided missiles. (It's tempting to entertain the meaning behind these broken phallic symbols, but let's not go there.)

Now that you know your basic Doodle DNA, also know this: Every one of us has a unique visual-linguistic stamp, like a signature or a fingerprint. It's yours and yours alone. It can be the starting point from which you reignite your natural ability to interpret and produce visual language in a variety of contexts. One must start somewhere, and your doodling origins are as good a place as any.

THE BASIC DOODLE ASSESSMENT

For the next activity, I'd like you to consider where you stack up on skills related to the basic Doodle. Below is the Basic Doodle Assessment. It is not a psychological survey. It's a quick assessment for your eyes only that will help you zero in on which fundamental doodling skills you already have and which you need to strengthen. You'll take the Infodoodle Assessment in Chapter 4. Ready? Go.

THE BASIC DOODLE ASSESSMENT	No frakking way.	I'd really rather not.	I'm perfectly capable.	I'm actually into that.	Only death could keep me from it.
SUSPENDING JUDGMENT ABOUT DOODLING — Moving past personal and cultural biases to explore this tool.					
OVERCOMING YOUR OWN CRITICISM ABOUT YOUR STYLE — You know what I mean.					
DOODLING STRAIGHT LINES — Just straight enough so viewers don't think they're curved.					
DOODLING BASIC — Making forms recognizable as circles, squares, triangles, etc.					
DOODLING FACES AND FACIAL EXPRESSIONS — Being able to show a variety of human emotions.					
DOODLING BASIC FIGURES — Generating the most simplistic forms of humans and animals.					
SEEING THE OUTLINES & STRUCTURE OF OBJECTS — Deconstructing a form with your mind's eye.					
SHARING YOUR WORK WITH OTHERS — Moving past concern about others' opinions in order to learn.					

So, how was it? If I were asked to hazard a guess, I'd guess the majority of you concurred that it *is* often hard to draw a straight line; you likely balked on facial expressions and figures (don't worry, I do, too); and last, you probably dismissed the prospect of not judging yourself as an impossibility. With respect to the latter, here's some loving guidance from the leader of the Revolution.

QUIETING THE INNER CRITIC

I've learned through teaching that it doesn't matter if I say "try and suspend judgment about your work" or if I suggest that you "be patient with yourself during the learning process." Vocalizing this advice never works, and the reason it doesn't work is because words are rational and suspending judgment about ourselves is not a rational event. It is emotional, and it needs repeated embodied experience to become real, *particularly* when it comes to visualization work. In this space, we feel universally inadequate and we are, as a result, unusually hard on ourselves. I've seen the phenomenon repeated around the world: When we attempt to represent something visually, especially when working with a group, we apologize profusely and we give up easily. I've discovered that in order to help people deal with this understandable but counterproductive behavior, it helps to put myself, as the instructor, in the hot seat. I have to show learners what forgiving yourself on the spot looks like and then let them try it. This is more effective than any comforting platitudes I could emit because I myself am an inept artist,[1] so in that way many of my pupils and I are peers.[2] To demonstrate my indifference toward real artistic talent *in the context of the Revolution* (a very important distinction), I go through this exercise with workshop participants:

Me: "Quick, yell out a word! I will draw it in five seconds."

Someone: "Dog."

Me: "Great. Here is a dog. Someone else give me another word."

Someone else: "Tree."

Me: "Fantastic. Here is a tree. Another word, please."

Someone else: "Car."

Me: "Done. Honk honk!"

Someone else: "Nanotechnology."

Me: "Who's the wiseass? You're now my favorite. Here is nanotechnology."

This exercise, of course, has more lessons than meets the eye, the more profound of which we'll explore in the next chapter. But here are three the class usually recognizes instantly:

1. Our instructor can't really draw.
2. She doesn't seem to care.
3. She's asking us to forgive ourselves for the "I can't draw" iniquity so it doesn't become a barrier to learning.

After pondering for a bit, the group then gets deeper insights.

4. Our instructor doesn't care if she can draw because effective Infodoodling and visual thinking are not about drawing. They're about thinking!
5. The rapid visualization of words and concepts—a fundamental skill in this work—actually requires simplistic and even sloppy drawing due to time constraints!
6. Words and pictures complement each other. So I don't need to know what nanotechnology looks like. I just need to add a caption to the closest thing I can come up with!

Their observations are correct on all fronts, and these observations involve breakthrough thinking for 95 percent of the people I work with. As we've discussed earlier in the book, our culture has some very inaccurate ideas about visual language, and those ideas are persistent and pervasive. They have indeed poisoned the well for centuries. The good news is that the madness stops with us. We have manhandled the myths about doodling, and in the next chapter, we will obliterate the mistaken belief that visual language = art. So for now and for eternity (even though it doesn't always change reality to *say* it), please let your inner critic rest. While that crippling giant sleeps, let's get you digging into the basic Doodle, starting with straight lines and the Visual Alphabet.

DOODLING STRAIGHT LINES

Those of you convinced of your natural talent at forming straight lines, skip this section and go straight (no pun intended) to the Visual Alphabet section. For those of you who have heard yourself say out loud, "I can't even draw a straight line," absorb this short lesson.

You are not the only Doodler who can't produce a straight line. This is a common problem and one easily fixed. Here's the trick: Doodle them fast. Like lightning.

Put your pen on paper and zip that line across the page. Throw that thing like you used to throw it when you played B.A.S.H. as a child.[3] Straight lines fail because people usually slow down when they try to make them. We have the impression that if we take our time, the odds of a straight line working out are in our favor. But the opposite is true. When we slow down, our muscles and our aim get wobbly. And if you go slow enough, you can actually see your heartbeat reflected in the line you make. Unless that's the look you're going for, be confident and move fast. Find a place on the page to aim, and hurl your line toward it. Practice on a flip chart, standing up, if you really want to engage some muscle memory. Whatever you do, whether you're sitting or standing, don't slow down. Release the *ánimo*, and you'll start to see lines so straight you'll wonder if they're in church.

THE VISUAL ALPHABET

Dave Gray is my friend and one of the coauthors of our book *Gamestorming*. He is also a visual-thinking wizard, harboring a depth of knowledge and experience with visual language that is to be admired and envied (at least by people who are into that). When we were writing our first book, he produced what he called the Visual Alphabet[4]—a twelve-letter alphabet that would allow even the most hopeless of artists to be able to visualize anything with minimal practice. I want to now bestow that gift upon you. You'll need it on your rise to greatness in Infodoodling. Behold, the Visual Alphabet.

Dave is also unreasonably tall. He and Yao Ming would look perfectly normal together.

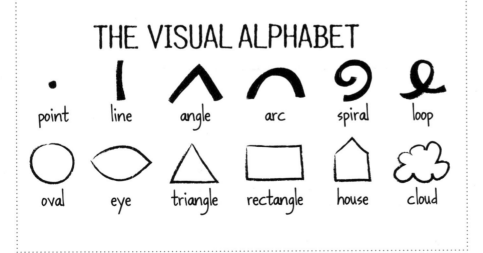

As you can see, the Visual Alphabet is composed of twelve "letters." We call them letters because they're the visual equivalent of alphabetic letters.[5] Six of these letters are what we call "forms," meaning that they are visual marks that, without purposeful manipulation, do not close in on themselves.[6] The remaining six are called "fields," meaning that they fold back in on themselves, forming a closed visual field.

Now, using the space provided below, please re-create this Visual Alphabet. Then, underneath, write the words corresponding to each letter for good measure.

D.I.Y. VISUAL ALPHABET

Considering the utter simplicity of this alphabet, I want to personally meet any of you who wish to tell me that you can't create it. Excusing gentle souls in comas and people who cannot move a muscle, I want to meet the person on earth who thinks she cannot produce the Visual Alphabet. I don't believe she exists since we can hold a pen and make marks with our hands, our feet, even our mouths. We can make marks without the use of sound or sight. The very large majority of us are acutely capable of producing all of these letters out of thin air—a gratifying certainty indeed since the Visual Alphabet is almost as valuable as the alphabet. When we dust it off and use it, we suddenly have an enormous range of communication possibilities at our disposal. Let's get to what's most important with respect to the Visual Alphabet, which is represented by this image right here:

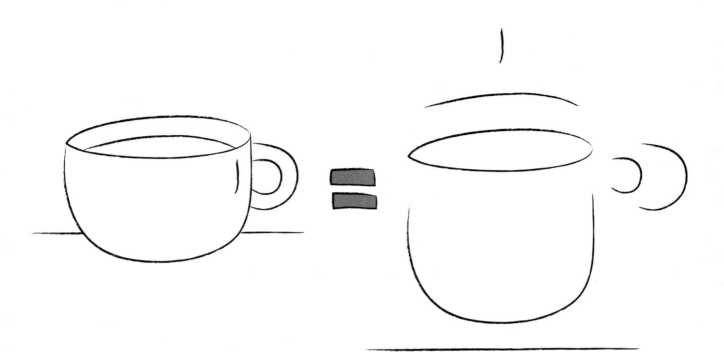

What this image means is that a coffee cup is not really a coffee cup. *Ceci n'est pas une pipe*, you see.[7] A coffee cup represented on paper is really just a collection of forms and fields (the pieces of the Visual Alphabet) that our minds interpret as a coffee cup. We've seen one before (you may be holding one this very instant), so we recognize it instantly because it matches an established pattern in our minds. BUT THERE IS NO COFFEE CUP, SWEET CHEEKS. There is only the illusion of the coffee cup created by the brilliance of our mental apparatus. What this means is that not just coffee cups but also ANY object, form, or figure can be deconstructed using the letters of the Visual Alphabet. Hallelujah, right?! Time for a doodle game.

DOODLE GAME:

This Is Not a Pipe.

Using the Visual Alphabet and the spaces provided, please reverse engineer five objects you see around you[8]—anything in your line of sight: chairs, tables, plants, lamps, pets, laptops, peanut butter. Before you re-create them, try to see them in terms of the letters of the Visual Alphabet. The rug is made of four lines. The way your dog is sitting, he's a triangle, an oval, and a line. Begin to peel away the mystery, breaking these objects into their component parts and then rendering them on the page.[9] If you need to, draw the objects multiple times until they look and feel right to you. Then, after you've done that, please stop telling me you can't make coherent visual marks because I just can't find it in my heart to believe you.

Object #1

Object #2

Object #3

Object #4

Object #5

Having had that experience, I'd like to try and anticipate the kinds of resistance that may have bubbled up. Perhaps: *These images don't look good. My five-year-old does better work.* Or this: *What happens when we don't have an object in front of us? My mind's eye can't conjure a dolphin and draw it. I don't know from memory where the tail is* specifically *pinned on the donkey.* And this one, more observant: *We have to be able to a-r-r-a-n-g-e the visual letters in such a way that it actually results in the object we're trying to depict. My dog looks like an Ewok in this picture.*

Yes. All of those concerns are legitimate. And here's my tough-love response: How did you learn to read? You practiced. How did you learn to write? You tried. I can assure you that your kindergarten short stories didn't come out of the box like Hemingway's. You had to *work* at them. Learning the Visual Alphabet is the same. It is an *alphabet*. It is the starter kit for becoming more eloquent in visual expression. It does not burn into your cerebral cortex through osmosis. It does not become a muscle without your flexing it. It needs your attention and your energy, and it will reward you for it. In a couple of important ways, the Visual Alphabet is more user-friendly than the standard alphabet. Let these two distinctions bring you comfort:

1. **Stumbling through the learning process of the Visual Alphabet is really rather fun.** Learning to doodle an image of an Ewok is far more enjoyable and satisfying than writing the word. When you write the word "Ewok" as an adult, you don't go running off to show someone, because nobody cares. When you show them a picture of an Ewok you drew, they actually take a moment to say "Cool." Which makes you want to do it again.

2. **To get by in the visual-thinking world, you don't need near the level of fluency in the Visual Alphabet that you do in written and spoken alphabets.** In both Doodling and Infodoodling, you can succeed—indeed excel—with just a slight uptick in ability. You'll see.

FIGURE THIS: STICK PEOPLE

Now that you're armed with your Visual Alphabet, we can go forth with greater quickness. I know some of you have ants in your pants, but let's avoid any inclination to leapfrog, okay? It's best to experience all of the basics at least once so that the building blocks for the Infodoodle are firmly in place. Now let's take on doodling an important form in the universe of objects that will consistently come in handy: figures.

The human form is unanimously one of the most difficult things for people to believe they can doodle.

When I first started working in the Infodoodling space, the thought of producing human figures made me want to soil my britches. I could not for the life of me figure out how a human's body and limbs should be posed when they were, for example, gardening, eating, or even sitting in a chair. The only human activity I was comfortable doodling was the act of standing up straight. Basically, I could doodle this guy:

But if I wanted this guy to appear to be thinking or making a purchase or running from Pol Pot, forget it. You might as well ask me to recite the *Iliad* in Hmong. I couldn't even *see in my mind* what a person playing baseball looked like, much less actually draw a representation that other people would recognize. So, given this reality, how did I overcome my aversion to doodling people? Well, here's the secret: I make glorified stick people my absolute highest aspiration. I set the lowest bar possible for drawing the human figure. I keep it as stupidly simple as possible. And here's why: My ability to draw a realistic human form is wholly unrelated to the goal of the Doodle Revolution, which is to get people to learn how to

think better using visual language. Learning to draw a human figure with realism and accuracy is an admirable goal, but it is not OUR goal. OUR goal in embracing visual literacy is to become just literate enough to be dangerous at problem solving. And all I need to be dangerous at that is the ability to draw the stick figure in various poses. That principle applies to all of you, too. So let's get serious on keeping the human form stupidly simple and learning to portray it in motion. This will come in handy when you start to solve complex problems using the Infodoodle because you'll need to be able to show your customers, clients, or stakeholders doing something with products or services, or having experiences that you can improve.

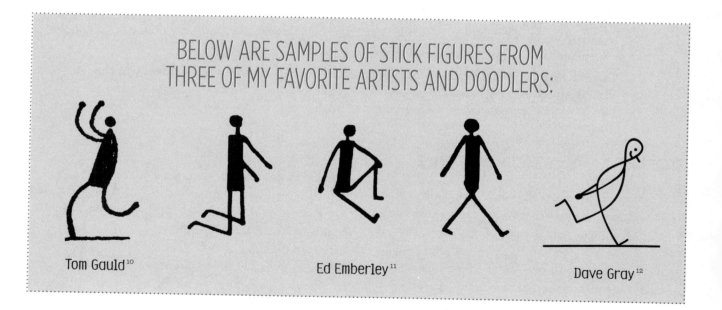

BELOW ARE SAMPLES OF STICK FIGURES FROM THREE OF MY FAVORITE ARTISTS AND DOODLERS:

Tom Gauld[10]

Ed Emberley[11]

Dave Gray[12]

I'd like you to consider all of these characters and ask yourself what they have in common. (I am totally fishing for an answer here.) But before I give you my rebel yell, in the rows below write three observations you have. Then, if you haven't written the specific answer I'm looking for (and I'm sure your answers are good), I'll give it to you. Because I can't resist.

OBSERVATIONS OF STICK FIGURES

1. _____

2. _____

3. _____

Having considered the people on the previous page, you may have discovered that there are surprisingly numerous observations you can make about these simple figures. But if you wrote the answer "*Anyone* can create these," well, congratulations are in order. You have used your powers of deductive reasoning to figure out where I was going with that.

The beauty of these stick figures, and stick figures as a tool, is that they don't require artistic flair. To be clear, the gentlemen whose stick figures were the inspiration for this section are all trained artists.

Each of them has an actual art education, and their knowledge of the human skeleton helps to give their stick figures such credible liveliness. Still, be not disheartened. A degree in art is not a requirement for generating believable figures in motion for the purpose of thinking through a problem. I know this because I don't have an art education (I have taken one memorable art class in my life—sophomore year in high school with a German art teacher whose name escapes me), and I use stick figures in motion to solve problems all the time.

The trick is threefold: Apply your Visual Alphabet, do whatever you have to do to conjure an image of an action (find a photo, use your imagination, or pose yourself or others), and keep in mind these helpful general guidelines.[13]

1. **Doodle big to little.** To suggest action, first try to determine where the large centers of gravity of a figure would be (based on what he's doing) and then draw those centers of gravity at the angles they'd be in while taking said action. On a human, for example, our torso is our largest center of gravity, followed by our legs and then arms. So if a human is scratching his toe, his centers of gravity might be angled like this.

On an elephant, the large centers of gravity are the body and then the head. So if an elephant were charging a circus clown, it may look like this.

Squint to find these big centers if they don't come to you readily. (I personally have to pose and feel where the gravity is in my body.) Other distracting details fall away when you squint, and it helps you determine what gives the object its object-ness. Looking at things from far away has that same effect. It helps you see the structure rather than getting caught up in the bits around it. So start big, and go little. And please note: The shapes of human torsos and heads have a wide range of options. You can make both out of eyes, ovals, rectangles, triangles, even squiggles. Look at the shapes of heads and torsos on cartoons like *Family Guy* (Stewie's head is unmistakably a football), *The Simpsons*, and *Ben 10*. Play with varying shapes but keep them simple. (We rarely go elaborate in Infodoodling sessions.) You'll find a signature style, so stick with it.

center of gravity in the torso of a person scratching his toe

center of gravity in the torso of a charging elephant

Mark this bozo's center of gravity, would you?

2. **Doodle through and over.** People tend to get precious about their lines when they're doodling figures or objects. Try to get comfortable crossing lines through other lines. In Infodoodling, the only person who gets flustered when your lines cross each other is you. So in service to creating a visual display quickly, let the lines keep moving, even if they cross in places they wouldn't in "real art."

3. **Include a ground line or horizon line.** This is the line of intersection of the horizontal and vertical planes. It's where the proverbial rubber hits the road. It's generally a good idea to include a ground line because it anchors your stick figures in space. Notice that the figures in the examples from the first guideline include ground lines and, as a result, these figures feel grounded. But the man from guideline #2 feels like a floating head, which, visually, he is. It's a good practice to use that ground line to connect your stick figures to the world, particularly if it adds to what you need to convey.

4. **Make the heads of children bigger than the heads of adults.** Children have heads disproportionate to the size of their bodies. If the stakeholders in the problem you're solving are children, clarify that by giving them good-sized heads. Obviously, height is an indication of being younger, too, but if there are no adults in the picture to give a relative scale, a bigger head is your best bet.

Learners often want to produce the lines of this face.

But it's not a crime for this guy's nose, ear, and neck to be see-through.

It's faster to produce and still gets the job done!

5. **Point the nose in the right direction.** Some of the distinctions between actions are subtle (like standing and thinking versus standing and searching), so use the nose as an indicator of action and direction for a quick and easy way to give more clues about what your figure is doing. Look at the three figures shown here. They make you wonder if it's actually the nose that's the window to the soul.

6. **If at first you don't succeed . . . you know what to do.** If you're trying to doodle a stick figure crawling and he looks more like he's barfing, just do it again. Stick figures take seconds to create, so you can keep repositioning them until the specific action is recognizable. Dancing is one of the hardest for me to get right the first time. My dancers always look like all four of their limbs are broken or they're having a temper tantrum. So I keep re-creating them until I get one in a position that works. Then I repeat that figure as often as I need to. Repetition is the mother of finally getting something you can use. And, thankfully, it's not often that I'm in an Infodoodling session that involves dancing, so I rarely find myself being asked to make multiple tiny dancers.

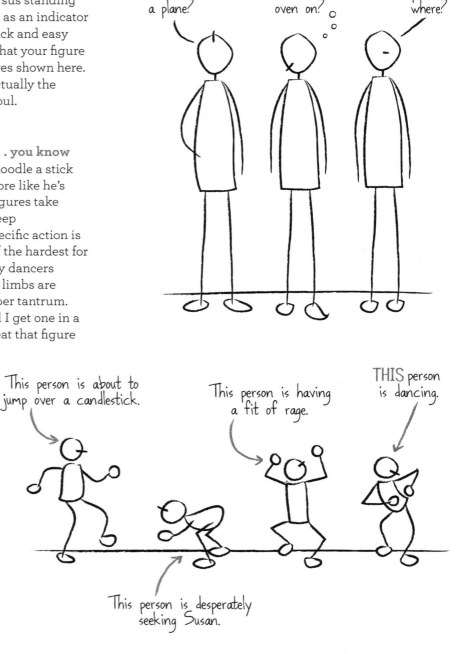

It's your turn to practice drawing quick stick figures. Odds are that you won't get every figure perfect on the first go (if you do, you clearly don't need the practice), but what you'll experience in your possibly messy efforts is how enjoyable it is to attempt to create a human form using simple lines. You may be surprised at how a slight shift in the curve of a line can change the entire behavior of a figure. (You should also be surprised at your remarkable visual cortex, one area of our brains so exquisite at detecting motion that we simply cannot trick it.)

DOODLE GAME: Stickify This

Below you'll find six square spaces. For this activity, take a stab at representing human figures performing the activities indicated above each space. If you need room for more iterations (and if you're anywhere as clumsy as I at doodling figures, you will), then take your people into the world and practice them there. Expand the types of things they're doing if you'd like, putting them in scenes with other stick figures and incorporating props like cell phones or microphones. You'll need the practice for Infodoodling because, as I mentioned earlier, customers and clients will often make an appearance in business discussions.

GO AHEAD. MAKE THEM MESSY.

Person Standing Person Sitting Person Cartwheeling

Person Running Person Thinking Person Crawling

I hope this section helped demystify doodling basic figures. Approaching human and animal forms in the most rudimentary way enables quick visual thinking while dismantling the tendency to focus on lengthy elaborations, perfection, and accuracy. The latter desires are too often barriers to entry into the Infodoodling process, and they don't serve our goals. Rather than compare ourselves with masters of the human form like da Vinci or Michelangelo, let's aspire to be closer to Charles Schulz's *Peanuts* gang.[14] Let's be socially brave and aspire to be even quite a few notches below—and, heaven forbid, let's not apologize for it. We are the world's visual-thinking pioneers! There's no shame whatsoever in that.

MAKING FACES

You know how to doodle people. Now let's learn to give them a face. You won't need to be remarkably skillful at this, but, like simple figures, you need facial expressions in your bag of tricks. They're valuable, for example, when you're working on challenges related to customer or employee satisfaction or when you're trying to build an empathetic persona when designing user experience. They also come in handy for those occasions when you absolutely *must* make fun of your boss (in private).

DOODLE GAME:
The Face Matrix

One of my favorite tools for exploring facial expressions is called the Face Matrix.[15] Like all of our tools thus far, it is extremely user-friendly, and it helps you bridge the scary gap between starting from scratch and considering yourself good at something. Make your (first?) foray into doodling faces by following the numbered steps of the next game. Above and below the space provided for you are thumbnail visuals in case you get lost in the woods.

1. Draw nine circles in a 3x3 matrix.

2. Add eyes looking in many directions.

3. Add noses. Use the visual alphabet.

4. Across the top, draw 3 sets of eyebrows.

5. Across the side, draw 3 sets of mouths.

6. Intersect the eyebrows & mouths to make a face.

Having completed the Face Matrix, you should review the emotions you doodled and give them labels. Could one of these faces be interpreted to represent multiple emotions? How many emotions could one face represent? After you experience this game, I hope one of your takeaways is that you see how very simple conveying emotion can be. You don't need a session of tortured practice; a short concave or convex line can make the expressive difference between joy and mischievousness. Granted, mastering the Face Matrix doesn't mean you'll suddenly be able to summon the most nuanced of emotions (like a combination of joy and relief, for example), but now you're able to visualize *at least* nine different expressions and use what you learned as a departure point for more sophisticated expressions if they're warranted in an Infodoodling session.

Now, I feel compelled to mention to those of you who will invariably criticize the faces you make that when working with groups of humans, perhaps surprisingly, you'll have a very forgiving audience. Your faces need not look even remotely like real faces. In the face department, our brains are extremely accommodating of even the most discombobulated face because we are hard-wired to look for and recognize faces—even when those faces don't exist.[16] Perhaps we'd rather err on the side of recognizing a face in the jungle than assuming that one isn't there and later being eaten by it. Or perhaps we need to be extraordinarily good at recognizing facial features so we don't try to mate with our long-lost sisters. Whatever the reason, facial evaluation and recognition strikes deep. We all know about the alleged face on the surface of the moon, and you've probably all had experiences finding nonexistent

I know you see the face in my pillowcase. You can't help it. You're wired to see it.

faces in clouds, in tree bark, or in shadows. Just the other day I found a face in my pillowcase.

Just as our perception of body shapes encompasses a wide range of possibilities, our minds also flex to take in a wide range of face shapes. If you're not into circular faces and you prefer a heart-shaped visage, then doodle one. Make that your go-to face shape. None of our brains will miss the signal. And just to reinforce this remarkable pliability of our brains to recognize faces, I'd like to introduce another game. I call this one Face It.

DOODLE GAME: face it

Here's what you do to play this game. Grab a piece of paper and pen. Close your eyes and poise your pen over the page. Make a haphazard, wild mark on your page that has at least one change of direction in it. (In other words, don't just draw a point or a straight line. Bend it. Loop it. Curve it.) Open your eyes, look at your line, and then convert that line into a face. You'll find that it is next to impossible to NOT be able to make a face out of any random line you produce. Do it again. And again. Try your best to *avoid* being able to make a face from it. You won't be able to. Do it and then go find a friend and ask him to make a face from your line. You won't be able to find anyone who can't do it. Don't believe me? Below are three lines I drew with my eyes closed (pinkie swear!), with my pen scampering at random. I was able to convert all of these to some kind of recognizable face. (But I didn't say they'd be pretty.)

original line

original line

original line

As you can tell from this game, there are faces everywhere among us. Even if you don't want to explore the depth of faces and facial expressions, know that you'll be served by being able to visually articulate the basics: happy, sad, angry, confused, worried, scared, satisfied. These are standard emotions of your customers and stakeholders. These are the doors of empathy with those folks when you wish to start mapping the experience they have with your product, service, or company. Give your people a face, and suddenly you and your team can start to identify with and understand them. In the last couple of chapters, the value of this will become crystal clear.

SHARING YOUR WORK WITH OTHERS

The last skill with respect to the Basic Doodle Assessment involves sharing your work with others. Now, I realize that sharing your work doesn't sound like an actual skill, but you'd be surprised how difficult it can be for many people. Audiences can be cruel—or at least indelicate with their responses—and even one freaky incident can cause a Doodler to go underground. It's worthwhile to address this so that we don't allow other people to siphon our strength in sharing. Let's answer the question of why we should share our work with others even at the risk of embarrassment, disappointment, or a decrease in social status. What reward do we get for the risk? I'd like you to consider this question on your own for ten seconds. Right now, please. Then I'll tell you what I've gotten out of sharing that makes it worth my while.

Over the last several years, my husband has seen and heard a ridiculous amount of ideas I've either doodled or just stated out loud. His feedback—and that of my producer, my editors, and my physical and digital audiences—has been priceless. With other people's eyeballs and minds on my work, I suddenly have an array of opportunities like:

· **The opportunity to make my work and ideas better.**
Because of other people, I've been redeemed from research bloopers, flawed hypotheses, bad jokes, and crappy visual structures. Due to the common condition of self-blindness, it can be difficult for an individual to evaluate herself or her work. People who pay real attention to what we create can sharpen our tools or smooth our edges. This is a gift from others well worth receiving.

· **The opportunity to thicken my skin and recognize that I'm capable of dealing with rejection.**
Consider the possibility that rejection isn't personal and it doesn't own you. Think of it as small doses of poison that will make you strong like Mother Jones over time.[17] Before you know it, you'll be sharing your work all over the Internet, soliciting feedback from people near and far, and you won't sweat the small stuff. You'll just use it to get better at your work. (Besides, when people criticize with neither compassion nor curiosity, it reveals more about them than it does about your work.)

· **The opportunity to impress upon others something that I believe matters.**
If I don't share my work, other people don't receive the contribution I have to make. And while not every spaghetti sticks, now and again I do affect someone. I show them a visual concept that expands their realities. It changes the rules; it alters their perception. This is my gift to them, like you sharing your work will be a gift to others. So don't deny people the chance to grow by being exposed to what you make. Protecting yourself from verbal sling blades just isn't worth the trade-off.

YOU HAVE REACHED THE EDGE OF INFODOODLE TERRITORY

Believe it or not, soldiers, this chapter has shown you all you need to know about the basic Doodle: the Visual Alphabet (a broad and liberating tool, don't you think?), how to sketch super-simple stick figures, and the emotion-filled Face Matrix. Let me assure you that, deep in your DNA, none of that is news. The basic Doodle is the very foundation of your soon-to-be megaskill: the Infodoodle.

THREE MORE DOODLE GAMES BEFORE YOU EMBARK

DOODLE GAME:
Cadavre Exquis

I call Cadavre Exquis a "co-doodling" exercise.[18] In a group of two or more, the goal is to collectively assemble images in a sequence, taking turns, so that no participant can see the entirety of what he is contributing to. Fold one sheet of paper multiple times and ask the first doodler to draw a body part. Then have her pass it on, and each participant take turns doodling random body parts in various positions until the whole sheet—and the freaky "exquisite corpse"—is revealed. This game is good practice for cooperative visuals—a major component of Group Infodoodling—and for getting used to the idea that it's okay to *not* know what an image will end up looking like.

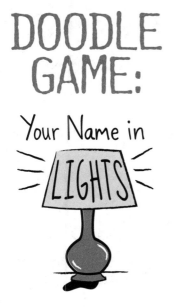

DOODLE GAME:

Your Name in LIGHTS

Doodle a word you've been working on since you were in kindergarten: your name. And just to make it a little more spectacular, surround your name with lights, or with some kind of icon you'd like to be associated with. Pick up a pen and lazily sketch your name and surround it. Trace over the lines again for good measure, and enjoy the process. It's strangely calming, perhaps because it's so uncomplicated. Repeat this process as many times as you'd like—doodle your children's names while you're at it—and pay attention to what you experience as you make your mark. This simple exercise offers languid, unadulterated joy that seems to make time slow down.

DOODLE GAME: Doodle BOMB

Your job as a doodle bomber is to hijack a magazine ad and doodle-deface it.[19] Sketch power tools in the hands of supermodels. Change the letters to say something funny. Turn the magazine upside down and corrupt its contents. Then share it with your friends and say "tee-hee." You'd be surprised what good practice this game is for improving your doodle skills. There's no pressure to get it right, and to morph an image into something else you must look closely at it. Then there goes the neighborhood.

INFODOODLE UNIVERSITY: Mastering Visual Thinking

INTRODUCING THE INFODOODLE: THE ASS-KICKING COMBINATION OF THE BIG FOUR THINKING STYLES

Now we arrive in the wild, wonderful world of Infodoodling, which is the real star of this book. Infodoodling is the most sophisticated form of Doodling, and it will be explored in all its glory in the next two chapters. The Infodoodling space is very expansive—it has a surprisingly diverse set of forms and functions—and it includes three subtypes, each of which packs its own intellectual wallop. You saw earlier that the three subtypes are Personal, Performance, and Group Infodoodling. I'll show you what those mean shortly. But first, a look at what makes an Infodoodler special.

DESCRIPTION OF AN INFODOODLER

The word "Infodoodler" describes someone who relies on a tight fusion of words, shapes, and images to represent text-based or auditory content. The content can come from a textbook, a white paper, a spreadsheet, a slide deck, a speaker, or a group conversation—anywhere words and numbers are available to be re-formed and better understood by becoming a visual display. The Infodoodler is a master of transforming data, information, and conversation into a more rich, immersive representation of itself, using whatever means are available at the time (e.g., markers, sticky notes, digital tablets, software, notebook paper, game pieces, you name it). What's important about the Infodoodling process is that it accommodates a full range of learning preferences and it's done with the intention of elevating thinking, whether you need to better understand, remember, innovate, align, design, or solve. The Infodoodle is a power tool that, once mastered, represents a major leap toward visual literacy—a kind of literacy that future generations can't afford to be without. Let's break down the three subtypes.

PERSONAL INFODOODLING

Personal Infodoodling is usually the most accessible entry point for people wanting to infuse their work and life with visual language. The practice takes place on a small scale—often in a notebook or sketch pad—and it's made with the explicit intention of helping *an individual thinker's process*. During Personal Infodoodling, a person depicts information from a book or a speaker in a visual language format. In other words, she enriches the meaning of the words by supplementing them with shapes and images. This technique, as you learned from the story of Dr. Virginia Scofield, is incredibly valuable at work and at school when someone is responsible for understanding and recalling complex information. The picture here shows one style of Personal Infodoodling, which is my visual capture of the content from one of David Allen's Getting Things Done workshops. In all forms of Infodoodling, the only limit to visual structure is the imagination.[1]

the personal infodoodle

Many future Infodoodlers will walk through this personal-work doorway before they explore the other two forms of Infodoodling, Performance and Group. Working at this size and for only your eyes tends to encourage experimentation with icons and images and minimize the natural fears that arise when using visual language in front of others. It is an excellent place to begin.

PERFORMANCE INFODOODLING

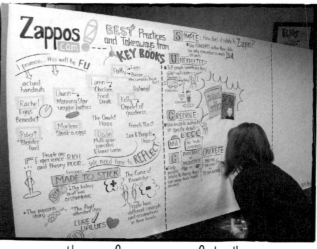

the performance infodoodle

A Performance Infodoodler is someone who writes and draws auditory content on a large scale for an audience to see while that content is streaming live from a panel or presenter. Performance Infodoodlers work on large sheets of artist paper, foam board, or whiteboards displayed panoramically around a room, or they work on an iPad or digital drawing tablet and use a projector to share their live content creation with the crowd. These Infodoodlers are part performance artist, because the visual display they create happens

spontaneously, in real time, and it unfolds before an audience's eyes. Performance Infodoodling is the most sophisticated of the three doodling types in terms of listening and filtering information rapidly. It's challenging because it aims to capture and represent as visually and accurately as possible what a speaker is saying while the speaker is saying it. Unlike Personal Infodoodling, the Performance Infodoodler cannot put a personal spin on the information she's hearing.[2] This method requires sharply honed listening skills (there's a subsection within that outlines tips to earning a black belt in listening) and a razor-thin margin of error in content capture in order to reach peak performance.

GROUP INFODOODLING

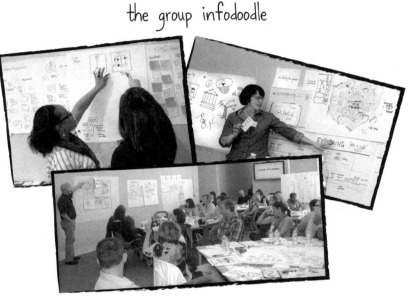

the group infodoodle

Group Infodoodling is the Doodle's most interactive incarnation. This work is participatory and immersive and, despite the deep thinking it conjures, can also be a delicious amount of fun.

During a Group Infodoodle, people work together to solve a specific challenge using a sequence of activities inside a visual-thinking process. These processes can last anywhere from thirty minutes to a week, but the Group Infodoodle has the explicit goal of addressing a challenge or problem using simple visualizations and questioning techniques. This type of work is explosively powerful, and it's used by many of the most innovative firms in the world. You'll read about a great example of this as you continue marching forward.

All of these methods—Personal, Performance, and Group Infodoodling—will be explored and experimented with throughout this book, because the Revolution is afoot to expand the universe of what's possible using a skill you already have.

INFODOODLE DISTINCTIONS: A VISUAL SUMMARY

I've crafted an infographic to help summarize the characteristics that distinguish these three subtypes of Infodoodling from one another. As you review the next visual, begin to consider what form of Infodoodling is most exciting to you. Think about areas in your life and work in which you could apply one or more methods for better understanding, communication, decision making, and problem solving. The sky's the limit with the Infodoodle, and there's no wrong way to explore these techniques. There's only a huge opportunity missed if we don't try.

DISTINCTIONS IN INFODOODLING: Categories and Characteristics

*OFF-AIR
(NOT LIVE OR IN REAL TIME)

*ON-AIR
(LIVE & IN REAL TIME)

* PERSONAL INFODOODLING

* PERSONAL INFODOODLING

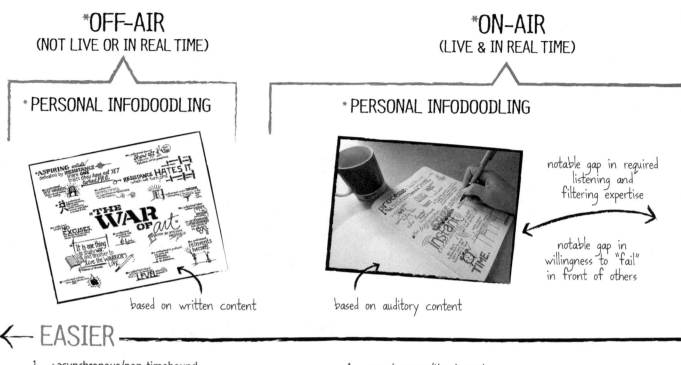

notable gap in required listening and filtering expertise

notable gap in willingness to "fail" in front of others

based on written content

based on auditory content

← EASIER ─────────────────────────

OFF-AIR	ON-AIR
1. : asynchronous/non-timebound	1. : synchronous/timebound
2. : tied to written content	2. : tied to auditory content
3. : small-scale (usually in a notebook)	3. : small-scale (usually in a notebook)
4. : may or may not require faithfulness to written content (choice of what info to capture is goal specific)	4. : may or may not require faithfulness to what's being said (choice of what info to capture is goal specific)
5. : not performance-based	5. : not performance-based
6. : not made explicitly to be shared	6. : not made explicitly to be shared
7. : can be perceived as artistic	7. : can be perceived as artistic
8. : requires no level of artistic talent	8. : requires no level of artistic talent
9. : is served by developing filtering skills	9. : is served by developing listening and filtering skills

* PERFORMANCE INFODOODLING

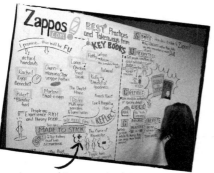

based on auditory content

* GROUP INFODOODLING

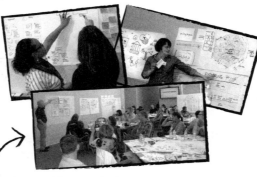

based on auditory content

HARDER →

* ALL METHODS RELY ON THE PURPOSEFUL INTEGRATION OF WORDS + SHAPES + PICTURES *

* ALL METHODS ARE SERVED BY DEVELOPING VISUOSPATIAL ORGANIZATION SKILLS *

* NO METHODS REQUIRE ARTISTIC TRAINING OR TALENT OF ANY KIND *

Performance Infodoodling:

1. : synchronous/timebound
2. : tied to auditory content
3. : large-scale (on giant artist's paper)
4. : must be faithful to what's being said (accuracy and fidelity to speaker's content is paramount)
5. : performance-based
6. : made explicitly to be shared (unless speaker requests otherwise)
7. : virtually always perceived as artistic
8. : requires a decent level of artistic talent
9. : requires excellent listening and filtering skills

Group Infodoodling:

1. : synchronous/timebound
2. : tied to auditory content
3. : small- and large-scale (on giant artist's paper, sticky notes, whiteboards, index cards, flip charts, etc.)
4. : must be faithful to what's being said (accuracy and fidelity to speaker's content is paramount)
5. : facilitation performance-based
6. : made explicitly to solve problems (sharing is common but optional)
7. : not perceived as artistic
8. : requires no level of artistic talent
9. : requires excellent listening and filtering skills

INFODOODLING: THE FOUNDATIONS

Due to your native prowess at doodling, that last chapter was probably a breeze. That's good because you're going to keep making incremental gains, coupled with the occasional giant leap, until suddenly you find yourself an expert at Infodoodling without having to experience any intense pain along the way.

We're going to take another assessment to establish the next baseline: your comfort level with the Infodoodle. But before we pass through this mountain and find the 12 Devices you need,[3] we must first face the Three Lies. Please idle in reading mode for the next few minutes. These Three Lies (and their accompanying beliefs) are full of destruction and mayhem. I need you to hear them so they will never (again) get in the way of your progress.

THE THREE LIES: A DESTRUCTIVE FORCE ON EARTH

The Three Lies became apparent to me in my work around the globe. As *you* go through the world as a smart and strong Doodle Revolutionary, you, too, will come across these lies—in your company, in your school, in your home. So below I expose the lies and offer you a few ways you can choose to respond to them.

LIE #1:
I will never be able to draw. It's a genetic flaw.

In Chapter 1, I described the phenomenon of drawing incapacitation that virtually all adults have in common. In service to those of you who see it as a genetic impossibility, and to your peers who summon this argument to avoid learning to be visually literate, I say this: It is reasonable to assume that people are born with certain traits that are genetically inherited. There are people who can consume mounds of ghost peppers and not die. There are people who grow werewolf-like hair all over their bodies. There are also people deathly allergic to peanuts. But there are not people born to be incapable of drawing. And there are definitely not people genetically incapable of eking out a Doodle. The reality is that our brains are like giant, muscular vines, and they can wrap themselves around almost any skill we ask them to consider. No genetic flaw on your mom's side can prevent that. But in many of the situations where I'm given the genetic-deficiency excuse, what I *really* hear is Lie #2.

LIE #2:
Doodling is anti-intellectual and not for leaders or serious thinkers.

This lie involves what I call a "transparent bias." It's transparent because most people aren't aware that they harbor this belief, yet their behavior and conversations prove otherwise. We touched on this earlier, but the notion that doodling and drawing aren't intellectually rigorous is *everywhere*—higher education and the press may be the two biggest culprits—so it bears repeating since *you will come up against it again and again.* Newspaper articles that involve a national or world leader doodling invariably describe the scene as a "gotcha," linguistically admonishing the "important people" for engaging in trivialities during meetings.

When people question, tell them this: Visual language, in the forms of doodling, sketching, or drawing, *does* ignite and support serious intellectual thought. People using even rudimentary visual language to understand or express something are *stirring the neurological pathways of the mind* to see a topic in a new light. World leaders may need the Doodle more than the rest of us because they find themselves in situations of high information density on a regular basis. If your audience needs proof of the intellectual contribution of the Doodle, recommend that they review the notebooks of Thomas Edison, Marie Curie, Bill Clinton, Leonardo da Vinci, Steve Jobs, Bill Gates, George Washington, Richard Feynman, and almost every other person who's contributed to the advancement of society, ever. Doodling is a deep ally of intellectual thought, and it always will be. Together, we can move people beyond Lie #2.

THE DAVOS DOODLE INCIDENT

In 2005, in Davos, Switzerland, the world's most preeminent leaders gathered at the annual World Economic Forum. They were discussing weighty topics such as global pandemics, the end of easy oil, and what was at stake in Iraq. When a press conference during the event came to a close, workers gathered the remains of the day and found something that, rather surprisingly, turned into a bit of a scandal: a doodle left behind by the then–prime minister Tony Blair.

Following this discovery, Blair's doodle was psychoanalyzed by graphologists—people who study handwriting and relate it to psychological states. From their analyses the assertions flew. Blair was "aggressive," "unstable," "chaotic," and even "megalomaniacal." He was a man under duress, preoccupied with phallic symbols, and one who perhaps should not be leading a nation.

When the dust from these allegations finally settled, a truth no one anticipated emerged about this doodle. It didn't belong to Tony Blair. In fact, it was created by none other than Microsoft founder and billionaire Bill Gates. This (amusing) realization naturally led to backtracking about the conclusions drawn, and it reignited an old debate about graphology as a pseudoscience. For our purposes, it's revealing to see the cautionary tale that both Blair and Gates received: Be careful where you doodle, gentlemen, because people are watching.

Is it any wonder Doodlers often stay in their closets? Perhaps this incident should be referred to as Blairgate.

LIE #3:
The use of visual language should be reserved for "real" artists.

You know this lie. You may have even told it yourself a few times. But the argument over whether some people are "real" artists is about as tiresome as partisan politics. Frankly, I'm uninterested in that debate because neither I nor the Doodle Revolutionaries have any skin in that game. Let the art school graduates hash it out. Revolutionaries are here to solve problems, to enhance our capacity to learn, unlearn, and relearn, and to make good things happen. We don't spend time even trying to be artists. One of the most pressing reasons for that may blow your lid, but stay calm because you need to know this. It is a moment of deep thought and a turning point for Revolutionaries.

VISUAL LANGUAGE
is not equal
TO ART.

That's right. Quote me on that. Visual language is not synonymous with art. In the universe of the Doodle Revolution, it is of the utmost import that we separate these two. If you hate this idea, try not to resist it for a moment, because there's a utilitarian and intentional reason for it. It may make you wince, but once those circles of "visual language" and "art" are separated in our minds, *then* we can return to a world in which the circles have overlap. But to rip this from our consciousness for now, we need to make a radical distinction between them.

VISUAL LANGUAGE ≠ ART

Recall that visual language is the combination of words, images, and shapes to communicate, understand, and/or innovate around a concept. Can "art" use words, images, and shapes to do that? Of course. But the trouble with conflating the two is massive, and that notion has to be shot down before you pursue the Infodoodle. When people equate visual language with art, they suddenly find themselves grappling with a host of beliefs about art that make them shrink from the Infodoodle or get confused about its purpose. If people believe that doodling or drawing must be attractive or demonstrative of talent to be of value, then we've lost the battle in an instant.

To drive this point home, I want to quickly explore the beliefs people hold about art and then vehemently disassociate those beliefs from the Infodoodle.

TROUBLESOME BELIEF #1:
Art is a luxury.

Counterpoint: Visual language is not a luxury.
What is the first thing to go when budgets get tight? ART. What is the last thing parents what their children to be? ARTISTS. What is something that in the

foreseeable future will never be given a line item in a company budget? ART. You see where I'm going with this. If people equate visual language with art, it will never see the light of day where we need it. Not in a school. Not in a government office. Not in a company. Many people running effective organizations believe art to be expendable and superfluous at best—frivolous and silly at worst—whether they say that out loud or not. CEOs don't jeopardize their positions with their boards in order to advocate for a greater infusion of art in the office. To type A business leaders, creative mushiness in the form of art is not necessary to do the hard work of running a company.

Because of this reality, Revolutionaries *cannot afford* to call visual thinking "art." If we do, our work gets flushed down the drain along with those other luxurious (read: expendable) artsy-fartsy items that people believe don't belong in the workplace unless they're decorating the lobby. **Comparing visual language to art is a giant no-no** because Infodoodling and visual thinking *are not* luxury goods. They are essential skills that should be present—and budgeted for—in any environment serious about thinking.

TROUBLESOME BELIEF #2:
Art is for "real" artists.

Counterpoint: Visual language is for everyone.
I'll get skewered for this by hordes of people, but what is a Revolution if not risky? We must get around this belief because it sits like a boulder in our paths to visual literacy.

Many people around the world believe "art" and the moniker "artist" should be reserved for people who

earn the title. I've heard time and again that so-and-so isn't a "real" artist, just a hack trying to be an artist. We have an inclination to withhold the label "artist" from people we don't deem worthy, even while the standards by which one might be called an "artist" are all over the place. The sculptor Richard Serra even once told famed architect Frank Gehry—the man who designed the Guggenheim in Bilbao—that he believes architecture isn't art; it's plumbing. Well, jeez. What's the takeaway for us lowly serfs trying to express ourselves through sensory crafts? It's loud and clear. We'll never be good enough to be *artists*, so we might as well take our paint-by-numbers and go home. Screw that. The Revolution is about encouraging people to doodle, sketch, prototype, and draw, and I won't have any elite-art bullies telling people not to bother because their work isn't good enough. Hear this, Art World! Doodle Revolutionaries don't need your approval. We don't need our work to be remarkable or beautiful or even decent. We need it to be scrappy and messy and applied to amplify our thinking. No amount of nose-tilts and pretentious air-sniffing can change that.

While I don't have the wherewithal to upend the pervasive notion that art is an elite craft, I can certainly exclude Revolutionaries from that system. In the Doodle Revolution, visual language is for the People. Any People. Including those we wouldn't deign to call artists.

TROUBLESOME BELIEF #3:
Art is the result of divine inspiration.

Counterpoint: Visual language is the result of hard work.

We seem to cling to the belief that the ability to make art is god-given the way we cling to the belief that insight is like a bolt of lightning from the blue.

We treat art and creativity as mysterious beasts or mythical muses. But this isn't accurate. Creativity and art require work just like anything else worthwhile, and they emerge through a steady process of taking in information, letting it swirl around in our cerebral soup, and *working* it so it can remix, transform, and surprise. Believing that art comes from the heavens is a surefire way to avoid any effort to make it, and this leads us back to the idea that it's counterproductive for visual language to be equated with art. If art is for those struck by heaven's lightning, and visual language is art, then why try and learn it? God didn't whisper in *our* ears, so maybe it's best to become an accountant. Leave all that doodling and sketching to the Chosen Ones.

This belief is another colossal error, in part because it's false[4] and in part because there are characteristics Infodoodling and art simply don't share.

CHARACTERISTICS INFODOODLING AND ART DON'T SHARE

Infodoodling is not designed to be emotive. Much more often than not, Infodoodling is an intellectual pursuit—and yes, an imaginative pursuit—but its application in workspaces and in schools is not intended to summon forth and/or process deep wells of emotion. Very often Infodoodlers are there to support the capture of content we don't even choose ourselves, so the likelihood of it being emotive is pretty low. Personal and Performance Infodoodlers are present to absorb information and transform it into a visual display that's memorable and clear. Group Infodoodlers are present to support the progress of a group's goal. If the content in either circumstance is emotional, then the Infodoodle can show that emotion. But its purpose generally isn't to release, excite, or unearth emotional

information. It is to catch information and show it. To learn and to teach. Not to emote.

Infodoodling does not have a focus around personal self-expression.

Thanks to the wonders of the Internet, we can all bear witness to the hordes of Infodoodlers operating in our midst. And while I will not deny any individual using combinations of words, shapes, and images the title of Infodoodler, I want to make clear which of those the Revolution is intent on highlighting. Doodle Revolutionaries working to legitimize this field in schools, governments, and places of business usually do so by visualizing content *relevant to the goals and values of those institutions*. We make ourselves useful in the broader context in which we work and learn, and we are in service to ourselves and to the other people embedded in those institutions. Infodoodlers of the Revolutionary ilk don't exploit the skill *solely* for the purposes of creating works of self-expression, or of displaying information that is only meaningful to them. This assertion is not inflexible, however. Someone Infodoodling a timeline of his family history is doing important work for himself, but that timeline may only be in service to him, and in order to advance the field of visual literacy, the distinction needs to be explicit. Authorities in schools, businesses, and governments are generally not interested in your personal self-expression unless it brings something to bear on their larger goals and strategies. So the reason that the Revolution seeks to shift our focus away from personal expression and toward group utility is that doing so elevates our value in a system. It makes us contextually relevant to a broader audience and strengthens the case that we increase in number.

Infodoodling is not designed to be ambiguous or to be open to broad interpretation by the audience.

Specificity and clarity around the content being discussed is a major goal of the Infodoodle. The idea is to keep doodling until what you and/or a group are trying to understand is understood. To get to a place where the lightbulbs go on and everything suddenly makes more sense. We want stakeholders on the same page. We want people to find a shared mental model so that data becomes clear, action can be taken, and decisions can be made. Contrary to many works of art, the chance to be interpreted broadly is not an aspiration of the Infodoodle. Subjectivity—insights from art that are personal and private—is a wonderful, wide-open space. But the Infodoodle wants the reality it displays to be understood as closely as possible to how it was intended.

Infodoodling is not about making something beautiful or exemplary.

Infodoodling *can* result in very awe-inspiring works, but if beauty results from the process, in many cases it's simply a fortunate by-product. The work of Infodoodling focuses on producing results, driving toward goals, innovating around products and services, helping people understand and think. In this way, it is distinct from the traditional ambition of art. Infodoodling does generate displays that can surprise and even delight the viewer, but if an Infodoodler focuses on visual beauty, she has missed the larger point: An Infodoodle can be ugly as all hell and still get the job done.

TROUBLESOME BELIEF #4:

Art and suffering are natural partners, and mental illness, drug addiction, starvation, and/or ruined relationships go hand in hand with artists.

Counterpoint: Visual language doesn't hurt anyone.

The author Elizabeth Gilbert gave a TED talk in 2009 wherein she acknowledged the odious nature of our belief that art = suffering, a belief she believes has been "killing off our artists for the last five hundred years." Gilbert stated, "We've completely internalized and accepted collectively this notion that creativity and suffering are somehow inherently linked and that artistry, in the end, will always ultimately lead to anguish." Then she paused for effect and asked, "Are you guys all cool with that idea?"

I hope Revolutionaries respond to that question with a resounding no. This idea stands staunchly in the way of a genuine cultural acceptance of visual literacy. If people associate visual language with art, many of them will also summon the idea that it causes pain or emerges from pain, that it is melodramatic, that it is agony or ecstasy. None of those scenarios encourages the application of visual language at work or in standard classrooms. Like it or not, reasonable or unreasonable, people will shut the door on the Infodoodle if it overlaps too intensely with art. So one last time I want to emphasize, in service to the pursuit of visual literacy, that

VISUAL LANGUAGE
is not equal
TO ART.

THE INFODOODLE ASSESSMENT

Below you'll see a grid just like the one from the last chapter. After soaking in some lessons that may have reshaped your reality a bit (or not), take a few minutes to shift your attention and quietly complete the assessment below. And if there's a category or skill set you don't quite understand, feel free to leave it blank until we elaborate on that topic in the chapter and then come back and make your mark. The plan is to put you in charge of your own learning, so this chapter will educate you on the foundations of Infodoodling so you can then learn to put it to WORK. Ready? Carry on.

THE INFODOODLE ASSESSMENT	No frakking way.	I'd really rather not.	I'm perfectly capable.	I'm actually into that.	Only death could keep me from it.
MASTERING ILLEGIBLE HANDWRITING Writing *just* clearly enough to be understood.					
FORGIVING YOURSELF FOR SPELLINK ERRORS Laughing them off & moving on. *Aaaand* realizing that no one else can spell either.					
BELIEVING THAT INFODOODLING ≠ ART Knowing you'll never need "art" to Infodoodle.					
WORKING W/TYPOGRAPHY Exploring letterforms to support communication.					
DOODLING WORD PICTURES Creating words using pictures.					
IMAGINING METAPHORS TO SHOW CONCEPTS Using your mind's eye to find shared ways to represent an idea.					

(continued on next page)

(continued from previous page)

THE INFODOODLE ASSESSMENT

	No frakking way.	I'd really rather not.	I'm perfectly capable.	I'm actually into that.	Only death could keep me from it.
DOODLING SHADOWS & SHADING Giving volume and dimension to objects.					
USING COLOR APPROPRIATELY Adding emphasis and meaning through color.					
SHOWING RELATIONSHIPS BETWEEN INFO Mapping interactions & indicating relationship types.					
DISCERNING RELEVANT CONTENT Discarding linguistic fluff and honing in on what matters.					
DISTILLING VERBAL CONTENT IN REAL TIME* Taking accurate notes of the core of a conversation as it happens.					

*This one is not relevant for Off-Air Personal Infodoodling.

You can see that the Infodoodle Assessment describes more sophisticated skills than the Basic Doodle Assessment does. Before that daunted feeling comes over you, remember that *every one* of these skills is learnable regardless of how you perceive your ability right now. I myself started at square one in Rookieville so I know how much potential awaits you. I also know how much you'll surprise yourself if you keep going.

Before I ask you to apply your mind in the following sections, let's confirm why we're doing this. Why do I want you to learn how to transform words and numbers into visual displays? Why can't you just make the lists that you're used to and keep taking crappy notes in class and in meetings? (Hey, everyone's notes are crappy. Not just yours.)

ON LISTS AND STANDARD NOTES: WHY THEY'LL NEVER BE REVOLUTIONARY

Tell me, exactly, what is wrong with this picture?

When System 2 is otherwise engaged we will believe almost anything. p. 81
Confirmation bias: people seek data that are likely to be compatible with the beliefs they currently hold. p. 81
Halo effect: the tendency to like (or dislike) everything about a person—including things you have not observed. p. 82
The measure of success for System 1 is the coherence of the story it manages to create. p. 85
Framing effects: different ways of presenting the same information often evoke different emotions. p. 88
Good mood and cognitive ease are the human equivalents of assessments of safety and familiarity. p. 90
System 1 carries but many computations at any one time. p. 95
Substitution: operation of answering one question in place of another. p. 97
The present state of mind looms very large when people evaluate their happiness. p. 103
Self-criticism is one of the functions of System 2. p. 103
System 1 is highly adept in one form of thinking—it automatically and effortlessly identifies causal connections between events, sometimes even when the connection is spurious. p. 110
System 1 constructs stories that are as coherent as possible. p. 114
The tendency to see patterns in randomness is overwhelming and incorrect. p. 116-117
We are far too willing to reject the belief that much of what we see in life is random. p. 117
Anchoring effect: what happens when people consider a particular value for an unknown quantity before estimating that quantity. p. 119
Anchoring as adjustment happens as you move from anchor and adjust when you are no longer certain; where you start (high or low) impacts adjustment as does cognitive resources. p. 120-122
Suggestion is a priming effect, which selectively evokes compatible evidence. p. 122
The selective activation of compatible memories explains anchoring; the high and low numbers activate different sets of ideas in memory; a deliberate strategy of "thinking the opposite" from an anchor may be a good defense for the anchoring effect because it negates the biased recruitment of thoughts that produces these effects. p. 127
If you cannot easily come up with instances of meek behavior, you are likely to conclude you are not meek at all. p. 132
Self ratings were dominated by the ease with which examples come to mind. p. 132
Smiling reduces cognitive strain and frowning increases cognitive strain. p. 132

Make five observations about how these notes are lacking in greatness. Write your thoughts in the lines below. (Make a list! I'm a fan of irony.) Then let's discuss.

OBSERVATIONS OF CRAPPY NOTES

1. _____

2. _____

3. _____

4. _____

5. _____

Doodle Revolutionaries don't love these notes, and I won't leave you in the dark as to whether or not your guesses were accurate. Let's outline the ways in which 95 percent of standard notes taken by humans actually conspire to confound the brain. I think it's safe to say that standard notes *wish* they had the following attributes:[5]

1. **More than one color.** (The word "monotone" is the root of the word "monotonous," as in "bore me to oblivion.")

2. **Discernible visual patterns.** (There are no trees on the page above. Only a dense patch of endless, wordsy forest.)

3. **Icons and imagery.** (Speaking of trees.)

4. **Typography and word pictures.** (Letters, too, can be transformed into memorable visual imagery.)

5. **An ability to show relative importance and emphasis.** (What matters most in the writing above? How would anyone know at a glance?)

6. **Spatial and relational associations.** (Why try to show hierarchy without a pyramid? Why try to show offspring without a family tree? Everything is relational somehow.)

7. **Three-dimensionality.** (The world can spring off the page and grab our attention if we just let it.)

8. **Imaginative content that supports and solidifies analytical content.** (Ideas inspire other ideas. Why not allow for creative offshoots when those moments of inspiration occur?)

9. **Wholeness or gestalt.** (The big picture is lost in the devilish details.)

10. **Efficiency.** (It takes forever to comb back through standard notes, desperately seeking a specific answer. This isn't a good use of anyone's time—especially not that of busy employees or students.)

11. **Alignment with the structure of the brain.** (Our brains drift toward a semihypnotized state when shown monotonous linear content. Visual notes allow for colorful, diverse displays, thus jibing with the physical structure of the brain and waking the brain from its slumber.)

I'm sure you suspected some of those. If standard notes were even close to useful, perhaps we needn't be so radicalized about the Infodoodling technique. But our current method of capturing and displaying information *so that we can learn* is flimsy at best and mind-erasing at worst. Did you know that Tony Buzan surveyed students around the world, asking for words they associated with note taking, and these are the responses he got?[6]

boring
punishment
depression
fear
wasted time
rigidity
failure

Yikes. Somebody call in the Doodle Revolutionaries! We need to make a power move. First stop: handwriting.

MASTERING ILLEGIBLE HANDWRITING

When I teach Infodoodling anywhere in the world, there are always people concerned about the quality or legibility of their handwriting. They're not only concerned about the group being able to read it; many people can't even read their own handwriting after they've taken notes. So you can imagine that this anxiety is understandable. After all, if you're working to show and share information, somebody must be able to decipher it. Here are four tips to mastering illegible handwriting:

(#1) S.....L.....O.....W D.....O.....W.....N

Stop trying to write as fast as the speaker is talking. It's not humanly possible, and it contributes to your handwriting looking like some kind of death scrawl. Take some deep breaths and listen for what matters in the information you're hearing. Capture the content that the speaker seems to be emphasizing, not every damn thing she's saying—you'll just break a sweat and start feeling stupid. Let yourself miss, say, 50 percent of the words you're hearing. Be leisurely about it. You'll see legibility emerge on the slow boat.

(#2) STAND UP AND WRITE BIGGER

When we stand with a flip chart or whiteboard and use our shoulders, wrists, and hands to write, we engage more muscle control. And in doing so, we establish more muscle memory. Practice drawing a good-looking *A* with more of your body. Its shape will be memorized by your muscles, and then you can scale it down to a smaller page once that record is established. Doodling your letters on a larger scale can give you much more visibility and control. My own handwriting improved dramatically when I started standing and writing. If you ask teachers who use chalkboards or whiteboards (or interactive whiteboards) if they now write more legibly on the board than they did when they began, I bet they say yes. It's because the practice of applying fine motor control can, and does, eventually pay off.

 (#3) trace A FONT TO PRACTICE YOUR LETTERS

Try Helvetica or Garamond. If it's too tiny to feel right, print the alphabet larger so the letters become more like pictures to you. Our brains interpret letters as small pictures, so when you scale up, you can start perceiving a letter as a shape and letting your visual mind memorize how the shape is formed. The goal is to get the shape of the letters to be more under your control. You probably haven't spent time trying to craft your handwriting. (Who does that?) So you're bound to see improvement based merely on the fact that you put attention on it. Add to that any amount of practice, and you'll find that tracing is like practicing your golf swing. You get better simply by repetition based on a good foundation, like Times New Roman.

#4 STOP TRYING

If, after experimenting with tips 1 through 3, you believe your handwriting will never improve, stop trying. Let that be okay. Seriously. You can't be good at everything, and there are other things you can focus on to be effective at the Infodoodle. Like what, you say? Like fonts and word pictures, shapes, icons, imagery, and diagrams. Those are coming up. And keep in mind that very often the Infodoodle is a group effort, so knowing your limitation allows you to request someone else's help where you need it (i.e., for the handwriting piece). You can wow others with your other talents.

SPELLINK ERRORS: WHY REVOLUTIONARIES NEEDN'T PANIC

Like the handwriting phobia, a spelling phobia can also surround the Infodoodle. Many people balk when asked to participate in the creation of a shared map or diagram, for fear that their spelling shortcomings will be found out. So when crafting a visual display, here are lessons on spelling it'd behoove you to cement to memory:

Lesson #1: Nobody else can spell either (especially when we're talking about English).[7]

The number of people who can spell seems to be decreasing every year. Millennials don't need to speak in whole words or sentences anymore ("No1s hm l8r? WDYMBT?"),[8] hip-hop culture treats consonants like they have some kind of virus,[9] spell-check is rampant, and the Internet age has us discarding vowels like they're stinking up the place. So don't give yourself a lashing if you don't spell every word right the first time (or ever). Trust me

when I say that your audience can't spell either or they're not brave enough to try in front of everyone. Here are two ways to work around the alleged spelling problem when it comes up during the Infodoodle.

1. Ask someone in the vicinity how to spell whatever word you're stuck on. Odds are that you won't be Infodoodling alone in the world, so just lean over and say, "How do you spell 'cantankerous'?" If the person can help you, she gets a zing of congratulations for herself.

2. Write down the first two or three letters of the offending word and then look it up. Odds are that either you or someone around you has a smartphone, so lmgtfy.com.[10] When you're creating an Infodoodle, you don't have to capture all content exactly when it happens. Just give yourself a textual trigger to come back to later (or you can use visual triggers like small icons to jog your memory of the word). After you've looked the word up (or written it down a few times until it looks

right—I do that), go back and finish the word on the display. Mission accomplished. And nobody passed out.

Lesson #2: Native speakers are better than you may think at discerning what you mean.

Surprisingly often, native speakers can understand a misspelled word or phrase, even one that looks fantastically scrambled. We do this well because we use the context to guide our decoding process and because our brain has an ability to "get the gist" as long as underlying grammatical structures and letter sequences aren't blown to smithereens. So for our purposes, absorb the possibility that you needn't be a fwalelss seplelr to be udnretsood.

Lesson #3: The ability to spell is unrelated to intelligence.

Stated differently, there is no predictable relationship between spelling chops and IQ.[11] The ability (or inability) to spell is not closely connected to general mental capacity. So if anyone comes to you and says that it is (and believe me, you'll encounter people who imply it), send them to me immediately. They know not what they say.

 If you find yourself feeling sensitive about your spelling skills in a group (because, yes, some people *will* correct you, tease you, or think superior thoughts), please recall these three lessons. And then take a deep breath and accept that there are many challenges in this Revolution, but spelling errors need not be one of them.

ENTER THE INFODOODLE: 12 DEVICES THAT FORM THE BASIS OF REVOLUTIONARY VISUAL DISPLAYS

Devices #1, #2, and #3: Typography, Fonts, and Word Pictures

Nonartists, please avoid getting freaked by the word "typography." While this word carries with it the fumes of grandeur, I'm not interested in Doodle Revolutionaries getting a professional-grade education in graphic design. We're going to simplify this device until it's virtually childlike. Since all Infodoodles involve words, exploring what's possible with typography, fonts, and word pictures will help add more visual substance to your work. And it may surprise you that people who struggle with legible handwriting can still be great in these areas because they call forth different sets of skills. But before we dive into these elements of the Infodoodle, let's lay out their definitions.

Typography involves the arrangement of type in space to affect visibility and meaning. Variables at play in typography include the choice of fonts, the size of letters, the length of a line, the spacing between the lines,[12] and the spacing between pairs[13] or groups of letters.[14] All of these components can be manipulated to affect how a viewer interprets and receives your message. Even without adding the powerhouse of imagery, letters all by themselves give you a host of options to enhance your Infodoodle.

Below are some examples of how typography alone can change meaning, emphasis, and emotion. As you can see, simply fluctuating the placement of letters gives the audience a visual link to the actual meaning of the word or phrase you're using. It offers a more cognitively rich view of information even *without* the use of icons or images.

slow down

CRUSH THE COMPETITION

The message is JUMBLED

Now, for those of you averse to your handwriting, when playing with typography, I recommend that you do some of the moves you learned earlier: stand up, slow down, and write bigger. These techniques will continue to help you experience how upscaling changes the clarity of your letterforms. And for all of you learners—handwriting lovers or otherwise—the goal of this section is to understand how much meaningful information is contained simply in the distribution and placement of letters. There's a whole universe of opportunity in this one aspect of the Infodoodle. Call it reading between the lines. Try your hand at it. I've given you four phrases that are begging to be typographized. Play with spacing options to start uncovering how spacing affects meaning.

I feel two inches tall.

Togetherness is beautiful.

Leave me alone.

Her dream is expansive.

I hope that wasn't terribly tricky. Exploring typography, especially if you're into quality assurance or data analysis, may not have felt like the most natural thing in the world. But at least you now have it in your toolbox and you can break it out when the need arises. In the unfolding journey that lies ahead of you, it's bound to come in handy.

DEVICE #2

FONTS
FONTS
FONTS
FONTS
FONTS

Fonts, also known as "typefaces," are a subcategory in the study of typography. They represent a complete set of letters or characters that share common design features. There are literally thousands upon thousands of fonts, and new ones are being designed every day. The reason that fonts are fabulous is because they offer *so many options* of flair and flavor for your Infodoodle. They also rescue those Doodlers who are less than excited about learning to draw, however simply it may be done, because fonts can imbue fertile meaning onto an otherwise dry landscape. And they do so without all the drama of trying to be "good" at either drawing or handwriting.

How, you might ask, do fonts convey meaning? Well, here's the special trick about meaning: We find it everywhere. Human beings are meaning-making machines. We look for and find meaning constantly in our lives, and we interpret any and all signals—including visual signals—as being infused with something meaningful. So fonts, with their infinite variation, serve as value-laden vehicles for meaning since we can add shape, dimension, color, texture, and imagery to their structures and convey practically anything we want. I offer you examples to illuminate my point.

WAR

lovely lady

ROBOT

STRETCH GOAL

SHARP MINDS

You see now how fonts hold emotional and metaphorical content for the viewer. The word "war" above is dark, sturdy, inflexible, and reliant on our shared image of the letters printed on army uniforms and equipment. The phrase "lovely lady" is soft, curved, and lilting. It reminds us of the female form and the myriad associations we have with it, including comfort and a yielding nature.[15] The word "robot" is straightforward and conjures the numerical face of digital alarm clocks and watches. The phrase "stretch goal" has the qualities of a rubber band—elastic and varying from thick to thin. It implies we're not "there" just yet. Last, the phrase "sharp minds" uses razor edges and tapering points to help us *feel* what it's trying to show. And all of these associations happen automatically, on sight. So you can use a trove of typefaces to design your Infodoodle. Indeed, you can even exclude imagery altogether and still leave the

viewer with the sense that he saw something rather than read something. An in-depth investigation into fonts and their variants is a good option for people not interested in moving toward sketching or drawing (although, by the end of this book, y'all won't really exist).

While we're in the font section, there's another aspect of them worth noting. There's evidence that so-called funky fonts—fonts that have enough personality to be considered nonstandard—actually support student learning.[16] In a study of 222 high school students who were asked to learn information in a variety of subjects (including English, physics,

history, and chemistry), the students reviewing information in a "disfluent" font performed better on testing than their fluent-font counterparts. The researchers concluded that nonstandard fonts offer what they call a "desirable difficulty," and they seemed to have the effect of elevating students' attention and retention. I know that's bad news for all you Comic Sans haters,[17] but there it is. Funky fonts do a body good. So play around with fonts in your Infodoodles. The adults you'll be showing your work to aren't different from high school students when it comes to attention and retention. Below are four phrases I'd like you to start off with.

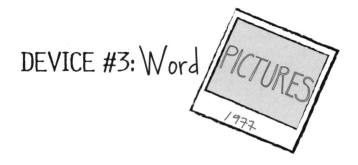

DEVICE #3: Word PICTURES 1977

We touched on word pictures in Chapter 2 when we learned about people from the font doodler camp. Now we're free to explore word pictures fully so you can see the possibilities they allow.

Recall that word pictures are words created by using pictures or by using recognizable pieces of objects to make the letters. They can also be words or phrases that are so embellished with imagery that the expression itself seems to become a picture. They're distinct from fonts in that they either include decorative images or are created specifically by the use of individual images to show individual letters. Word pictures are impish creatures that can add a lot of liveliness to your Infodoodle. The challenge of word pictures is in figuring out which words can be effective word pictures and in determining which images you can use, in what layout, to display the word. Despite those challenges, word pictures still offer some comfort to beginners. Many newbie doodlers take refuge in them because they're a kind of bridge—a hybrid species that embodies a blend of letters and imagery without all the fuss about realistic drawing. They can be user-friendly for people who don't love their handwriting—they provide a chance to produce an Infodoodle focused around a central visual concept rather than a lot of words—and they're also good for people who aren't ready to be immersed in drawing but who still want to incorporate visual elements into their work.

Word pictures are mostly nouns, so by nature they lend themselves to images more readily than do abstract concepts (we'll learn how to visualize those in the next section). Indeed, usually the images that form their letters are directly tied to the meaning of the word itself. For example:

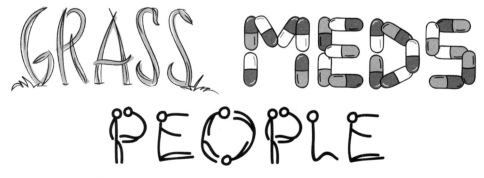

As I'm sure you've gathered, word pictures range from simple to complex, and in one important way they embody the nature of the Revolution: They are deliberate fusions of words and images. In being so, they give the creator and the viewer a fuller experience of their content. They tell you something and show you something at the same time! Brilliant, they are. Now you try.

coffee bean

$\llcorner\!\!\longrightarrow$

supply chain

$\llcorner\!\!\longrightarrow$

fighter jet

$\llcorner\!\!\longrightarrow$

management

$\llcorner\!\!\longrightarrow$

social media

$\llcorner\!\!\longrightarrow$

IMAGING METAPHORS TO SHOW ABSTRACT CONCEPTS

When I teach Infodoodling—Personal, Performance, or Group—this question of how to visualize concepts that are abstract always comes up. I recall with absolute clarity my own disorientation around this practice. How on earth would I doodle an idea that isn't anchored to an object in reality? How does one visualize nouns like "justice" or "strategy," or adjectives like "crunchy" and "manipulative"? Abstract concepts like love and happiness and peace and infinity have done us all favors by getting themselves iconized, but what about the words that don't have associated objects or icons? What are we to do with high-concept words like "failure" and "transcendence"? I used to start sweating trying to answer this question. Now I know that I, like many of my students, was making much ado about nothing.

Remember when we shared the following ideas in earlier parts of the book: (1) Faces are everywhere, (2) misspellinks don't matter, and (3) meaning is all over the place? Well, there's a thread tying all of those thoughts together and it is this: We *want* there to be a connection between things. We look for relationships among bits of information. We take comfort in the fact that the world is recognizable and that we're not floundering in the wilderness, knowing nothing and understanding nothing. We tell ourselves stories about what we experience *all the time*, and we want things to make sense. It is this behavioral principle of human beings that ultimately makes us great at imagining and visualizing abstract concepts.

Here's how this translates to doodling abstractions. Imagine that you're working on a Group Infodoodle, and your role is to help capture and doodle what people are talking about so the team can plan more effectively. You know the topic because it's your team, and you also know the kinds of concepts likely to emerge. You work at a public-relations firm, and in this particular meeting, y'all are kicking around the idea of a PR campaign for a certain legislator. Words floating around the room? "Strategy." "Voters." "Election cycles." "Sex scandal." "Fund-raising." Your job as the Infodoodler is to represent these ideas in visual+text form to support the conversation. You can do the text; you're making a leap on the visuals.

For "strategy," you doodle a chess piece. Nice. "Voters" is easy—a stick figure with a ballot for one hand. "Election cycles"? How about an *e* inside a circular arrow? That'll work. "Sex scandal." Hmmm. A penis with a censor over it? Um, no. You're at work. How about a red capital *S* with a censor? Okay! Last: "fund-raising." You default to the dollar sign. No sweat! You did your job as an Infodoodler perfectly well for a first-timer.

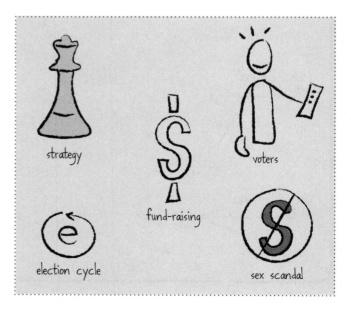

What just happened here? Well, one thing that happened is that you just effectively imagined and portrayed abstract concepts in doodle form. Another thing that happened is that the other participants unwittingly agreed to your symbolic language. They were watching you capture that information in real time, and they correctly associated the right images with the right words. You didn't even have to use clarifying language, or captions, in this case. Your doodles were clear enough. More importantly, think of the principle we just discussed. The participants in this session want the doodles to make sense. They don't want to experience dissonance in interpretation—they want a symbol that everyone can align around so they can keep the conversation moving. In this respect, they are on your side. If you had doodled a battleship for the word "strategy," they would have made it mean strategy. If you had chosen a shoe for the word "voter," they would have stretched to make the concepts line up. (Voters walk to the polls, got it.) Yes, there is a limit to how far people are willing to go to make your doodle believable—if you drew a refrigerator for "sex scandal," it's likely people would question it—but it will surprise you how much flexibility you have in visualizing concepts that seem extremely difficult to represent. To drive this notion more deeply into your mind, please play this next doodle game.

This game is a guaranteed good time.[18] You can play it alone or with a group, but it intensifies quickly with competition, which makes it more fun. Here's how the group version works: One person leading the game should select seven to ten random words. Give everyone something to doodle with; then put ten seconds on a stopwatch. (Reset the stopwatch for each round.) Tell the group they have ten seconds to doodle per round; then give them the first word. Watch them squirm, laugh, and scramble to visually represent it in the time frame. Ask them to pass their work to others so everyone can see the many ways to doodle one concept. Also, use a sequence of easy to hard words. Start with "necktie" and "pillow," and then move to "flirty" and "ambiguous." You'll hear people groan as the ideas get more abstract, but that's where the real lessons come in. Find a "winner" in the group, and give her a prize for best concept doodle. Repeat the process as necessary for learning and laughing. (I often throw in words that are suggestive, like "pervert," if I can tell that the group has a good sense of humor.)

DOODLE GAME: Graphic JAM

I hope you've learned from this section that the assignment of a doodle to a concept (and the assignment of a concept to a doodle) can be a very elastic process. An image of a coffee cup can mean a dozen things: awake, alert, morning, caffeine, drug, work, industry, agriculture, vacation, relaxation, aroma, habit, routine. More obviously, each of those words could be represented by a wide variety of doodles other than a coffee cup. A picture is worth a thousand words indeed, and now you know that a word is worth a thousand pictures, too.

DEVICE #4:

captions

Having eased your fear that you'll never be able to coherently depict abstractions, I'd like to offer you one more safety net: a caption. A caption is a snippet of explanatory text used to clarify an image, like the one shown below.

Grace remained skeptical about whether she wanted to get on the bus.

The director and author Errol Morris[19] said something interesting about captions that lends weight to the point about meaning I made above: "Without a caption, without a context, without some idea about what the picture is a picture of . . . I simply cannot talk about the photograph as being true or false. . . . A captionless photograph, stripped of all context, is virtually meaningless." Or, stated even more simply, "A picture unaccompanied by words may not mean anything at all."[20]

This, Revolutionaries, is part of why we are Infodoodlers. This is why we are people who use words + imagery and not just imagery or words alone. We neither need nor want an image to carry the full semantic weight of what we're trying to express, and we neither need nor want language to bear the full burden either. By adding captions, by even adding brief written context to an image, we can help to remove ambiguity—a function, you may recall, that's one of our primary goals.[21] And this function is partly why we're so useful. Infodoodlers know how to visualize content to leave an impression on the visual field of our audience's mind, but we also have words at our disposal. We have access to both worlds, and we know how to make them work together. Sharpening those skills lets us shine a brighter light on information making its way to the surface.

So how might a caption function in the Infodoodling world? You've seen them throughout the book so you know I use them to clarify and further explain doodles (and sometimes to amuse you). You'll use captions similarly in your work, and it'll come naturally to you. The urge to clarify, to avoid misunderstanding, is not at all unusual. Here's one use of captions that makes beginner Infodoodlers more comfortable about their attempts to depict something.

When you're becoming an expert Infodoodler, there will be many a moment when what you have doodled does not come out the way you'd hoped. You will have wanted to doodle a supply chain, and instead you drew Medusa's hair. You will have wanted your facial expression to show disappointment, and instead it will show bemusement. You'll draw a wombat, and it'll look like a honey badger.

wombat
(for now)

At times like these—and there will be times—simply acknowledge the imperfection to either yourself or the group . . . and then add a caption. No one will continue to wonder what, exactly, you were trying to show. They'll simply do what humans do best, which is to make meaning and sense of the word/image duo you've placed before them.

DEVICES #5 AND #6
C→O→N→N→E→C→T→O→R→S and S/E/P/A/R/A/T/O/R/S

So much of our knowledge is about relationships. In fact, the world is so intertwingled that it may very well be impossible for any piece of information to exist disconnected from everything else.[22] As much as we enjoy making sense of knowledge, perhaps it's worth considering that "the cross-connections among the myriad topics of this world simply cannot be divided up neatly."[23]

However compellingly this thinker has argued that we can't really make things hierarchical, categorizable, or sequential,[24] I've found that it is the *very act of trying* to do so that illuminates our understanding. This, dear reader, is an overly philosophical way of introducing you to your next two devices: connectors and separators.

To create a viable Infodoodle display, you will undoubtedly need connectors and separators. These devices at their most simplistic are lines that either establish a connection between bits of data or sever it. You see them in every mind-mapping software on the planet. You see them in org charts and infographics.

DOODLE GAME: captions among us

Most people understand intuitively how captions change our perception of an image or photograph. But there's no substitute for experiencing what shifts when we apply different captions to different images. This doodle game will help you absorb that idea by experiment.

Draw a square panel on a page, and inside of it quick-doodle a figure doing some activity: gardening, running, dancing, falling over, patting a child on the head. Include a street scene or landscape if you'd like. Then write one sentence below the panel describing what the person is doing and why. Fold the sentence underneath the page, and then show the sketch to people around you and ask them to verbalize the caption they would use. See if any of them get close to what you wrote. Consider how your perception of your own scene changes with the different interpretations you hear.

A variation on this game involves using a comic book or graphic novel. Pick a page and then cover the dialogue that's inside of speech or thought bubbles. (Cut or torn sticky notes work well for this.) Photocopy the page for as many people as you can get to participate. Ask them to rewrite the dialogue starting from scratch. It will become abundantly clear how much words and pictures need each other to really be clear to the viewer.

You see them in family trees and *Wired* diagrams. In some ways, connectors and separators are the DNA of diagrams and Infodoodles. They will almost always, at some point, be required to articulate any nuanced view or complex system. Luckily, they themselves are not complicated and they offer us a variety of different ways they can appear.

Connectors and separators can be thick or thin, dotted or dashed, gray or colorful, made of squiggles or squares. The connector or separator itself can even be visually coded to indicate the nature of the connection it confirms or denies. It can indicate the type of relationship, duration, strength, transaction, etc. These devices will come in very handy for you as you work because they are very often the "bones" of an underlying structure that you, and your team, need to be able to see.

DEVICE #7 FRAMES

Frames are supersimple devices that make your Infodoodling efforts almost effortless. They require no artistic talent to do their job, and they're exactly what you think they are—squares, circles, rectangles, clouds, speech bubbles, thought bubbles, and so forth. Frames are any visual form that encapsulates bits of information to distinguish that information from the surrounding content. If you so desired, you could produce a very sophisticated Infodoodle using exclusively words, frames, and connectors. These two devices together allow you to expose the individual components of a process or system, which would be a very saucy Infodoodle indeed. Some examples demonstrating the use of frames are featured below.

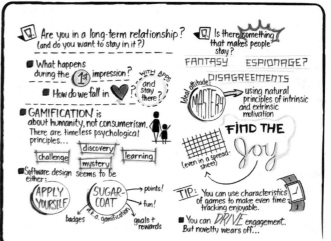

DEVICE #8

I never can quite embrace the violence of this term. Let's all blow gigantic holes in our pages! Let's blast our PowerPoint slides until they're begging for mercy! "Bullets" is an odd term to describe a harmless device that really only wants to help. But "bullets" it is, so let's discuss.

If you never learn to draw a face or figure, if you never learn to portray an object or scene, if you never learn word pictures or fonts and you loathe connectors with all your heart, please, for the love of clarity, use bullets.

We all know what they are and how they function. They are visual forms, usually circular, that peg language to a page. Bullets give us anchors for text. They keep the onslaught of words we see from floating off into space, and they tell our visual cortex that those lines of text we see aren't all just one big run-on sentence. Many worthy contributions are given to us by the bullet, *and* there's another great attribute they have that's worth mentioning.

Bullets can be almost any shape or image. They have lovely versatility for being such nondescript devices, and if you add color, shadows, or shading

to a bullet, why, you've just given your display more interest without any taxing effort. You've also possibly grounded the visual content with a *theme*, or you've visually associated the bullet with the brand of the company you may be working with. For example, if a group were working through a problem about a gourmet cat-food product, perhaps I'd choose a cat's paw for a bullet. Or, if I were partnering with a tech company like Square, I'd probably use its logo for a bullet since it so readily lends itself to one.

Compare the two items below. On the right you see a list without any bullets, and on the left you see a list with fully decked-out doodle bullets. Which one would you rather see on a whiteboard or in a slide deck? (I mean, if you *had* to see a slide deck full of bullets, which I do not approve of.) The answer is obvious. Generally speaking, our eyes gravitate to things that have more going on. Think of bullets as your friends. Your little underestimated, text-anchoring, Infodoodling companions.

DEVICES #9 AND #10

SHADOWS and **SHADING**

I know what you may be thinking. It's the same thing you were thinking when I used the word "typography." *This is not art or design school, so please don't subject me to understanding artistic techniques, including the depth and volume of objects.* Well, I won't. I myself have an underwhelming ability to flesh items out, so to speak, so I won't ask too much of you. It is important, however, that we call out shadows and shading as devices because, for those of you who are interested, they can add depth and intrigue to your work.

Quick question: What's the difference between shadows and shading?

Anyone?

Anyone?

Shadows are darkened areas caused by the obstruction of a direct light due to an object being in the light's way. Think of the shadow cast by a backlit attacker approaching you in an alley.

Actually, no. Don't think of that.

Think of the shadow cast by a giggling child running through a sprinkler at five o'clock on a Saturday.

There. That's better.

Shading is different from shadows in that it involves creating an illusion of depth ON the object itself. People use shading to visually suggest three-dimensionality by applying varying levels of darkness to different sides of an object.

The reason you would care about shadows and shading is that their virtues generate interest from your viewers, who are biologically primed for depth perception. While you needn't concern yourself with the seemingly infinite nuances of light, you can choose to employ a very basic approach to shadows and shading to make your Infodoodles look smashing. Below I've included examples of shadows and shading to show what I mean. You'll see there are many ways to show shadows and shading, and some are faster than others.[25]

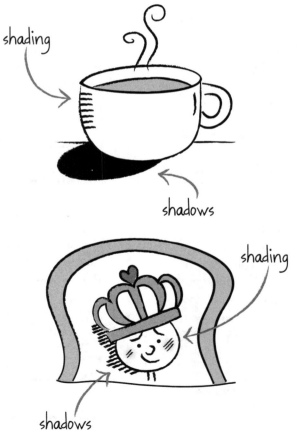

shading

shadows

shading

shadows

Of all the devices you've learned, consider shadows and shading the most expendable. Doodling pictures without depth still affords you a highly functional approach to problem solving, which is what Revolutionaries need the most. Much of our thinking work happens quickly anyway and doesn't require even a modicum of elaboration on depth. That said, you can develop your own quick-and-dirty methods of including shadows and shading, and you'll probably appreciate them later. The game of comparison below will help you practice how to quickly throw in some depth without any gnashing of your teeth.

DOODLE GAME: In the Shadows

For this game, I'll ask you to find a room that's slightly dark or a space that isn't filled with direct sunlight or illuminated by harsh overhead lights. Then find five objects and put them on a table in front of you—not in a row, just scattered about. (If you're not into the flower-and-fruit still life paintings of yore, pick tech devices or office supplies to play with. On a table, place a stapler, a cell phone, a laptop, a pen, and a coffee cup, or pick objects you think you may actually need to visualize in the coming weeks.) Then get a light source—a lighter, a flashlight, a lamp you can point, a penlight, or a candle. The goal is to first doodle the object without the light source. Two-dimensionally, flat as a pancake, appearing to be floating in space. Doodle that same 2-D version once more beside the original doodle so you have two versions that look the same. Next, move your light source toward the object and look at how the shadows and shades are affected. Use your pen to sketch the changes that you see onto one of the versions of the object. Compare the difference between the two doodled objects. Repeat this process with the next four objects but try different shadow types on them. Try shadows and shading with dark blobs, hatch marks, dots, or short lines. Consider how the shadows and shading influence your desire to view the objects; then decide if you think this device is valuable to you or if you can live without it. If it's valuable, pay attention to shadows and shading when you're wandering around life. Eventually, it will change the way you see and the way you doodle, long term.

You may have noticed that I mentioned that there are twelve devices. In this chapter I cover only ten of them because two of them you already know: faces and figures. Faces and figures were included in the Doodle University chapter because I consider them to be fundamental to the basic Doodle, whereas the remaining ten devices lean toward the erudition of the mighty Infodoodle. What this means is that you now have been exposed to every possible tool you'll need to express yourself visually sans artistic talent. This is a milestone for Infodoodlers! A real turning point toward better thinking. Serious congratulations are in order.

If you need a cheat sheet for remembering the twelve visual devices now at your disposal, dog-ear this page. At this point in the book, you've learned them all, but you may need a tickler when you're in the moment.

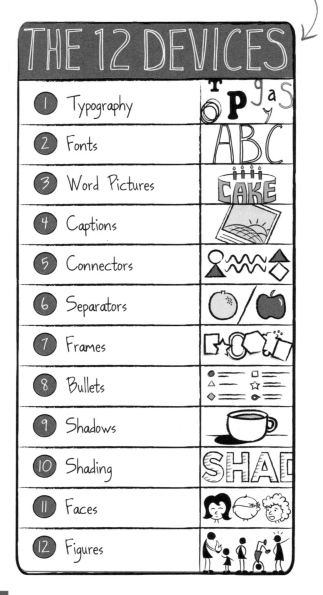

THE 12 DEVICES

1. Typography
2. Fonts
3. Word Pictures
4. Captions
5. Connectors
6. Separators
7. Frames
8. Bullets
9. Shadows
10. Shading
11. Faces
12. Figures

Before we tie a bow around the devices section, there's one more topic with respect to visual language I'd be remiss to exclude. I'm purposefully not categorizing this topic as a "device" because, while it's present in many an Infodoodle, it's not essential to creating one. Still, I know there are many people who'll feel they were left adrift if this topic isn't acknowledged, so the next interlude is for them.

COLOR

There's something very vital you need to know about color as it relates to the Infodoodle: Mastery of or even budding knowledge of color is nonessential for creating one. A monochrome visual display is perfectly, unequivocally acceptable. For some of you it sounds horrific—a world in black and white!—but it's true. Infodoodlers can and do produce quite effective Infodoodles relying on only one color.[26] See here.

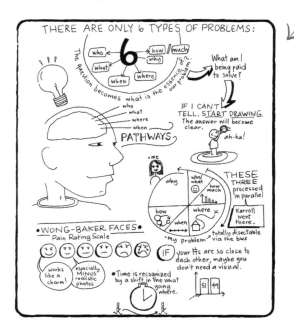

There are two other significant points about color that you should know because they affect my advocacy of color as it relates to visual displays.

First, people in most business settings have a limited color palette available to them. It usually includes black, blue, red, and the glaring neon of highlighters. For that reason it's not very pragmatic of me to go prattling on about color to people who don't have art supplies in their office buildings (and who don't necessarily want them). Students and teachers aren't always flush with colorful supplies either. We work with what we have available.

Second, concentrating on the use of color in displays in which *the content and structure* is virtually always more important can lead an Infodoodler astray. Color is such a compelling and moving tool that people get lost in it, and we need people to focus more on the information at hand and on what that information is doing.[27] I love color, and I swoon over the inks of my calligraphy pens, and even though I know color to be incredibly useful for conveying emphasis and meaning (and please, explore those dimensions!), I'm not fixated on color as a tool for better thinking. Call me crazy.

Having betrayed color like some kind of Brutus, I would still like to offer three basic guidelines so you don't go careening off a cliff in despair. Obviously, many of you intend to use color in your Infodoodles, and depending on which technique you're immersed in—Personal, Performance, or Group—you'll have varying levels of interest in the topic. To reach the largest number of the color-curious with the most relevant information, I'm including three universal best practices, commandments really, that'll come in handy in *all* of the categories. And that will be all I have to say about color.

THE THREE COLOR COMMANDMENTS
(for use in all three Infodoodling categories)

1. **Light colors like yellow and orange stink for displaying text.** The viewer has to squint to see them, and they have a dizzying effect due to their lack of high contrast. Use orange and yellow to brighten up or emphasize certain areas of your Infodoodle, but please, use them sparingly, if ever, to write phrases or sentences. A couple of exceptions to this rule are (a) if you're writing a word notably large, say four inches or more, and you're planning to put drop shadows behind it, or (b) if you don't actually want anyone to see what you're writing. If either of these are the case, then yellow and orange are acceptable.

2. **Dark colors are ideal for writing text.** The reason for this is the opposite of the first rule—high contrast makes for better visibility.

3. **Outlines for shapes and images should be in the darker-color range.** Outlines usually look best in dark gray, blue, purple, or black (brown could be used but it looks iffy), and they tend not to look thrilling at all in red, orange, or green (don't even consider yellow).

Beyond those tidbits, I'd rather not spend any more of your time on color. There are so many impressive books on the topic that it seems narcissistic to try and encapsulate it, especially since it's not central to the Revolution. If you love color, by all means go forth and explore its wonder and whimsy.[28] Colorize your work to your heart's content. Demand that your company leaders give you Sharpies of every hue. But don't lose focus on what matters: content, accuracy, and visual structure. *Those* are the nitty grits of the Infodoodle, and they need your attention more than anything.

A QUICK VIEW FROM THE SIDE OF THE ROAD

You've taken in a lot of information since we began, so let's pause and regroup. You may be wondering where we go from here. Your game bar should show that you've made impressive progress on the journey to the Infodoodle, having covered the basic Doodle, handwriting, spelling, myths on visual language and art, the 12 Devices, and color. You've learned about and played around with every component of visual language that you'll need to show any mental model you want. You already have your soldier's uniform halfway on, and it isn't even high noon. Ten-hut, brothers and sisters!

To prepare you mentally for the next major stop on this journey, I want you to know what the following section will be dedicated to. It requires your rapt attention. You are leaving the shallow end of the pool, people, and you'll need to trust me and discard your orange arm floaties.

The next section will involve an exploration of the *structures of visual information.* You folks couched safely in the warmth of words and numbers may be freaked right now. *The structures of visual information?* Do not speaketh Greeketh to me!

Tranquílate. See below. A visual drink of water to cool your cerebral sweat. Here are three examples of what I mean by a "visual structure."

Many people would call these diagrams. Others would call them charts, graphs, maps, blueprints, or perhaps infographics. Call them what you will. I'm using the phrase "visual structures" to encompass the lot of them. Few people will chastise you for using the other terms interchangeably. Since you're now armed with the foundations of visual language, you're *so very close* to walking confidently through visual structures. Yay for you! They're one of the best parts of this work. They will blow you and your organization's minds. That's why there's a whole section dedicated to playing with their possibilities. And that's why Chapter 5 is dedicated to playing with them inside of problem-solving group work.

Before that section can unfold—I thought you could use a little teaser—there remains one stop that's pivotal for you to successively evolve in this work. That stop involves tackling the "Info" in Infodoodle.

We must keep our eyes trained on one of the Revolution's core values, which is that the "Info" and the "Doodle" are of equal import. The "Info" and the "Doodle" go together like shoo-bop-shoo-wadda-wadda-yippity-boom-de-boom. And we Revolutionaries are ambidextrous, so we master *both* of these domains. We take neither of them for granted. The domain of information is a wild and unruly beast—you know we all swim in a downpour of content. So before we apply visual structures, that content beastie must be wrestled to the ground. Information must be crafted, distilled, and disciplined by your razor-sharp wit. Ladies and gentlemen, for the next few pages, I ask you to focus your mental laser beam on taming information, so that when you waltz into Chapter 5, you'll look like you own the place.

INFODOODLING: THE ART OF SUBTRACTION

In this section, our full focus is on taming information. But I want you to have a panoramic view of where that ability—powerful in and of itself—will ultimately lead you. There are more abilities to develop after we learn to tame data, and the arc of learning the most sophisticated form of Infodoodling looks like this:[29]

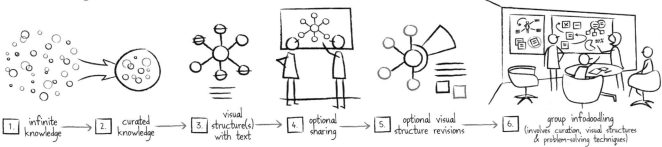

1. infinite knowledge → 2. curated knowledge → 3. visual structure(s) with text → 4. optional sharing → 5. optional visual structure revisions → 6. group infodoodling (involves curation, visual structures & problem-solving techniques)

To proceed along this learning arc, we'll start at steps 1 and 2. I'd like you to understand why an ability to own the "Info" in Infodoodle is of fundamental, critical, crazy-ass importance.

A THOUGHT EXPERIMENT

In the spirit of Einstein and Tesla, let's conduct a thought experiment. In case you're unclear, a thought experiment is the consideration of a scenario or hypothesis for the purpose of thinking through its consequences. It's a "what if" or an "I wonder" exploration, and the thinker follows the experiment through to hypothetical conclusion(s). That's what we'll do together now.

The Infodoodler's Thought Experiment

Consider the idea of a universe of knowledge. Imagine that universe is composed of infinite tiny bits of information, all floating around in a vast, formless intellectual ether. Imagine that this field of knowledge exists whether we see it or not and whether we understand it or not. In this thought experiment we're conducting, knowledge is like air. It is everywhere. It

CONDITION #1 OF THE KNOWLEDGE UNIVERSE: bits of information in the vast formlessness

just *is*. It just *be*. This vast formlessness is the first condition of the knowledge universe. Below is an image of how it might appear.

THE UNIVERSE OF KNOWLEDGE

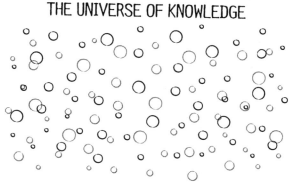

CONDITION #2 OF THE KNOWLEDGE UNIVERSE:
disparate access and different perspectives

The second condition of the knowledge universe is one that arises when individuals enter the system. It involves limitations on access to knowledge and different interpretations of that knowledge. Imagine that some of the knowledge in our hypothetical universe is shared among individuals. Some pieces of knowing are accessible by multiple people who've had a similar experience or who've been exposed to similar narratives or sets of data. You write kanji. I write kanji. Cool. But imagine also that much of that knowledge is individualized. It is only available to a single person, and it's filtered through the lens of that particular person's mental models. We all know that models of the world start forming very early through a complex interplay of experiences, beliefs, culture, education, and personality. This means that it can be a sizable challenge to have access to other people's base of knowledge or to share an interpretation of that knowledge. This is the second

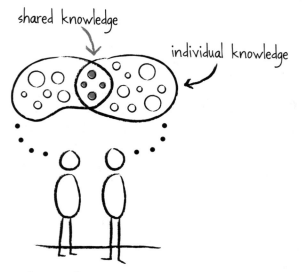

shared knowledge

individual knowledge

CONDITION #3 OF THE KNOWLEDGE UNIVERSE:
limited individual knowledge

condition of the knowledge universe: disparate access and different lenses. The consequence of this condition is that, despite our best intentions, we often find it difficult to really see and understand what others see. (You empathize with Voldemort? What is *wrong* with you?!)

There is a third condition of the knowledge universe. Consider the possibility that, while there is a vast body of knowledge available to any

one person, there is also a limit to the knowledge that any one person has. In other words, there will forever and always be a lot of things I personally do not know. No matter how informed I think I am, I will always have abbreviated awareness simply because I am only one person. This is our finite knowledge base, and it is one we'll need tools to purposefully expand.

My view of the world. It's eensy-weensy, really.

Based on this brief thought experiment, you and I can surmise that the conditions in the knowledge universe pose inherent challenges for Infodoodlers. If we are ultimately embracing this work in order to light up our minds and to better know, see, and sometimes save the world,[30] we'll need techniques to address these challenges. We're going to need to tell these challenges who's boss.

CHALLENGE #1: Curation

The first condition of the knowledge universe throws down a mean gauntlet: the challenge of grappling intelligently with the immense amount of information we're faced with at any moment. It's a gigantic knowledge universe, and there are many times we'll need to tame it. If we're cloistered in a classroom or boardroom and a flood of content is coming our way, Infodoodlers need to develop a keen sense of confidence in selecting what matters and discarding everything else. I refer to this process alternately as curation or subtraction since they're two sides of the same coin. When we curate, we invite bits of information into our sphere of knowledge. When we subtract, we exclude information from our sphere of knowledge. They're both active processes, inspired by the vastness of the knowledge universe and made possible by the Infodoodle.

Whichever term you prefer, what's happening in this process is that information is purposefully being bottlenecked. Infodoodlers can neither write nor draw at warp speed, nor do we attempt to memorize extensive volumes of text or talk. To try is a suck of cognitive energy and comparable in silliness to climbing Everest without supplemental oxygen. Infodoodlers subtract. We subtract with pleasure, determination, and skill. This is partly why we're remarkable learners—because we know how to select good content (*very* quickly in Performance Infodoodling) and use it as the foundation of what we visualize. Infodoodlers remove excess masterfully in non-live work, and we do it as best we can during live experiences. We target the information that's relevant to the topic and—this is important—related to our goal. *Knowing our goal* is paramount, because

when we subtract specific to a goal, we're in a much better position to layer the information we've selected onto a visual structure. Steps 3 to 5, involving visual structures, are further along the learning arc you saw at the opening. You'll explore them in depth in the sections to come, so pace yourself.

While steps 1 and 2 present Infodoodlers with an ongoing challenge, they are surmountable every time. We'll tackle those skills in the remainder of this chapter. But first, let's acknowledge two remaining challenges that roar from the great universe of knowledge. You need to see them coming and know they'll be no match for you. This will keep you motivated to walk down the path toward benevolent, cognitive Revolution.

CHALLENGE #2:
Seeing and Displaying Realities

The second challenge posed by the knowledge universe really involves being able to see—in our mind's eye and in doodle form—the components of our own reality as well as the cogs of others' realities. Remember this image? What someone is thinking and the approach, position, or idea that someone is arguing for can often elude even the thinker herself because she can't

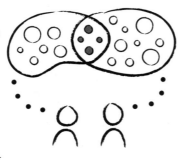

see the entirety of her reality. Until that reality is visualized, it is often transparent even to the keeper of that reality.

Put another person in the equation and you can see the train wreck coming, again and again. Due to the sometimes vast differences in knowledge and perspectives that occur among individuals, the picture suggests this fundamental and often painful quirk in the system: It can take a ridiculously mighty effort to share a vision. In other words, to get to this happy place:

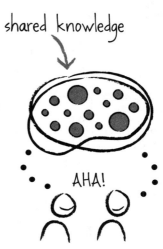

shared knowledge

AHA!

We've all been through the struggle of trying to get anywhere close to being on the same page with another person. Two people may share four data points in their knowledge subsets, but there are myriad other points on which they don't see eye to eye. And without an Infodoodle, without a way to make mental models explicit and visual, sometimes we don't even know we're not seeing the same thing. Consequently, we're not even *on the trail* to getting an aha! Instead, we keep falling back on language, rehashing tired, cyclical conversations, waiting for the words to illuminate us. But something has to give. Sticky problems require more than just a few shared data points to be solved, and problem solvers need much more knowledge overlap in order to work together. They also need white space and training to doodle the pieces of the problem so they can finally be seen.

When you start to consider the broad variations in knowledge among individuals, this need to share and visualize content becomes almost urgent. How

can we effectively understand and solve problems without at least a temporarily shared reality?! How can we make progress without collective understanding? Since we all have such a teeny-tiny sliver of the massive knowledge universe, we should consider ourselves lucky to find *any* perceptions of the world that are truly shared.

For this reason, Infodoodlers must be able to see realities. We must be able to pull the knowledge universe toward us and give it a visual form. We must extract digestible spheres of information and bring them to Planet Earth.

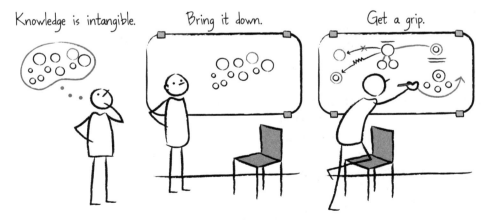

This is one of the many reasons that being able to Infodoodle is like having a superpower. Infodoodles give knowledge a visible shape that brings it to life before everyone's eyes. They provide a more tangible grip on realities that might otherwise be too abstract or too nebulous to wrap our minds around. I'd say this is pretty

significant, like shooting spiderwebs from your hands, since with our newfound visual handles we can share, shape, tweak, and transform knowledge. We can comb out the intellectual and creative tangles of the universe! Top that, Spider-Man!

Seeing obscure realities is the second challenge of the universe of knowledge. It is also its huge opportunity. Your ability to begin the process of visualization so you can start to know and share realities has been ignited in previous pages. The flames will be fanned in the next section, when we explore visual structures in depth. So get your marker tips ready. We'll be there before you can say "*Viva la Revolución!*"

CHALLENGE #3:
Expanding Realities

The third challenge of the knowledge universe, one we address in the grand finale on Group Infodoodling, is that there is an inherent limitation when it comes to one person's intellectual viewfinder. The vast majority of us have a golf-ball-sized lens through which we look—you might even say "tunnel vision"—so it's derivatively true that we're missing out on different and bigger pictures. This can be a significant problem if you're seeking to innovate, create, or make new. It can also be a problem if your organization is trying to compete in the knowledge economy, because competition usually requires going out on a limb. (Or, as my friend the cartoonist Hugh MacLeod would say it, it requires putting your balls on the line.) But humans tend to revisit the same neurological pathways we know and are comfortable with. Most of us default to staying within our safety zones.[31] You've

attended so-called brainstorming meetings; you know what I'm talking about. To really stretch our creative and intellectual boundaries, to really push what's possible and what's available, we need techniques that are *designed* to stir us up, to shake our bits of knowledge around like the flakes in a snow globe.

As many scientists who study creativity and insight will tell you, a solution to a problem very likely already exists either in your mind or in the collective mind of a group. It's mostly just a matter of having the right inputs in place and getting the best-suited neurons to connect and crackle at the same time. This is what the Group Infodoodle does with great panache. It gives us a purposeful method of expanding and shifting our realities by using thinking games coupled with visual language. This technique is the powerful culmination of all the abilities you've been building along the way.

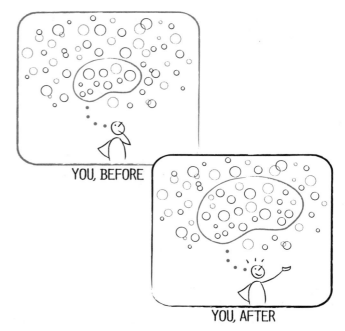

YOU, BEFORE

YOU, AFTER

THE GROUP INFODOODLE WILL SAVE US.

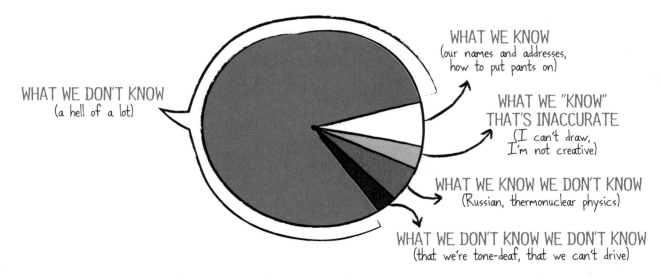

WHAT WE DON'T KNOW
(a hell of a lot)

WHAT WE KNOW
(our names and addresses,
how to put pants on)

WHAT WE "KNOW"
THAT'S INACCURATE
(I can't draw,
I'm not creative)

WHAT WE KNOW WE DON'T KNOW
(Russian, thermonuclear physics)

WHAT WE DON'T KNOW WE DON'T KNOW
(that we're tone-deaf, that we can't drive)

Let's take a second to review. What you have in front of you are three powerful skills: curating, seeing and displaying reality, and then expanding it. These skills are the hot core of the Infodoodle. The first unfolds in the rest of this section, the latter two in the remaining chapters. Let's not waste any more time. Let's get our hands dirty learning how to curate and subtract. In your order of operations, this is the gateway.

YOU ARE HERE.

1. infinite knowledge → 2. curated knowledge → 3. → 4. → 5. → 6.

THE ART OF CURATION
Words Are Relentless, but They Can Be Slowed.

Before Infodoodlers really explore visual structures and group visual-thinking work, there are two principles about information you need to understand. At first glance, they may feel slightly cerebral, but they're principles you'll want to know because they come with the territory of the Infodoodle. So take a moment to breathe, shake it off, and clear your head. (For the kinesthetics, now's the time to stand and get a cup of coffee. Maybe do a cartwheel.) You're about to start mastering the Info in Infodoodle.

PRINCIPLE №1: In (almost all) Infodoodling, words come first.

To turn you on to the first principle, I offer this visual explanation of its premise.

As we learned earlier, without a caption, it's not 100 percent evident what this visual—or any visual—is trying to say. So let me verbalize it. The image above says that *in this work* content precedes visual structure. Or, a different caption: Information drives both imagery and diagrams, rarely the other way around.[32]

Stated full throttle, this means that the large majority of images and diagrams in the world are virtually meaningless in Infodoodle territory without an ability to first gather and distill content. All the info-castles are made of sand if you don't know the coins from the flotsam on the beach. In this field, the parsing of information is essential, and this parsing takes place *prior to* the construction of the castle. It is rare to build a coherent Infodoodle without respecting the notion that verbal content usually comes first.

Now take a moment to ponder why this might be true. With respect to the Infodoodle, why am I suggesting that words (or numbers) need to pave the way for a words+images fusion? If you are in the dark, I will leave you there no longer. Let's examine this assertion.

A major reason why language must precede images in order to design an Infodoodle is that words are the primary channel through which we communicate at school and at work. This is obvious. Your boss doesn't speak in pictures to get her point across. Neither does your professor stand in the front of the room holding a string of photos in the hopes that you understand. (Okay, this *might* happen in art history.) Point being: Humans speak and write in words. In almost every environment in which you will produce an Infodoodle, the process will be instigated by language. This means that 99 percent of the time language will provide the skeleton of your Infodoodle. As you know by now, someone relying on *images alone* will struggle greatly to illuminate a complex topic.

A quote from Jef Raskin, an HCI[33] expert known for starting Apple's Macintosh project, always puts a grin on my face. Raskin understood the challenges of images without words and was resistant to Apple's use of an interface that relied on icons rather than text commands—a graphical user interface, also known as a GUI. He expressed his distaste by saying, "An icon is a symbol equally incomprehensible in all human languages. There's a reason why humans invented phonetic languages."[34] Indeed.

Now please don't take this as a declaration that images should never be a catalyst for words. I'd be remiss to suggest that, and there are many times in which the words-come-first principle can be thwarted and images are powerfully used to spark linguistic thought. Three examples:

- Studying anatomy so surgical students know where and what to chop first

- Learning a subway system so someone can find her way around

- Using celestial navigation at sea (most cultures are losing this technique but still, some retain it)

You may grok that the circumstances in which visuals precede language are those in which the subject matter is visual by nature, meaning that it first appears in the world in a visual form. There are sundry other situations where visuals precede imagery, and it's true that this reversal can sometimes better serve a person's goals.[35] I'm *not* suggesting that it's impossible for images to inspire words. What I *am* saying is that the big bulk of the time when WE are working to build an Infodoodle, we'll be operating in an environment that starts with words. So we'll need the *foundational language* on which to make that Infodoodle meaningful and specific—whether it comes from a speaker, a document, a book, or our own thoughts. In our context, trying to apply an images-come-first principle would be akin to sending a coworker a doodle and asking him to write a memo accurately reflecting your thinking. That is bass-ackward for the Revolution because we're not conducting creative writing experiments. So tattoo this on your elbow: In the Infodoodle business, words (almost always) come first.

PRINCIPLE №2: In Infodoodling, we subtract.

Revolutionaries have the explicit aim of simplifying and clarifying information and then visualizing it so that the message can be stripped of the weight of excess babble and seen for what it's really saying. Because of the high density of information we all deal with . . .

THE ART OF SUBTRACTION IS ESSENTIAL.

This skill of subtraction, mind you, is not about the *visual* language work of the Infodoodle. It is the indispensable underbelly—the language work. Being able to appropriately subtract that which is extraneous, to remove the words that cloud our thinking and our retention, this is THE SKILL that ultimately gives us a clear view, bringing the world into vivid, visual focus. You are going to manhandle this skill like Chuck Norris manhandles bad guys. And you should know that there are two ways to go about it.

2 CHANNELS OF SUBTRACTION : AUDITORY VS. READING/WRITING

There are two channels through which we have an opportunity to practice subtraction: the auditory channel and the reading/writing channel. You need to be aware of these distinct channels because of the three subtypes of the Infodoodle. Only "off-air" Personal Infodoodling lends itself to subtraction of the reading/writing persuasion. All other Infodoodling—Performance, Group, and live Personal Infodoodling—requires auditory subtraction.

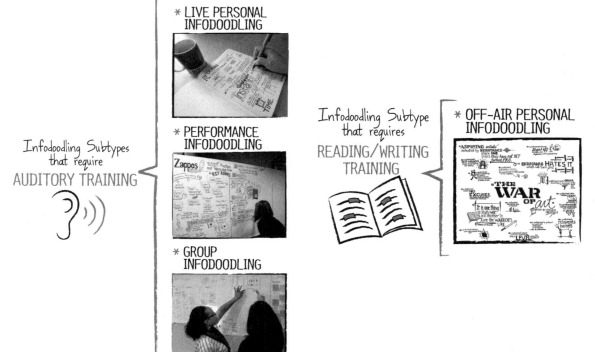

* LIVE PERSONAL INFODOODLING

* PERFORMANCE INFODOODLING

* GROUP INFODOODLING

Infodoodling Subtypes that require
AUDITORY TRAINING

Infodoodling Subtype that requires
READING/WRITING TRAINING

* OFF-AIR PERSONAL INFODOODLING

PAUSE. GUT CHECK.

Before we determine which channel is best for you to train in, a pause is in order. You'll need to do a gut check and consider which channel you think will require more of your attention and commitment—auditory, reading/writing, or both? If you aspire toward Performance, Group, or live Personal Infodoodling, you'll need to focus on training your auditory channel. The world is full of chatter, and it behooves you enormously to craft your listening skill.

If, however, you prefer to focus on off-air Personal Infodoodling, you have that option in front of you. If you work best at your own pace, you still can *choose* to excel at the auditory channel—which will come in handy when you're in a class, a meeting, or a conference taking notes—but you can also work on your own and in quiet, subtracting text from a book or a research paper or crafting words from your own mental models and Infodoodling based on that.

Training yourself in either channel is a respectable (and necessary) endeavor, so I applaud you whichever route you choose. I'd like to start the learning process with the Auditory channel, however, for two reasons: (1) More of the subtypes require that kind of training, and (2) significantly more of us struggle with this aspect of the work. You may recall that in the first chapter, I asserted that doodling done really well integrates the auditory channel and therefore enhances information intake and processing. I stand by this assertion, but here's the rub: We won't get the cognitive benefit without the work. We have to *train* the Doodle to integrate verbal language. This is one of the biggest missing links in pursuit of expert doodling: Most of us flop about like drunken eels when it comes to allying what we doodle with something that's being said.

Bad idea

Because the relationship between listening and doodling seems to be strained the world over, the next section is about learning to *purposefully relate* our visual work to the auditory content we're experiencing. It sounds challenging, but I ask you this: What is more challenging than what you're already doing? Perhaps putting a sweater on a horse.

What follows is everything you need to know about cultivating an auditory technique to produce a truly high-performance Infodoodle.

THIS IS A BOOK ABOUT DOODLING. I'M ANNOYED THAT YOU WANT TO TRAIN ME TO LISTEN. WHY?

It can be a feat of unusual size to get people to understand why listening is so important with respect to the Infodoodle (and, really, with respect to all of life). But listening is *so* important that it should have been inscribed as the 11th Commandment on Moses's tablets: Thou Shalt Listen.

Despite listening's significance—an idea you'll grasp very soon—this much is also true: There is no on-switch for becoming an impressive listener. To listen is a conscious decision that an Infodoodler makes, and it takes commitment and practice. It's like any other pursuit worth pursuing—over time, with practice, you start to develop "muscles," and you then strengthen those muscles on purpose.[36] The good news is, you'll be rewarded for learning to listen, and there are many reasons why we strive to excel at it. Those reasons are these:

THE ODDS ARE AGAINST HUMANS EVER WRITING AS FAST AS WE TALK.

Unless we develop a mutant gene for rapid writing, normal people cannot capture in written words the entirety of what someone is saying while she is saying it—not even close.[37] The recommended word-per-minute rate for audiobooks is 160 max, and the average human hand writes at 31 words per minute. Two minutes into a presentation or lecture, and we're all screwed. There's no playing catch-up in the listening game.

To further complicate matters, humans also have a very limited bandwidth of information storage relative to release.[38] In other words, even if I aspired to write down everything someone was saying, I couldn't store his content long enough for it to eventually seep out of my pen. Given these two realities, Infodoodlers *must* have techniques to compensate for the fact that we can't compete in

This is why students almost unanimously despise taking notes.

the standard note-taking game. We'll get creamed, guaranteed, every time.

To master the Infodoodle subtypes tied to the auditory channel, there's no getting around elevating the quality of your listening. It is fundamental to the process. And it's a blessing in disguise. Why? Because getting good at listening increases our comprehension. It also increases the quality of our experience and our questions. Here's how.

Good listeners have developed the ability to momentarily suspend (or at least quiet down) their internal thoughts in order to pay attention. Consequently, they tend to pick up on information that other people miss entirely. This can include more subtle signals like body language and underlying tone, yes, but it also encompasses the subject matter itself. Most people struggle to even absorb the surface content because their minds are sending so many competing signals simultaneously that they don't allow someone else's signal to come through.

When we learn to soften, even temporarily, our internal chatter, we gain repeat opportunities for a *much* richer and deeper learning experience. So we take that first step, which involves simply making the decision to hear what someone's saying, and then we take that second step, which involves practicing calming our inclination to critique, judge, make counterarguments, be overly emotional, or otherwise interrupt with personal thoughts and reactions.[39] In this way, we set ourselves up for a significantly fuller learning experience. We become available to hear; then we become available to remember (since Infodoodlers stitch verbal information with visual information and intensify its depth); then we become available to respond intelligently. After someone else's speaking session is over, we have raised the caliber of our questions by being capable of listening.

Now, it should be said that being adept at listening doesn't mean we believe everything someone says. Turning off your mind chatter doesn't make you a thoughtless drone. It simply means that you're in a better position to learn, to remember, and to respond credibly because of the depth and purity of your attention. I'm not saying this is easy; I'm saying it's doable and out-of-the-park valuable. All of the benefits you receive from learning to listen are more than worth the tiny decision it takes to start practicing. But if you're not yet convinced, here's one last reason to bother learning. It feels kind of woo-woo, so stay with me. I'm on your team.

LISTENING IS A PRICELESS GIFT YOU GIVE TO OTHERS, AND TO YOURSELF.

For social creatures like us, to go ignored or unheard is akin to not existing at all. It's like being dismissed from the world. It SUCKS. So listening intently to someone is one of the most generous things you can offer, and it's virtually free! It costs you nothing but energy. Try giving someone your full listening capacity, and watch the practice literally transform your interaction (especially if that someone is accustomed to your predictable vocal contributions). Now, I know I tend toward hyperbole, but I don't make reckless promises, and I promise you that if you minimize the movements of your own piehole and simply listen to someone else, she will walk away with a lift in her step. Being heard without bias or opinion changes people's lives. This is one reason that people pay therapists so much—so they can have access to at least one person on the planet who pays attention without discernible judgment or opinions. Such a treat it is. And don't think you're doing only the speaker a favor when you pay close attention; you're also doing yourself a major one-up since, as you discovered earlier, your awareness and comprehension almost always simultaneously increase.

Those are the reasons why part of the Revolution involves cultivating listening. Now let's discover how you do it.

OPTIMIZING THE SPOKEN WORD: CUTTING THROUGH THE CLUTTER IN A SPEECH

Perhaps you've heard the folksy wisdom that an audience remembers only 10 to 20 percent of what someone says?[40] This popular trivia could explain why even Confucius—no slouch among men—insisted that what he heard he forgot.[41] Word on the street is that people neither focus on nor retain the actual words coming from someone's mouth. Instead we home in

on and are sensitive to the emotional content underlying the language, a.k.a. the tone. We focus more on *how* people say what they're saying rather than the content of their conversation.

This indicates a rather efficient and intelligent behavior on our parts. Frankly, about 90 percent of what people say *is* extraneous, and the Tootsie tends to be surrounded by a lot of Pop.[42] So developing a keen ability to distinguish between the two is an incredibly worthwhile practice. This is a lesson I learned from experience, mind you, not from some inborn female intuition.

Lucky for you (wink!), I've boiled down techniques for listening to a few digestible best practices. After you take them in and start working with them, I hope they'll give you relief from trying to absorb the flood from the Tower of Babel, because what you'll learn is that there are specific items you can listen *for*, and there are ways to adjust *what* you're listening for based on the context of a conversation. Let me explain.

relevant content

extraneous content

IN LISTENING, CONTEXT IS HALF THE BATTLE

As an Infodoodler, you'll very likely find yourself in three situations: at school, in a meeting, or at a conference. You probably won't be trying to capture information in a wind tunnel, nor will you be listening to dolphins underwater. Given the realities in which you'll be practicing, you may be comforted to learn that a major leap forward involves understanding that *context* is half of the listening battle. If you just know what you're going into, you can start to prime your auditory focus toward what will matter. Infodoodlers who are serious about their work anticipate the context and the content to give themselves a head start.[43] If you're a student, this means reading your assigned chapters.[44] If you're at a conference, this means getting a sense of what the theme and speakers are all about. And to make this idea relevant in your work life, chew on this for a second.

No matter what it may feel like, there is actually not an infinite number of types of meetings. At the risk of offending attendees of balloon-animal gatherings and Star Trek conventions, I'd like to suggest that there are about six major meeting types conducted around the world.[45] They are the following:

1. **Planning Meetings**
 (e.g., project kickoff/launch)

2. **Problem-Solving Meetings**
 (e.g., ideation/innovation)

3. **Decision-Making Meetings**
 (e.g., new hire, budget allocation)

4. **Feed-Forward Meetings**[46]
 (e.g., context-setting/state-of-the-organization, status/project updates, research presentations)

5. Feedback Meetings
 (e.g., 360s, performance reviews)

6. Combination Meetings
 (e.g., leadership off-sites, BarCamps, board
 retreats, strategic planning)[47]

The good news for beginner listeners is that these types of meetings each have only a few variables of interest to the meeting participants and they're fairly predictable, barring those truly horrifying meetings where no one knows what's happening or why they're there.[48]

If you know you're about to attend one of these types of meetings, you can prime your listening before the meeting starts simply by reminding yourself of the purpose of the meeting. The incredibly simple and quick step of acknowledging why you're going and what the meeting is about can help you be more present during the session. Just take ten seconds before a meeting to center on its purpose and remind yourself of the context. For example, if you're going to a planning meeting about a project, you know you need to listen for scope, timeline, and probably roles and responsibilities. If you're going to a performance review, you're listening for strengths and opportunities (you're also sniffing out two parts per billion around the plausibility of being laid off). You've been around the meeting block—I don't need to elaborate further. Context is half of the listening battle, so make a choice to become aware of it before you enter a room. Set the mental stage for your own success.

INTO THE MEETING ABYSS

Now you're IN the meeting (or classroom), so now you need to deploy real listening techniques to tune out the drivel. (That's right, I said "drivel." Listen: My team and I have worked in meeting cultures around the world. Very few organizations have a grip on when or why to have a meeting, nor do people know how to run them properly. This is a universal meeting illness, and it's as common as a cold.) You need to have listening techniques available to you because lasering in on the appropriate verbal content allows you to conserve cognitive energy, which is in short supply until you eat or sleep again. Learn to dole out attention to only those points that directly relate to the purpose of the conversation. And, like initiating any "sport," give yourself time to warm up.[49] That way, you avoid wasting either time or energy, chasing the wrong rabbits and getting more distracted by the minute.

14 TIPS FOR DOODLING AUDITORY CONTENT IN REAL TIME

TIP №1: When you commit to excelling at listening, first practice with your eyes closed and with content you enjoy.

Closing your eyes to listen is an excellent opening technique for graduated learning. Our visual sense is so dominant that when our eyes are open, much of our attention is distributed immediately to what we see. When you're starting out, if you're serious about learning to listen, choose content you're interested in to decrease any initial resistance to listening you may have. Then press play, close your eyes, lie there, and pay attention. Let your mind slow down, and start to notice the cadence of the speaker's voice. Notice the nuances in tone, where she escalates and where she slows. Listen for the messages, the evidence. Observe your own reactions to what you're hearing. Feel how active or contrary your inner voice may be. Eventually, you can become a master of the listening

skill. You can certainly become good enough to enhance your learning experience; I promise you that. Skillful listening is the work of Jedis, and there's not one among us who doesn't have Jedi on the inside.

TIP №2: Recognize that listening requires P-R-A-C-T-I-C-E, and don't expect your skills to transform discernibly overnight.

Rome wasn't built in a day, and Bruce Lee's one-inch punch didn't appear overnight. Really great skills require and deserve careful attention. So try not to rush the process of learning to listen—you will have opportunities to practice for the rest of your life. Words are everywhere; give yourself time.

TIP №3: Stop what you're thinking and listen.

To be an exceptional listener, you'll need to cultivate an ability to suspend your own frame of reference. Focus externally. Turn down your ego and your inner voices. Turn toward another person's experience. Give the stage in your head to someone else.[50] Try this, and when you fail, keep trying. We've discussed the benefits that exist for you when you do.

TIP №4: Prioritize what you're capturing. Listen for "the bones."

Remember when we learned that much of conversation is extraneous? Your goal is to listen for what I call "the bones." Listen for the key points and the supporting evidence that hold a speaker's message together. You won't be tested on the names of the speaker's family members and their favorite breakfast cereal; you're listening for what matters. Qualifying statements like "you don't want to miss this" can give you a hint that something relevant

is coming. Learning to find the bones will save you serious time and effort. Think of it as X-ray listening.

TIP №5: Pay attention to the narrative build.

Presenters or teachers often begin their presentations by stating what they're going to take you through. They'll say, "First I'm going to go over some facts. Then I'm going to describe the value. Then I'll give you tips." This means you can know literally where you are in a presentation—the beginning, middle, or end—and that helps you anticipate pacing and spacing.

TIP №6: Use telegraphic sentences or phrases.

When someone says, "Today I'm going to discuss five important initiatives that will lead our company to success," just write, "5 Initiatives to Success." Sometimes you can use just one word and in this case that word would be "Initiatives." (Nice quote by Stephen Sondheim: "It's the word, not the sentence." So true.)

TIP №7: "Cache" content.

"Caching" is a computing term that refers to the temporary storage of Web documents to reduce server load and lag. We learned in Chapter 2 that most people have very limited working memory, so caching content in our minds isn't a sustainable approach to live Infodoodling. There will be leakage. A more useful technique is to make your page or screen the cache space. (This harkens back to the concept of the extended mind.) Use your page to hold info bits to help manage the flow of incoming auditory information. If a speaker's pace is too fast, write or draw *just enough* to trigger your memory and go back to it later when there's a lull in the dialogue or the event or class is over.

Give yourself two letters of a word or half of a phrase or a visual clue of some kind. The context and the clue will help spark the memory later.

TIP №8: Listen for metaphors, similes, and descriptions about structure.

"This project is like a rabbit hole." "Let's spitball this idea." "It's a vicious cycle." "The system is hierarchical." "These departments run parallel." "We're moving in circles." These literary devices are cues that lead you to a ready visual without imposing too much load on your brain. No need to (metaphor approaching!) reinvent the wheel. When someone hands you a metaphor, use it.

TIP №9: If content starts to seriously outpace you, resort to lines, connectors, frames, containers, and color.

There are some presenters who throw you right into the deep end when they start talking. A trained Infodoodler can discern the plausible rate of speech within the first two minutes and modify his approach at the onset. If there seems to be no slowing in sight, now is not the time to sweat over visual metaphors or try and build elaborate illustrations. You are in diagram land, baby. Just throw down your abbreviated phrases, wrap them in boxes, and connect the boxes with lines. Take the Infodoodling to the bare minimum, and let me be the first to tell you there's no shame in it. Intrepid Infodoodlers do what we have to do.

TIP №10: If you feel like you missed a significant point, move on.

Getting your wheels stuck will only cause a traffic jam for future content. Any lover of improv will confirm that. No matter what happens (barring a bomb threat in the building) and no matter what you hear (did he just claim to be the best hacker of all time?!), keep moving. Don't sacrifice approaching content to lament having missed something. You likely have other people available in the same session anyway. At an appropriate time, you can lean over and ask, "What was the fifth habit of a highly effective person?" Add what you missed to your notes later.

TIP №11: Don't fixate on imperfections in your visual OR verbal language.

If you're engaged in Personal Infodoodling, odds are that no one will see your error but you. If, however, you're Group Infodoodling, try and think of your audience as *a resource to help you correct what you don't like*. No need to jeopardize the process by mourning over an imperfection. If you can't spell a word or draw an image, ask someone else to do it. Group Infodoodling is about rapid prototyping and experimentation with content. It really shines in a system amenable to mistakes. So if you or the group tries to avoid imperfections, you're overthinking it. Worst-case scenario, there's always Wite-Out.

TIP №12: Be aware of the word/image balance.

This tip changes depending on the type of Infodoodling you're doing. Let's start with Personal Infodoodling. When doing a Personal Infodoodle, experiment with varying ratios of words to doodles to discover what ratio has the best impact on your personal comprehension and retention. There is no "best way" when it comes to what works for you personally. It's just about finding your signature balance. But the game changes when you're involved

in either Performance or Group Infodoodling. Here's why. When you're engaged in either Performance or Group Infodoodling, the audience then becomes *other people*. It's no longer just you. This means that the balance you may have struck for your personal best may need to shift to accommodate a general population. There are two reasons for this.

Reason #1—and this won't surprise you because we've covered it—is that images are subjective. That means that the viewing audience will need text-based information to *accurately decipher the visuals and understand the conversation*. So if your Personal Infodoodle style relies on a word-to-image ratio of, say, 20/80, you'll need to adjust it to 50/50 or even 70/30 *when you have an audience*. When you're in service to a group, your goal is to create a visual artifact of verbal information that encapsulates, as fully as possible, that information. Words and images *both* play an important part, and the ratio matters.

Reason #2: When we operate as Performance or Group Infodoodlers, our work often will be distributed digitally after the event to an extended audience so they can get up to speed on what they missed or use it as a reference. Imagine if we were to send that audience a summation that was only in pictures. They might find it lovely, but they wouldn't have any real idea of the content they missed. On the other hand, imagine if we sent them a summation with only words. The meeting-minute person could have done that (better). So when I ask that you "be aware" of the word+image balance, it's because those variables shift depending on the purpose of the Infodoodle and the audience.

TIP №13: Keep your images simple.
Very basic shapes suffice to create a visual landscape that will trigger your memory and the memory of anyone watching you create it. Think of simplicity and economy of visual language as attributes in this work. They're not indicative of a lack of talent; they facilitate the ease of content capture, which is our job. There's nothing worse than an Infodoodler who goes off on a tangent drawing something elaborate if he's supposed to be paying attention to an external source. Unless we're doing visual translation from a book or document at our own pace—in which case we can elaborate to our heart's delight—we keep our images fairly simple *on purpose*, because the images are designed to add richness and trigger our memories, not to take our focus away from listening.

TIP №14: Develop a visual vocabulary.
A visual vocabulary will save your bacon. That's the dirty little secret behind live Infodoodling (that

There are exceptions to this rule when working with groups, albeit rare. An example of one: When refugees from Hurricane Katrina were gathered, months after the event, and asked to tell their stories and have them captured visually by an Infodoodler, one of my colleagues elected to focus on vibrant imagery and visual scenes to depict their experiences rather than on words. What the people felt and saw was more powerful than words could describe. So when assessing the appropriate word-to-image balance, the question to ask yourself is: Would the narrative of this group be better served by an emphasis on pictures?

and a yellow marker—see the sidebar below), and it has made many an Infodoodler appear far more talented at visual improvisation than he or she actually is. A visual vocabulary is a collection of predetermined visual representations of words or concepts. It's a very powerful resource for rapid visualization while listening. Committed Infodoodlers come to a session primed with ideas for how to represent information. (And the really hard-core ones design a mini topic-specific visual vocabulary for each event.)[51] For example, how might you represent the word "idea"? (Too easy. A lightbulb.) "Partnership"? (Stick people with their arms around each other.) "Strategy"? (A

chess piece.) One of the best things to support your process of content capture is to create your own icon library, become fluent in it, and add reusable icons as you're exposed to different topics. It's an exercise in efficiency, and it builds confidence at the same time. A no-brainer.

Whew! We made it through the listening tips. I hope that advice was enlightening rather than harrowing. The reality is that you'll come to know many of those tips once you start having your own *embodied listening experiences*. So don't tax your mind by trying to commit them to memory. Once you start experimenting with listening in various contexts, I promise you the methods will become instinctive. You just need to dive in and let them come. In no time, you'll surprise yourself with the power of your listening muscle.

The use of the yellow marker is a technique I learned many moons ago while working at the Grove Consultants International in San Francisco, California. It's a brilliant technique for beginners, and it involves making preliminary yellow lines on your page before you commit to darkening in whatever those lines were supposed to be. So if you're not quite sure how to draw a customer trying on shoes, you can draw her first in yellow lines and then correct accordingly and draw over her in darker markers without anyone in the audience being the wiser. You can also use the yellow-marker technique to keep your text in a straight line. Use the yellow to draw a horizon line (keep throwing the line until you get it straight enough for comfort) and then use that line as your guide to keep your text from angling downward as you work. Because the color is yellow, it's practically invisible to the audience unless they're looking for it.

OPTIMIZING THE WRITTEN WORD: CUTTING THROUGH THE CLUTTER ON THE PAGE

If you decided at the beginning of this section that you are never going to Infodoodle live and you're only going to engage in off-air Personal Infodoodling—a very useful technique, to be sure—then this section is for you. For that technique, you don't need to learn how to listen (although it'd be your loss because listening is hugely important in life). What you do need to learn is how to subtract information from a page so you can visualize it. This section, therefore, gives you a commonsense approach for removing extraneous content so that your resulting visual display becomes optimal for learning and retention. Remember Virginia Scofield? This is a celebration

of her using Personal Infodoodling to get through a vicious organic chemistry textbook and to graduate into her life! It's also a celebration of your future as an expert visual translator.

Are you ready? Whoo! I'm about to introduce you to what I call the Pragmatist's Razor.

The Pragmatist's Razor

I told you at the beginning of this book that I'm a pragmatist. I'm only interested in you placing your energy where it gets the best use. I don't want you learning all the parts of speech and analyzing what content to subtract based on whether you're seeing a noun, a verb, or a gerund (what is a *gerund*?!). Instead, I developed a set of questions that will help you determine whether the content you're staring at in a textbook or a research document should be in or out of your Infodoodle. Those questions are coming at you now:

1. *What is the goal of this Infodoodling experience? Am I looking to visualize something specific from this base of information?* We have mentioned this before, and it begs reinforcement. If your goal in going through a chapter is to get a timeline of the French Revolution, then you could focus on time and events. You need not focus on sidebars about the baking of baguettes UNLESS one of those stories somehow relates to the chronology of the French Revolution. Got it? Always know WHY you're reviewing information and don't get swept up in unrelated hoo-ha. Unless you have time for that, which leads to the next question.

2. *How much time do I have?* Or, *How much time do I want to spend?* Time is of the essence, as they say, so define the scope of your Infodoodle and its content by reconciling that with how much time you have at your disposal. More time equals more detail and more information indirectly related to your goal. Less time equals the opposite of that.

3. *Does this piece of information relate specifically to my goal or to the goal of the person I am accountable to?* If it doesn't, look away. If it does, put it in your Infodoodle. Example: It's nice to know that Thomas Edison was a power-napper, but does that influence your knowledge of how an incandescent electric lamp works? I don't think it does. If you were studying Edison's innovation process, then his napping would be germane. You see where I'm going with this?

4. *Will I be tested on this information?*—a.k.a., *Do I have to learn this for school or work?* If someone other than yourself expects you to know the information, you can't just discard it as extraneous, even if it's horrifically boring. Boring bits for which you're accountable to someone else should make their way into the visual display.

5. *Does this piece of information contribute substantially to my overarching understanding of the topic? Is it central or marginal?* If you were to doodle concentric circles of relevance, with the main concept in the center, and then plot pieces of information in the rings, where would the bit you're considering be plotted? Knowing how far away something is from the central concept helps you evaluate whether it belongs in the Infodoodle. Stated another way, *if* some set of information further illuminates the core nature of a specific topic, it can reasonably be considered grist for the mill. If it is peripherally related or contextually out-of-bounds, don't trifle with it.

6. Do I find this information interesting and personally want to learn this? If you're excited by some content and you have the bandwidth to visualize it, please do. The Pragmatist's Razor is not about forcing you to ignore things you're interested in. It's about offering a way for you to align with the systems and obligations you're in (systems being classrooms or teams at the office, and obligations being upcoming tests or projects). As long as there's no cost to you to include it (cost being in terms of time or comprehension), then by all means, have a go.

7. If I plan to distribute this to an audience later, will any of them care if I include this information? Conversely, will their understanding be compromised if I exclude the information? Recall that just because you have the opportunity to create this Infodoodle in your own time doesn't mean it can't be of use to others who need to study the content. If you intend to share what you've produced with other people to enhance their knowledge, then you'll want to consider whether there are people who'll review it that could be served by the inclusion of certain types of information. This doesn't mean you should go out of your way to customize your Infodoodle for nineteen different personalities and roles, but it does mean that you may want to put some consideration into the value of certain content for others who might end up using your work as a reference or teaching tool. That's being a considerate little Infodoodler, and we're into that, too.

There you have it. Seven questions that will make your life of off-air Personal Infodoodling a trillion times easier. I've compiled these questions based on my own experiences of determining whether content should be in or out. They're not the Bible, the Qur'an, the Torah, or the Bhagavad Gita. They're just questions any person

pressed for time but with a goal in mind would ask himself. And they're important to bring to the surface because many Infodoodlers base their choices of what to visualize on how they feel or on what's interesting about the topic to them. If you're going that route, make an Infodoodle for fun and for practice. Don't expect it to be useful for being tested or being accountable for knowledge. Infodoodlers seeking to use the tool for focused learning do not use their feelings as the bellwether of information's importance. Your chemistry teacher is not going to test you on your philosophical response to atoms. He's going to ask you about their structures and how they bond. Your boss is not going to be interested in how data sharing relates to democracy. She's going to expect you to know how the data will transfer across platforms so you can tell the customers. As you develop your own practice as a confident Doodle Revolutionary, blaze your own trail. Develop questions you prefer to ask yourself when evaluating whether something merits doodlization. There is no hard-and-fast answer, and my questions are simply for support. Just keep your eye on the goal, which is to avoid getting lost in irrelevance.

Here's a quick example of subtracting from the written word based on an excerpt from Scott Berkun's Essay #56, "Creative Thinking Hacks." For your edification, I'm going to strike through everything that does NOT need to end up in an Infodoodle, and I'm going to highlight **in red** every piece of information I would keep.

First things first, a question to self: What is my goal?

My goal for this Infodoodle is to jolt myself out of a creative rut and pinpoint the advice Berkun has to

offer. Note that this is a personal goal, not a task coming from someone on high, so you have the opportunity to curate content exclusively based on your own needs.

Next question to self: How much time do I want to spend?

I have many other projects to work on, so I'll give myself ten minutes. This time frame does not include the visualization work, mind you. This exercise is about subtraction, so let's focus on that since, as we learned together, information precedes imagery in the Infodoodle.

CREATIVE THINKING HACKS

Start an idea journal. ~~The rule is:~~ **any idea** ~~that pops in your mind, at any time,~~ **write it down.** ~~There are no inhibitions: any idea for anything goes in here. This will help you find your own creative rhythms, as over time you can note what times of day you're more creative. I recommend a paper journal, so you sketch or draw things, but digital journals can work too.~~ **Whenever you're stuck, flip through** ~~your journal. You are bound to find an old idea you've forgotten about that can be used towards the problem you're trying to solve.~~

Give your subconscious a chance. ~~The reason ideas come to you in the shower is that you're relaxed enough for your subconscious to surface ideas for you. Make this easier:~~ **find time to turn your mind off.** ~~Go for a~~ **run, swim, jog, have sex,** ~~something that's as far from your creative problem as possible.~~

Inversion. If you're stuck, come up for ideas for the opposite of what you want. ~~If your goal was to design the best album cover ever, switch to designing the worst album cover ever. Five minutes at an inverted problem will get your frustrations out, make you laugh, and likely get you past your fears. Odds are high you'll hit something so horribly bad that it's almost good, and you're inspired to switch back to your original goal.~~

Switch modes. ~~Everyone has dominant ways to express ideas: sketching, writing, talking. If you switch the mode you're working in, different ideas are easier to find and your understanding of a particular idea changes every time you use a different medium to express it. This is both a way to find new ideas, and to explore an idea you're focusing on.~~

Take an improvisational comedy class. ~~This will be easier and less painful than you think. It will teach you an entirely~~ **new way of thinking** ~~about the craft of creation.~~

~~Most improv classes are structured around fun, party type games and teach you ways to combine ideas in real time:~~ **a powerful skill for any creator.**

Find a partner. ~~Many people are most creative when they're with other creative people they like.~~ **Partnering up on a project,** ~~or even being around other creative people who are working on solo projects,~~ **keeps energy levels high.** ~~It also gives you a drinking buddy when things go sour.~~

Stop reading and start doing. ~~The word~~ **create is a verb.** ~~Be active.~~ **Go make things.** ~~Don't study it like accounting: you have to go do it, and make lots of mistakes, to learn anything about your own creative process. So get off the web and start making something.~~

Great Scott, that was amazing! Subtraction can be *so* satisfying—like clearing a table by throwing dishes at a fireplace. If you paid attention to what I was doing, then you know that I was taking a ruthless approach to paring it down. I was slashing and burning the content, keeping my eyes on what was meaningful to achieve my stated goal. If *you* were razoring this information, you might peer at this article through different eyes, searching for advice specific to, say, partnership during the creative process. There are no words in this article that have eternal, intrinsic value. We whisk away the information *we* don't need in order to find the underlying content that we do, based on the endgame we're playing.

For statistical enlightenment, let's figure out what percentage of words we cleared out. There were 447 words total, and I reduced it to 102. This means that we unburdened the linguistic load by 345 words, and we *still* managed to grok all of the key messages. That's a clutter-clearing percentage of just over 77 percent! Don't call it a comeback. We amaze at all times.

Later on, if we were to take the next step and visualize Berkun's messages, we'd raise the cognitive reward even further. What better way for our minds to take in information than to simplify it and then visualize it? The best way I can summarize this feat is to say this:

Visual language manages to simultaneously **ABBREV.** and E—L—A—B—O—R—A—T—E.

What tool, pray tell, can perform the same remarkable task?

As you go through the new world we're building, walking confidently with these liberating tools, remember the vastness of the knowledge universe. Know that by sharpening your ability to clear away clutter—spoken or written—you are taking small and great leaps into making it possible for human beings to better understand each other. Even if it's just for a little while.

INFODOODLING: STRUCTURING INFORMATION

1	2	3	4	5	6	7	8	9
Diagram Legend	System Map	Process Map	Comparison Map	*Game: Talk to Me	*Game: Part of Process	*Game: Want vs. Is	*Game: Image vs. Word	Diagram DNA

This section lands us in one of my favorite romps through the learning process: making the conceptual and then real-world leap from a limited words-only way of thinking to an all-inclusive view of information. My guess is that this section will be like mind-fire for the bulk of you. In a society obsessed with language, it can initially be counterintuitive—even cognitively uncomfortable—to understand (much less perform) the act of visual translation starting from a base of words. I recall my own effort as if it were yesterday, and believe me, it wasn't pretty. But I got there without dying, and you will, too. And there's more good news! On our learning arc, you're now here.

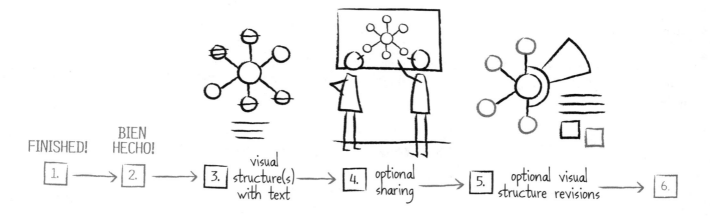

FINISHED! — BIEN HECHO!

1. → 2. → 3. visual structure(s) with text → 4. optional sharing → 5. optional visual structure revisions → 6.

This section is the place where what you've absorbed thus far really starts to gel. As we go forth, you'll see the 12 Devices in play, you'll see how much subtraction's role matters, and you'll also start to see visual structures (a.k.a. diagrams) in effect. In this special place, unseen mental models get to take on explicit visual expression. It's like POW! Right in the kisser. To give you an opening example of how a visual

structure might be used in real life, consider how most people design a presentation they plan to give or a paper they plan to write. If they make time to prepare at all, they usually explore their topic like this:

This traditional approach is fine—we can and do make it through school and work this way. But using a visually structured approach is a much more effective method to understand your content, be aware of where you're taking an audience, and know what they'll experience—intellectually and emotionally—along the way. An Infodoodler using her visual savvy would prepare for a talk or build the outline of an article more like this:[52]

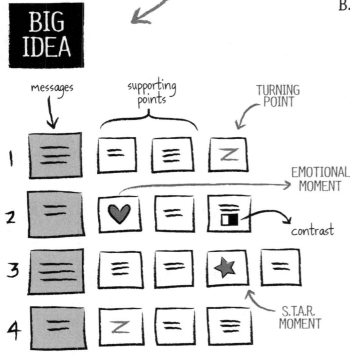

This gives you a peek into why visual structures matter and how they may be used. Mind you, in this section we're also setting the stage for the Group Infodoodle, a technique that will help you unleash not just your own mental powers but also the powers of the people you're surrounded by. To get there, you'll need (and love) the Diagram Legend I'm about to put in your path.[53] SHAZAM! How about these apples?

THE DIAGRAM LEGEND (we'll pretend) YOU'VE BEEN WAITING FOR!

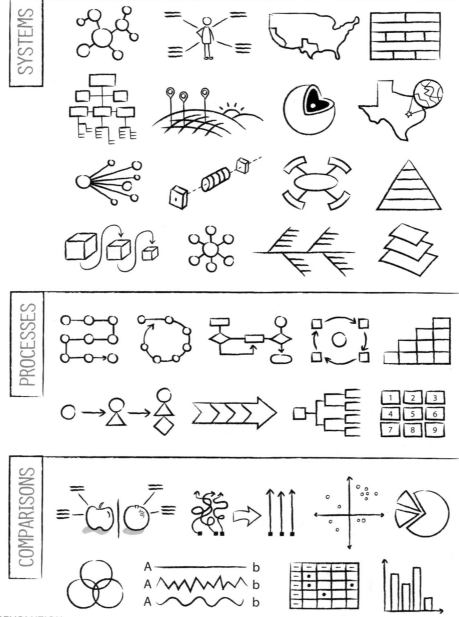

Now, I know you're marveling at this big hunk of eye candy. I give you this spread as a reference tool. You need not memorize it or even understand it at this point. I just want you to have it because it gives you things to play with for the rest of the chapter. It establishes a visual precursor for what you're about to cover.

AND INFODOODLE MAKES THREE: SYSTEMS, PROCESSES, AND COMPARISONS

I'm tossing you a mind sizzler right now, so pay close attention. You need to know something before we go on, and it is this: There are valuable Infodoodle frameworks that exist, and they're highly relevant to your ongoing greatness. I wrote them sneakily on the sides in the legend above, but we're about to actually learn what they are so we can continue to elevate our Infodoodle chops. Take comfort, dear Revolutionary, because I've made this process easy and awesome.

There are only three overarching Infodoodle frameworks. Just three! So tell your inner lazy lady to keep calm and carry on. These frameworks—essentially ways of understanding how to model information—are so useful it borders on absurd. What these frameworks ultimately do is show you how to approach the information you seek to Infodoodle.[54] This will be much a less esoteric statement in about four paragraphs.

Now, dear Doodler, I want you to know that these frameworks exist, but I also hope you know you have a lot of doodling freedom and flexibility in the world we're building together. I'm giving you structures to rely on in your tool kit, but I also want you to choose to defy or innovate around these structures at any time. General Eisenhower said that plans are useless but planning is indispensable. That's akin to how I

feel about the three frameworks. It's good to know that they exist because they help you formulate a plan, but you can also discard them when the mood strikes you.

Onward to the three frameworks. Are you ready?

The three Infodoodle frameworks include **process maps**, **system maps**, and **comparison maps**. Taken together, these maps give us the full monty for the relationships we'll explore using the diagrams and visual structures I offered on the previous page.

Let's look at system maps first. Stated simply, system maps exist to show pictures of

nouns. They are doodlicious representations of any kind of holistic view of a system. Typically, they represent the WHO, WHAT, and WHERE in the world.[55] An aerial view of the United States and an Infodoodle displaying the Milky Way are examples of system maps. This type of map excels at showing people a bigger picture. Remember our golf-ball-sized view? System maps help expand and clarify what's in our viewfinder. There are infinite systems we have an opportunity to see, like supply chain systems, wealth distribution systems, and technological systems. It will always behoove us to be able to discern and doodle systems because none of us really operates outside of one.

On to process maps. The purpose of process maps is to show

pictures of verbs. These maps display ways to see the world through mechanism and motion, process and dynamics, cause and effect, explanation and narrative.[56]

Process maps are often used to reach conclusions and make decisions, so these are particularly valuable in organizations working to optimize, align, streamline, etc. Outside of a work context, process maps illuminate endless interesting topics like how cupcakes make your ass fat or how a bill becomes a law. (You know you saw that last one in school.)

Our third framework is the comparison map.

Comparison maps are slightly different animals in that they can focus on either nouns or verbs, but always in the spirit of allowing the viewer to make comparisons between different states, processes, or conditions. Comparison maps show you what life would look like in different scenarios—past and future, before and after. This kind of map might be valuable when trying to understand the difference between building Department A or Department B, or when trying to decide if gentlemen prefer blondes or brunettes. (The answer is neither. Gentlemen secretly prefer redheads.)

Because I know you're paying close attention to learning all this, I'd like to acknowledge something that may be puzzling you: These maps are often inclusive of each other. In the real world, you'll necessarily encounter what we can call "combination maps," which are maps that visualize and intertwine both systems *and* processes. An elaborate subway map is an example of an Infodoodle that can show WHAT, HOW, WHEN, and WHERE, since it can display the subway system itself, the different ways to get from Point A to Point B, the sequencing of stops, and often a timetable. So it's a system *and* a process map. The famous infographic below by Charles Joseph Minard showing Napoléon's disastrous march to Russia combines WHO, WHERE, WHAT, WHEN, and HOW (MANY).[57] It's a combination map as well because it shows a process and a comparison.

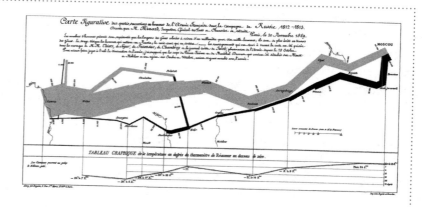

This comparison map displays the losses suffered by Napoléon's army in the Russian campaign of 1812, almost too effectively depicting how many soldiers died during the advance and retreat from Moscow. The graphic begins at the Polish-Russian border, with the thicker gray band showing the size of Napoléon's army advancing. The thinner dark band shows his army in retreat. Each successive loss of life is tied to temperature, time scales and significant geographic markers like river crossings. Out of 422,000 soldiers, only 10,000 returned alive. According to Dr. Edward Tufte, emeritus professor of political science, statistics, and computer science at Yale University, this is "probably the best statistical graphic ever drawn" because of its brilliant design and vivid historical content. It is also deeply depressing.

If you're ever hesitant to settle on one map category, my general rule is to get clear about the map's essential purpose. Ask yourself what information, if removed or altered, would distract from the map's most relevant function. Let's consider the New York subway map, shown below in black and white.

This map's most important purpose is getting people to the right place. So the makers of the map didn't choose a visual representation of the actual structure of the subway. Instead, they chose to compromise the visual's fidelity to the subway's physical infrastructure (i.e., scale, precise location, and turning points) in order to better serve the map's purpose. So if I had to choose, I'd say this orients it toward being more of a process map than a system map because it focuses more of its energy on clarifying HOW. The presence of combination displays is just something to consider as you dig deeper into creating your own visual structures.

Enough talking. Let's look at (and D.I.Y.) some simple examples.

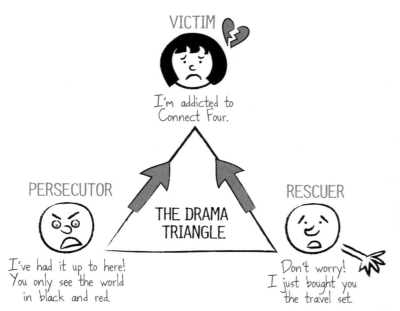

VICTIM

I'm addicted to Connect Four.

PERSECUTOR

I've had it up to here! You only see the world in black and red.

THE DRAMA TRIANGLE

RESCUER

Don't worry! I just bought you the travel set.

The Infodoodle above is a lighthearted (and upside-down) interpretation of Stephen Karpman's 1968 model of a predictable scheme of human interaction.[58] It's called the Drama Triangle. Avoid being trapped in it at all costs. You can probably guess that this is a system map. It shows three nouns and indicates the relationships between them—WHO does WHAT. It gives some information on how the actors might fulfill their roles, but it ultimately displays a dysfunctional system, a structure that, if immovable, will go nowhere good. Remove all the trappings and the

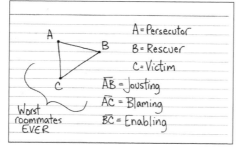

A = Persecutor
B = Rescuer
C = Victim
\overline{AB} = Jousting
\overline{AC} = Blaming
\overline{BC} = Enabling
Worst roommates EVER

Infodoodle's foundational structure is a triangle. Visually, it doesn't get much simpler than that. For comic relief, I'm also including an interpretation of the Drama Triangle by the cartoonist Jessica Hagy.

The triangular structure—so simple and yet laden with immense power to communicate. Below are two more simple system maps so you can see different styles. (My version to the left is a bit polished because I've had the time to refine it. Most system maps, however, start off spontaneous and doodly, like the ones you'll see next.)

The first example here is a map of what the Doodler[59] is calling "biological keys." It's a depiction of three areas or parts of the body and their associated functions. It very simply maps that system using a reliable words+image combo. You could certainly make a list of these keys, but why would you? They readily align to a visual structure. You might even say they *want* to be seen rather than just said.

BIOLOGICAL keys

LOGICAL Head MIND RATIONAL THINKING

hands PRACTICAL touch texture DOING MAKING

heart emotional gut

DESIRE FEAR FEELING

The second system map is a doodled view of the State of Web 2.0 in a post-Facebook-IPO era. Done by the cartoonist Hugh MacLeod, it represents a snapshot of the shifting landscape in publishing, entrepreneurism, data, and even the philosophy of self. This social-commentary dashboard does its job well by asking the viewer to consider the implications of a new world order, so to speak, that we're all experiencing. It's not a causality Infodoodle; it's a momentary glimpse to ignite a conversation—a system map that uses characters and their thoughts to show us an overview of reality.

Now it's your turn. As I said before, we all operate inside of systems. It's just a matter of learning to see and display them so we can understand them. Up next, two system map doodle games so you can learn experientially. The Revolution needs all hands on deck, people.

DOODLE GAME: All Systems Go

Pick a system in your life that you feel affected by. This can involve organizational systems in your workplace, transportations systems you use, rooms in your home that you spend a lot of time in, or community systems you're a part of. Think about the individual pieces of that system (e.g., people, highways, furniture or appliances, activities) and think about how those pieces might be laid out if they were displayed visually. Use your Visual Alphabet to create simple icons for each piece, and try to place them inside of a visual landscape. If you need to, use the Diagram Legend as inspiration for constructing different Infodoodles. Avoid trying to map a perfect system the first time around. Intentionally allow yourself to discover the system without anticipating and planning too much. When you're done, reflect on your display. What's missing? How do the pieces relate in ways you are surprised by? Where do you fit into the system? How might you fit in somewhere else? What could you add to improve the system?

DOODLE GAME: Talk to Me

For this second doodle game, I've listed below some of the elements involved in the act of communicating, and I'd like you to try and display the system that incorporates all of those elements using each of the three diagrams below. Each diagram has eight components, and the system has eight variables. The purpose of this game is to explore what happens to content when you place it inside of different visual structures. Draw your own versions of these diagrams in the space I've provided below. Write the words in the individual circles (and try adding simple images if you're feeling adventurous). As you Infodoodle, think about what the structures imply about the relationships among the information. Consider which structure does the best job at displaying that information in a coherent way. Why does it work? What happens to your understanding when the content doesn't fit so well?

Idea

Meaning

Audience

Author

Message

Form

Content

Tone

I hope those two games gave you some insight into the making of system maps. For the perfectionists out there (and I know you are legion), let it be okay if your first stabs at doodling system maps look like a drunk person tried her hand at makeup. Remember, Infodoodlers work with the physical and visual experience in order to spark the mind. We don't give a hoot about overly demanding expectations. Our imperfections are our teachers. Now let's look at a process map.

You see that this process map is showing a sequence of actions to take that would alienate you from your customers, guaranteed. Its core focus is on the verbs, the action, and it adds a narrative to support the viewer's understanding. It tells you HOW to do something. Clearly, this one is in jest. Don't try this method at work unless it's your last day.

Here are two more process maps to keep warming your brain to the idea of them. Like any maps that Infodoodlers produce, process maps don't have to be meticulous, well illustrated, or even accurate the first time around. The act of making them from scratch, messy and unpredictable, is what helps us start to clarify the information we seek to understand.

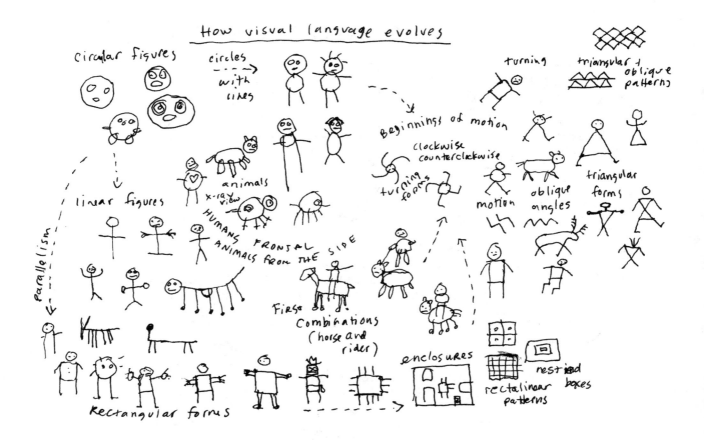

The first process map takes a look at how visual language evolves in children. In this image, the Infodoodler[60] is mapping the unfolding of the visual language capacity as it occurs in a particular order. This unfolding is a biological and developmental process, and that process is displayed in the organic structure he chose. You can see that the elements of the Visual Alphabet and the 12 Devices are present, performing the functions they were born to do.

The second process map[61] displays the active system of how the body breaks down and stores food energy. For me, this map is effective as a visual reminder of the benefits of choosing healthy food. Clearly, I need this hanging prominently on my refrigerator.

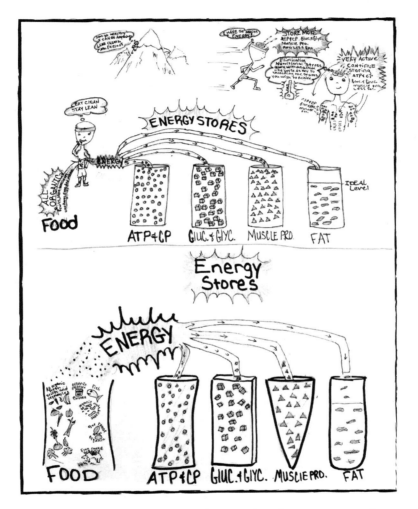

As you can see, both of these Doodlers are working with information to understand and display it, not necessarily to beautify it or perfect it. (Although anyone could argue that the woozy lines make them rather lovely.) Keep their stylistic scrappiness in mind as you produce your own Infodoodles. Your old "I can't draw" excuse just won't fly in the presence of the kind of unselfconscious aesthetic these Infodoodlers are displaying.

Up next, a doodle game about process maps.

DOODLE GAME:
It's All Part of the

P R O C E S S →

Here's a process most of us go through (unwillingly) every day: getting ready for work. For this exercise, I want you to show the sequence of things you do in order to arrive at the start of your workday. I've given you the diagram to use to show this process, but the number of steps I've shown is arbitrary. So when you produce your own version in the space provided, extend your path as long as you need to. Add images of yourself in motion if you'd like. It's a good

opportunity to practice your faces and figures. After you establish your sequence, ask yourself: Are there any things I do in the morning that I could NOT do? Is there any way to change the order of operations to save time? Could I delegate some of these tasks to anyone else? Could I shorten the length of some of these steps? What tasks could I do simultaneously?

START
HOME

END
WORK

YOU. MAKING YOUR WAY TO WORK. (a process map)

The value of process maps is that they help us see the actions we're taking to move toward an end state, and they allow us to evaluate the validity and effectiveness of that process, to become less subject to it and more aware of it. Early in my career, I created a process map of our sales interactions with clients and realized that our caboose was missing—we didn't have a follow-up schedule as a part of our steps. Hello, McFly! Needless to say, that's not a problem anymore, because once you see and internalize something, it's next to impossible to forget that it needs attention.

COMPARISON MAPS

This brings us to the last framework, the comparison map. Below you see an Infodoodle showing my interpretation of the distinctions between a company thriving in industrial economies (the divided company) and one thriving in knowledge and experience economies (the connected company).[62] Both organizational structures have a valuable purpose in different contexts, but making the distinction between the operating methods and the ethos of the companies is worth doing. This is a simple one-to-one comparison map that slices the world into a binary perspective that's valuable for the viewer. Comparing the two types of companies gets the viewer thinking about the pros and cons of each. It ignites the brain's process for deeper investigation.

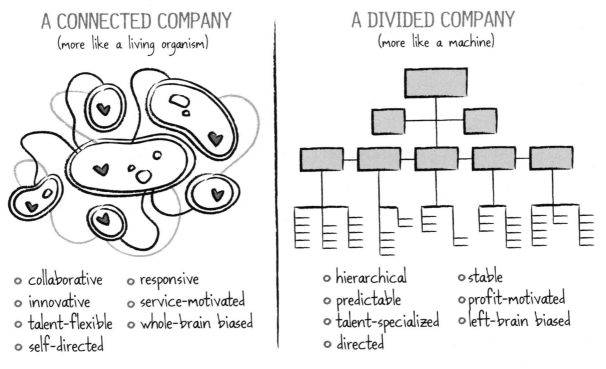

A CONNECTED COMPANY
(more like a living organism)

- collaborative - responsive
- innovative - service-motivated
- talent-flexible - whole-brain biased
- self-directed

A DIVIDED COMPANY
(more like a machine)

- hierarchical - stable
- predictable - profit-motivated
- talent-specialized - left-brain biased
- directed

As you know, comparison maps can display WHO, WHAT, WHERE, WHEN, WHY, and/or HOW because they're a container for both system and process maps and serve to juxtapose topics. You've been using (or at least seeing) a type of comparison map for years. Math lovers and statisticians call them graphs or charts, like these:

Scatterplots, pie charts, bar charts,[63] and line graphs are fantastic ways to display information visually, and they've been building understanding for centuries. But upon inspection of your Diagram Legend, you'll see that there are many other ways to show content for comparison purposes, both quantitatively and qualitatively. Follow your nose to which style appeals to you. And let's take a look at more versions of comparison maps to give you extra angles.

Below is a comparison map highlighting different textures of a surface. This is a simple but effective piece of work because it does exactly what comparison maps do, which is to ignite thinking about similarities and differences. While the map about companies was a one-to-one comparison, this represents the comparison of multiples, which comes in handy when you're choosing from or trying to understand the relationships between more than two things.

Texture

The surface of something; how it might feel to the touch

Which texture would you put where? I think I'd lay the cactus prickle on my husband's pillow during the day. (I was raised by Puritans. I'm still working on my unfortunate belief that napping is a sin.)

One last comparison map for good measure. The map below shows the globe in various states of being. The globe fried. The globe sliced. The globe in diapers. Like the Infodoodle on page 138, it lays out different options to ignite the viewer's natural tendency to start comparing items. Humans can't help it. When we start putting things side by side, we inevitably consider linkage and breakage, meaning, use, variety, possibility, and, of course, similarity and difference.

You understand what I'm getting at. Comparison maps, like any good map, trigger deeper inquiry. And that, per se, is a good thing.

You must play games to experiment with the Infodoodle. This is a reality-check thinking game for you to dabble with building your own comparison map. My nickname for this game is "Dammit." It works like this.

Most people living on the planet experience some dissonance between what we think life should be like and what it really is like. For this game, I ask you to Infodoodle the difference. You can choose any aspects of the world you're interested in—the political or economic systems, cultural systems, beliefs, behaviors, personal relationships, how we grow up, how we get educated, how we become who we are, how our company or classroom works. Imagine and Infodoodle the two different landscapes—one that shows life as it is and the other that shows life as you would design it. Maybe for you they're one and the same (if so, more power to you). But if they aren't, show the differences. Use a hub-and-spoke structure or a storyboard sequence. Let your doodle mojo fly. Once you've got something down, take some time to consider which variables you could accept as they are and which ones you feel compelled to influence. Think about why things are the way they are, how they arrived at the state they're in. (That cause-and-effect could be a process map, you know.) Show and tell in the space provided. Use the techniques you've learned. And if you need more breathing room, create some for yourself outside of these pages.

Pensar el Mundo

Fernando de Pablo dibujario.com

LIFE AS IT IS.

LIFE AS IT "SHOULD" BE.

DOODLE GAME:

📐 vs. Word

This next thinking game involves comparing two powerful tools that we've been exploring all along: images and words. The photograph below is of Bowman Lake in Montana. The word is "beauty." For this exercise, I want you to think about the differences between this image and this word. Explore their distinctions in terms of *functionality, production, interpretation, use, sensation, value, communication*, etc. Write and draw your impressions and thoughts until you end up with a mind map showing lines radiating and branching around each item. If you need to, close your eyes and experience the difference in your mind. Think about what the photo conjures for you; then make your Infodoodle. Next think of the word "beauty" and be aware of what the word inspires. This game is about purposefully putting your attention on how these tools can be used differently, and for what purpose. Both words and images are remarkable tools. But like sculptures and books, they are not the same. Think about the nature of these tools (using the criteria I offered above if you'd like) and display your thoughts as a double mind map.

Note: The astute Infodoodler may observe that this exercise involves the production of a comparison map *by way of* producing two system maps side by side. As I indicated previously, comparison maps are often the benevolent keepers of their system and process map brethren. And God said this was good.

Brave Revolutionaries! You have arrived at the end of the frameworks section. For some of you, it may have been a bit taxing, and that is o-kay. Readily determining how to structure vast swirls of information is not always intuitive, and it often requires a few bloopers before a feel-good map emerges. Keep in mind that as you explore and experiment with these frameworks, the question you'll virtually always want to ask yourself first is this: Am I attempting to Infodoodle a system, a process, or a comparison? What is the visual outcome I'm looking for? If you're trying to show how your IT infrastructure handles virtualization and data transfer between applications, you're looking at a process map (a gnarly one). If you want to show the impact of a small but expert sales force relative to a large but novice sales force, you'll need a comparison map. And if you want to Infodoodle a menu of nourishing and hearty breads around the world, why then you'll need a system map. And afterward you'll need a grocery store because you'll be hungry.

The purpose of the Diagram Legend is to give you an assortment of visual choices you can make once you've decided on the kind of Infodoodle you need. If you struggle to see in your mind's eye how something might best be displayed, review the legend and let it support your thinking process. Choose a visual structure for a system map and quickly scratch out a sample. Don't worry if the first structure you choose isn't ideal. Unless you're a highly practiced Infodoodler or the information you're mapping already has an associated diagram, it'd be kind of shocking if it were. The point is that you'll discover from the process of selection and experimentation what diagram works best. You'll also start to see the information you're noodling with in ways you weren't expecting. This is just one of the many powers of the Infodoodle that will continue to surprise you. For good measure, I present you with the Diagram Legend once more.

DEFINING THE DIAGRAM

Even though diagrams are kind of like pornography—you know 'em when you see 'em—let's be sure and define what a diagram is. A diagram is defined as a two-dimensional geometric symbolic representation of information (otherwise known as a mouthful). That's what all those little figures are about. They give you a visual structure in which to place your thoughts and then rearrange and dig deeper into them. You can spot diagrams in many an Infodoodler's work because of their high communication value. Take this page from the notebook of the designer Mike Rohde.[64] You see the diagram he used, just as natural as a baby's bottom. You have the structure he used as well as the dozen or so others I've provided. Look them over. Love them. Put them down on paper. They kick ass.

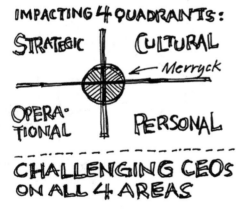

Here's an interesting fact about diagrams: They often *are* a complete Infodoodle, and they can also be compositional pieces of an Infodoodle. They can represent a part and a whole at the same time. Did I just go science fiction on you? I did not. One of the virtues of a visual structure is that it can be itself and also inside of itself. In this way a diagram is a sort of cousin to the fractal, which is a gorgeous mathematical equation (I believe invented by fairies) that exhibits a self-similar pattern. Stated another way, a fractal looks the same up close as it does from far away. The whole has the same shape as one or more of the parts. No kidding. Some fractals you've probably seen firsthand: lightning, seashells, snowflakes, broccoli,[65] and feathers. Think about it.

Now, in Infodoodle nation, this behavior of self-similar patterning involves what I call metastructures and microstructures. I sometimes call them mother diagrams and baby diagrams to anthropomorphize them to my liking. This matters to you because in your quest to display information visually you can choose a metastructure, the mother diagram, under which you can doodle a variety of microstructures, the baby diagrams. Described visually, what I mean is this:

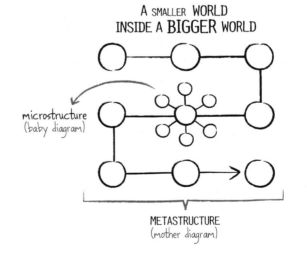

In the diagram section earlier, I offered you some visual structures you can use to build your frameworks to produce your system, process, and comparison

maps. The structures you see are meant to kick-start your thinking about visualizing content. They're not intended to freeze-frame you into limiting the ways you Infodoodle. There is plenty of room for making hybrids of visual structures to customize them for the data you're dealing with. And guess what? You may be pleased to learn this next piece of information.

(SOME) INFORMATION HAS A VISUAL DNA

Remember our knowledge universe? Well, you might be tickled to discover that some slivers of the knowledge universe have discreet but innate structures that visually represent them best. It's true. These slivers of information have a kind of Infodoodle DNA that can be showcased inside different visual structures. Most of us (including Yours Truly) can't see the structures immediately without practice and effort,[66] but, like gravity and foul-smelling odors, they're there and they will materialize. But the initial invisibility of Infodoodle DNA actually reinforces the earlier premise of *why* content must precede visual structure— because we need at least the 1.0 version of *the words and numbers we're exploring* before we can attempt to place them inside of some kind of diagram. Below I've shown an example of what happens when we *don't* allow content to drive structure. In this work, it gets either messy or confusing pretty quickly.

You see instantly how a family tree doesn't work inside of a pie chart. You could draw pie charts for the rest of your life, and they will never properly illustrate filial relationships as in who begat whom or who has what role in the family. The diagram above is incoherent, as a bar graph trying to represent the export paths of weapons sold globally would also be incoherent. A pie chart would work better showing how much time Chimi spends with each member of his family, or how much Changa looks physically like the other family members. A bar chart would do well breaking down the ingredients of an enchilada or stacking a burrito against a quesadilla in terms of *el sabor picante*.

FICTITIOUS FAMILY: A PIE CHART

Chimi (husband) 63%
Changa (wife) 17%
Enchi (brother) 11%
Lada (stepmother) 4.5%
Quesa (sister) 3%
Dilla (grandmother) 1.5%

I don't want you to think you'll need to be a chart wizard to be an Infodoodler—au contraire. The expectation is not that you'll know the whims of every chart that's been invented. Exploring those is playtime for the next chapter (and, on some level, for the rest of an Infodoodler's life). I just ask that you take home this lesson: that certain information lends itself to certain diagrams and, conversely, certain information *doesn't* lend itself to certain diagrams because some information is born with its own little diagram DNA. It's primed in the intellectual ether with a native structure that represents it better than other options. *Capisce?*

Now that you've got the diagram-DNA concept, it's important to point out that Infodoodles created live have *much* less expectation around the rapid production of a diagram's DNA. Infodoodles made on the spot and in the moment can't afford much analysis; they're born from spontaneity and bold improvisation. In other words, a Performance Infodoodler won't have time to dilly-dally, pondering which diagram is best. She's visually dispatching information as fast as it comes, so she'll very likely end up with diagrams that don't perfectly suit the content. In that category of Infodoodling, that is perfectly fine. She cannot sacrifice the capture of content in pursuit of the perfect diagram.

BUT Infodoodles created at your own pace DO permit an iterative dance of information versus visual structure. They DO allow an Infodoodler to explore and tease out which diagram will fit hand in glove with the information available. *After* you've lasered in on the content that matters—at least the preliminary version of it—then you have this marvelous opportunity for the two worlds—word and image—to collide. Content and diagram can craft

and smooth each other to their heart's content. That process is supported by the Diagram Legend and by the bajillion other diagrams available to you in books, online, and in your imagination. All that's required is your willingness to investigate.

My dearest friends, you now hold in your powerful hands every piece of learning you need to prepare you for the next chapter. You can visualize any simple object. You can visualize any metaphor. You can trim information into its essential parts. You can embed that information inside of a diagram. And now you are about to add the Group Infodoodle to that list. Your world will never be the same.

Let's do this.

TAKING THE INFODOODLE TO WORK: Transforming the Way We Think in Groups

GROUP INFODOODLING: TRANSFORMING THE WAY PEOPLE WORK

Welcome, fair Infodoodlers. You have arrived at the end of the learning arc, and you have come so far! You're entering step 6 shown below, at the final frontier of becoming a Revolutionary of magnificent proportions. I can hardly contain my excitement. (And I'm not sure why I would.)

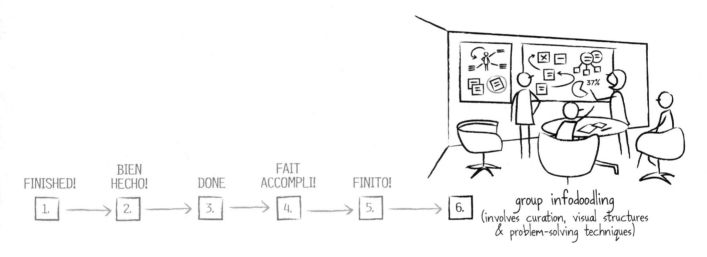

FINISHED! — BIEN HECHO! — DONE — FAIT ACCOMPLI! — FINITO! —

1. → 2. → 3. → 4. → 5. → 6. group infodoodling (involves curation, visual structures & problem-solving techniques)

Since you've been with me through many mountains, you know the promise of the Group Infodoodle. This Infodoodle technique is a surefire method to dig our hands fearlessly into that vast universe of knowledge we now know we're a part of. This is the way in which we uncover, sift, collide, expand, upheave, and grapple with the tiny, infinite bits of information that make up our cognitive field. This type of Infodoodle differs from the others in that it elevates the method to its most sophisticated form, making it even more physical, immersive, and interactive. In this way of the Doodle, we get to think, play, and sketch *together* and leave our limited perspectives in the dust. Seriously. I'm giddy.

To start this leg of your journey, I want to give you two things: first, a quick, real-world scenario in which Infodoodling sparked intellectual-property innovation in a large, global company and, second, a list of supplies you'll need to do this work. Don't get me wrong—you could technically perform a Group Infodoodle with sticks in the sand, but as always, I'm looking at where you're most likely to be.

INNOVATION, INFODOODLE STYLE

One day, the leadership of a ginormous telecommunications company discovered something unnerving:

Because these were proactive business types, this problem would not stand. So the company invited an amalgam of people versed in their technology to tackle the problem head-on:

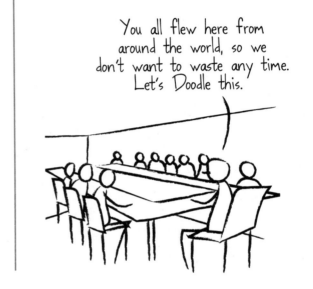

As a method of attack, this group and I orchestrated a two-day event weaving the Infodoodle through a series of thought experiments. After those two days were through, the group of twelve had successfully imagined and prototyped five patentable technologies that previously didn't exist and probably wouldn't exist for seven to ten years. In other words, this group successfully went radical using the Infodoodle.

The challenge was to hatch visionary innovations. The visual-thinking approach we used was effective because it gave us shared visual spaces in which to dissect, manipulate, invent, and change perspective on information. It unleashed a fuller expression of thinking styles available to us, and because of that, it made more ideas possible. Our efforts would have taken much longer to accomplish or may never have happened without the use of the Infodoodle.

Now I want you to have a peek at what I call an "Infodoodle sequence"—words, pictures, and movements woven through a series of thinking exercises. These sequences are a veritable machine for solving problems. The actual order of Infodoodling activities that we used to obliterate the patent problem described above is on the next page.[1] Seeing this sequence will prime you for your journey toward a master aptitude in Infodoodle usage. You don't yet know what each activity specifically involves, but the remainder of this section aims to crack open what's inside.

SESSION GOAL: Develop five patentable technologies in two days.

INFODOODLING
SEQUENCE:

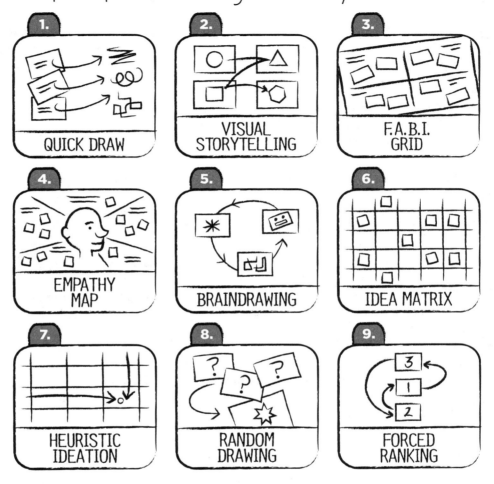

1. QUICK DRAW
2. VISUAL STORYTELLING
3. F.A.B.I. GRID
4. EMPATHY MAP
5. BRAINDRAWING
6. IDEA MATRIX
7. HEURISTIC IDEATION
8. RANDOM DRAWING
9. FORCED RANKING

By now I hope your Spidey senses are starting to discern that there's impressive power in using simple visual language when working with a group. One of the beliefs of the Revolution is that if we're inviting people to solve a problem—any problem—they deserve as many tools as possible to help them along the way. Given our evolutionary path, human beings respond particularly well to tools involving visual and kinesthetic intelligence, so we should always have ready access to them. This is part of the savvy IQ brought to you by the Doodle. In this section of the book, you'll find fifteen Infodoodle activities in various sequences that help solve common organizational problems, among other juicy pro tips.

An important note: Visual language embedded in thought exercises inside of a collaborative setting is, in my experience, one of the highest functions of the Doodle. If you're a facilitator or meeting-leader type, then you know that the sequence of those activities and the tone set by the facilitator heavily influence a group's level and habits of thinking and the outcome. These Infodoodle activities are *best* done with someone experienced in leading meetings or in a risk-taking and Doodle-friendly culture, but truly they can be led by anyone.

If you're not a facilitator or meeting-leader type, the next section will show you that you don't have to be one in order to up your ability to think in groups using the Doodle.

So, in your school or office, you'll need access to this:

1. **Some kind of good-sized visual space.** This can be a whiteboard, a chalkboard, a large tabletop covered with paper, walls covered with paper, a flip-chart-sized pad, a room covered with IdeaPaint,[2] an interactive whiteboard, or an iPad, digital tablet, or laptop

whose screen you can project. You need something that allows you to doodle in a space big enough for multiple people to at least *see*, even if they aren't directly interacting with it (which, frankly, isn't an ideal scenario).[3]

2. **Markers**—whiteboard, permanent, or a stylus for your tablet.

3. **Sticky notes**—all shapes and sizes are welcome.

4. **Index cards**—ditto.

5. **Large-scale paper**—this can be rolls of paper or flip chart paper hung side by side. Whiteboards or chalkboards around a room are awesome, but they do pose a mobility problem (unless they're all on wheels) that is solved by using the timeless technology of paper.

6. **A roll of masking tape, painter's tape, or artist's tape** so you can display some of the work you've done for ongoing viewing and thinking. If you have magnetic whiteboards, well, la-di-da.

7. **Any other physical or digital tools or objects at your disposal.** These come

in handy for rapid prototyping, which often happens during a Group Infodoodle.

Those items form your basic tool belt. You can mix and match your tools as you please. Also, as you start to get familiar with the process of the Group Infodoodle, you'll know what you need based on the activities. You probably won't need my list but once.

Now, to teach the Group Infodoodle, this chapter explores the six meeting types I brought up before. I'm taking on meetings at work because classrooms, lecture halls, and conferences have wild and unpredictable variations in goal and structure. There's no neat way to encapsulate one systemic approach to learning inside of them.[4] In most of those settings, the best thing for you to do is to deploy what you already know: how to curate and visualize content for your own edification; in other words, to use the Personal Infodoodle. For meetings in the workplace, what you need is a way to *display and experiment* with information so that it's visual and available to everyone in the room, and *in a sequence that's useful.*

Remember that large telecommunications company struggling with the development of intellectual property? That was an organization that successfully applied the Group Infodoodle to tackle a serious, real-world challenge. You're finally going to get to see behind the curtain of how they did it. (Well, not *that* curtain or how *they* did it. That information is proprietary.) But I'm going to give you what we can call "Infodoodle sequences" that will show you how to solve problems in settings in which multiple stakeholders are involved. I'm offering these sequences in the context of meetings that are universal, meetings that are held all over the world, no matter what an organization produces or sells.

To refresh your memory, those meetings are:

1. **Planning Meetings**
 (e.g., project kickoff/launch)

2. **Problem-Solving Meetings**
 (e.g., ideation/innovation)

3. **Decision-Making Meetings**
 (e.g., new hire, budget allocation)

4. **Feed-Forward Meetings**
 (e.g., context-setting/state-of-the-organization, status/project updates, research presentations)

5. **Feedback Meetings**
 (e.g., 360s, performance reviews)

6. **Combination Meetings**
 (e.g., leadership off-sites, BarCamps, board retreats, strategic planning)

How to move a group successfully through sequences of Infodoodles is what you'll discover in this chapter. (Along with the fact that you have even more skills that you didn't know about!) How does that tickle your fancy?

Before we get cracking, let's go through a quick orientation for navigating this chapter.

HOW THIS CHAPTER WORKS

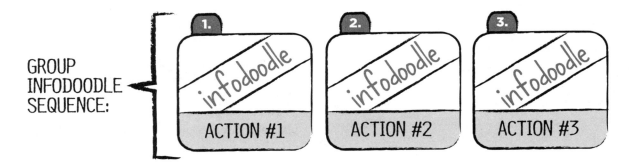

GROUP INFODOODLE SEQUENCE:

1. infodoodle — ACTION #1
2. infodoodle — ACTION #2
3. infodoodle — ACTION #3

What you see above is a high-level visual agenda. Throughout this section of yet more insightful prose (wink!), each type of meeting will have a supporting visual agenda that shows the sequence of Infodoodles needed to lead it, or it will come with other instructions appropriate to make the process work smoothly.[5] The visual agendas will be one major clue that we're embarking on a new meeting. Think of them as helping hands moving you safely and intelligently through each session. And please note, the sequences needed to lead each meeting will come with these tidbits:

1. **Meeting goal**

2. **Goal of the Infodoodle activity**

3. **Number of Infodoodlers needed**

4. **Duration of Infodoodle activity**

5. **Notable assumptions of the activity**

6. **How to actually DO the Infodoodle**

7. **Best practices for the Infodoodle activity**

I'll be with you to illuminate and provide instruction for each activity along the way. Ultimately, however, since you're now fully capable of using visual language, you'll be able to run these sequences by yourself at work or elsewhere. You do not need expert facilitation knowledge to put them in effect, because they are guided visual-thinking processes designed to support nonexperts. While your efforts with the group may be nonexistent or rusty in the beginning, experience will be your best teacher. So come with me to try them out, knowing that by the end, you won't need me any longer.

Let us at last explore the preeminent Group Infodoodle by taking on the first meeting in the list: Planning Meetings.

ENTER THE GROUP INFODOODLE

Planning Meetings aren't the sexiest sessions in the world, but if you don't have them, you can take that brilliant idea you had and blow it into the wind. As much as I deeply admire a capacity to live forever in the moment, people must plan, and in most companies, much of what people plan are projects. Here's how an Infodoodler might approach this.

Below is the first of six visual agendas I told you would be making an appearance. You can surmise that these agendas are doodled displays of *possible sequences* of visual activities you can use to run meetings that people can actually look forward to. (Your boss isn't around. We don't need to pretend that you love meetings.) Think of these agendas as your visual maps, carrying you away from the dull and life-deadening existence of standard office get-togethers. This particular agenda is for the Group Infodoodle you can deploy to make a Planning Meeting suddenly become awesome. I swear on your mother's Doodle. (Is that wrong?)

PLANNING MEETING

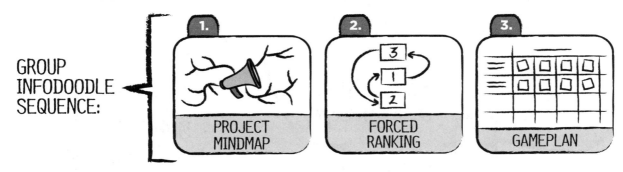

GROUP INFODOODLE SEQUENCE:

1. PROJECT MINDMAP
2. FORCED RANKING
3. GAMEPLAN

Meeting Goal:
To map, evaluate, prioritize, and plan projects.

GROUP INFODOODLE #1: PROJECT MINDMAP

Goal of Project Mindmap:
Establish a clear picture of various projects based on the three variables: Features, Benefits, and Challenges.

Number of Infodoodlers:
2 to 20 (can be related to the number of projects you want to evaluate, which I've explained below).

Duration:
20 to 45 minutes.

Notable Assumptions:

1. There exist multiple pursuable projects that the group could benefit from mapping and reviewing.

2. The group does not have the bandwidth or resources to pursue all of the projects.

3. Even if the group could eventually pursue all of the projects, they still need to evaluate and prioritize them.

4. All of the projects to be evaluated have either not begun, are in the early stages of execution, or are at a stage where reevaluation would be valuable.

Soldiers, the agenda for the Planning Meeting opens with the meeting participants producing a mind map, which involves doodling a central image and surrounding branches. For this module it would be helpful to bring at least one example of a mind map (they're everywhere online, or you can doodle one for the group during or before the meeting)[6] to show the participants what they're being asked to produce. If you don't have an example of a mind map, no biggie. Here's an abstract Infodoodle to demystify them.

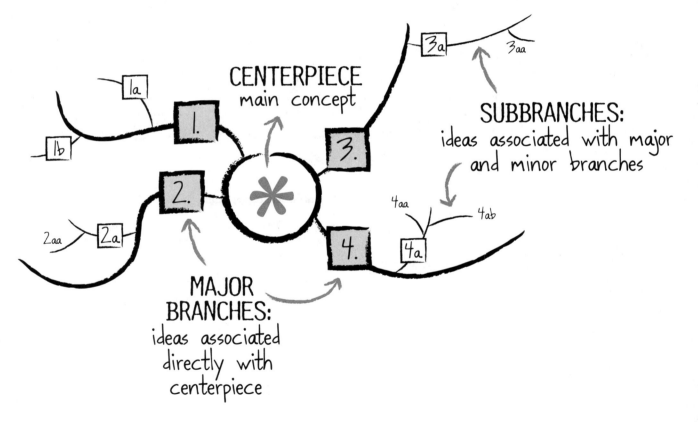

A VISUAL EXPLANATION OF THE MIND MAP

CENTERPIECE
main concept

SUBBRANCHES:
ideas associated with major and minor branches

MAJOR BRANCHES:
ideas associated directly with centerpiece

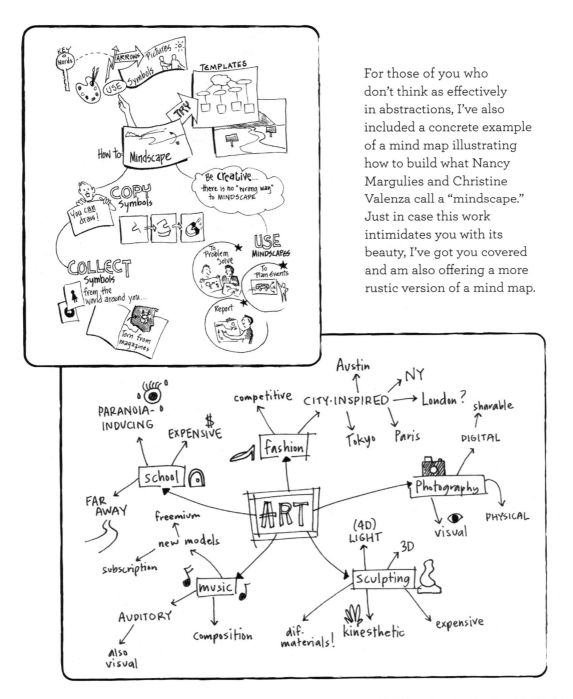

For those of you who don't think as effectively in abstractions, I've also included a concrete example of a mind map illustrating how to build what Nancy Margulies and Christine Valenza call a "mindscape." Just in case this work intimidates you with its beauty, I've got you covered and am also offering a more rustic version of a mind map.

Now, to set up Project Mindmap, re-create the first example above on a scale visible to a group, or produce[7] one with specific content and let the meeting participants know that the idea of a mind map is to sketch a visual representation of an item or concept in the center of a page and add branching lines to associate related words and phrases. The branches of major categories radiate from that central image, and derivative concepts become subbranches of those larger branches. You can have as many major categories as you like, and you can extend the branches for as long as you deem appropriate to illuminate the central concept. Like all great Infodoodles, mind maps are combinations of words and images. So the group can choose to visualize any aspects they desire, or they can stick with words and rely on the underlying visual treelike structure to enhance their understanding. Also, the groups could use small sticky notes to capture initial concepts and mock up their first mind map with those rather than committing the concepts immediately to paper. (A whiteboard would also solve this problem.)

If the group does go down the route of committing concepts to paper only to discover they want to remove or rearrange some of them, let them know they can simply doodle the work again. Redos are a natural part of the iterative process of thinking visually. It's like editing anything else. Cross-outs, white-outs, tear-outs, and even the crumple-up-and-start-again maneuver are all valid approaches. The first time is rarely the charm.

Now that the group understands how to build a proper mind map, your next move as the meeting leader is to ask them to actually build a few.

1.

PROJECT MINDMAP

Project Mindmap How-To

To launch the Project Mindmap activity, first break the larger group into smaller groups.[8] If you want the meeting to move more quickly, ideally you'd have the same number of groups as you have projects to evaluate. If that's not possible, don't sweat it. Remember: We're Infodoodlers; we're undaunted by imperfect circumstances. (Plus, I'll give you advice on how to handle it.)

Once your participants are in small groups, assign a project to each group to evaluate. Make sure the people in each group have at least a general grasp of the project they're working on. (Is this obvious? You'd be surprised.)

Ask the group to agree on a central image that represents the project they want to evaluate and then to doodle that image in the center of three distinct large white spaces. Each group is going to doodle THREE mind maps, so they need three sheets of flip chart paper or three discrete areas on a good-sized whiteboard, like so.

Request that each group title each image with the specific project's name so that the other groups, which will eventually come around to see the work, will know which project is being discussed. An image alone will either confuse everyone or force people to deduce which project they're looking at based on the surrounding information. A waste of time. Not cool. (Sing with me: Words and pictures sitting in a tree! K-i-s-s-i-n-g.)

Three white spaces. Let the mind mapping begin.

Explain to the groups that one mind map will be for showing Features of the project, one will be for showing Benefits of the project, and one will be for showing Challenges associated with the project, so they should label their mind maps accordingly. The goal of this mind-mapping exercise is for members of each group to get a full(er) contextual understanding of the projects, which they'll be ranking next. Tell them that "Features" can be defined as characteristics or attributes of the project, including physical components, integrated or associated products and services, the inherent structure of the work (Does it involve multiple stakeholders? Is it cross-disciplinary?), and other distinguishing properties. "Benefits" can be defined as the value or contribution of the project to customers, to internal stakeholders, to the organization as a whole, to the marketplace, etc. "Benefits" signifies any advantage that results from the project coming to fruition. Last, "Challenges" can be defined as any obstacle to the emergence, value, or desirable impact of the project.

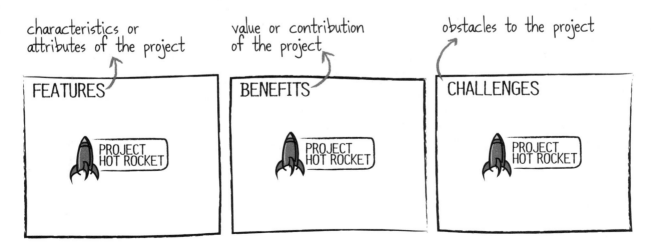

Now each group's task is to use what you taught them about mind maps to produce three visual displays that indicate fairly close group agreement on the landscape surrounding specific projects. The groups should work thoughtfully (at whatever speaking volume they choose) to flesh out each of these variables—Features, Benefits, and Challenges—in order to get to know the projects and see them in a clearer light. To rank projects (the activity they'll be doing next) without an intelligent lay of the land is a fool's game. It's akin to covering your eyes, pointing to a random guy at a bar, and agreeing to marry him, at least for a few months. How does *that* spell success? For each distinct mind map and topic, let the group's branches wander and split to their heart's content. Each new offshoot represents a clarifying notion about the project. By the end of this activity, each group will have three mind maps doodled before them, laying out the universe of the project to better inform their eventual votes.[9]

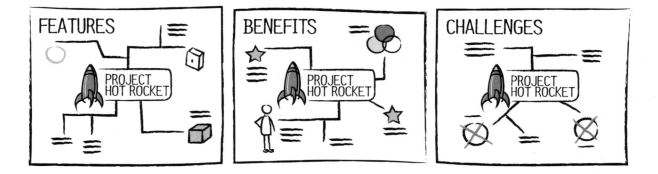

To wrap this activity and segue to the next one, conduct what I call an "Infodoodle Walk." At this point, all mind maps should be displayed on a wall or table amenable to audience viewing. The walk involves each group moving around the room, reviewing the work of each other group, and adding or elaborating on what the previous group has Infodoodled. You can conduct this rotation with all people seeing all projects or with groups that you select reviewing specific projects.[10] You might also choose to leave one member of each group at each station to help explain the work to the approaching group(s).[11] Whichever variation you prefer, more eyes and hands on each project description means a more comprehensive depiction of the project. So when or if you find that people are reticent to "graffiti" other people's work (which is how they often view it), assure them that adding their contributions is an essential part of the process. They are not marking up the *Mona Lisa*. They are contributing to a kind of low-tech database that will better inform the whole group's next move.

THE INFODOODLE WALK: Rotation for Group Education

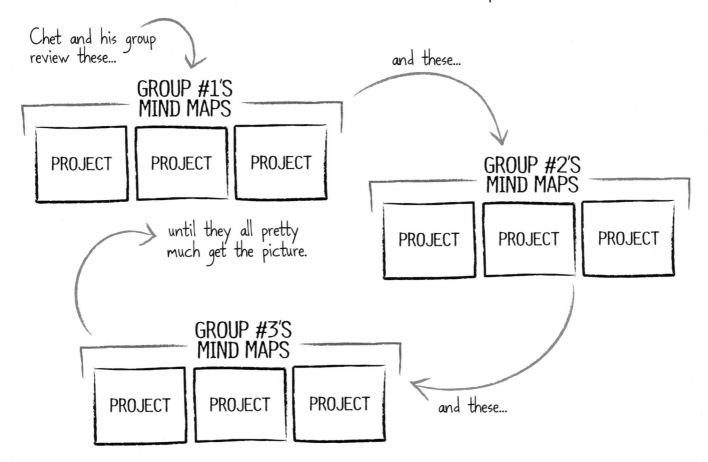

Chet and his group review these...

and these...

GROUP #1'S MIND MAPS

| PROJECT | PROJECT | PROJECT |

GROUP #2'S MIND MAPS

| PROJECT | PROJECT | PROJECT |

until they all pretty much get the picture.

GROUP #3'S MIND MAPS

| PROJECT | PROJECT | PROJECT |

and these...

In closing Project Mindmap, if you have time or want to make time, ask for volunteers to present their Infodoodles. Much of the awareness building was built in to the Infodoodle Walk, but it doesn't hurt to allow a verbal summary as well, as people tend to add details in talking that vary from their visual displays. The most important thing in finalizing this game is that every stakeholder who will be involved in project ranking ends up with a good sense of each project.[12] Because, as Bette Davis might say, the next game ain't for sissies.

Best Practices for Project Mindmap

- As I acknowledged previously, you may have more projects than groups, but everything is still under control! Just distribute the projects as evenly as possible among the groups and ask them to go through the steps of Project Mindmap however many times is required to map all projects. To spell this out further (because I know many of you thrive on concrete examples), this means that if you have four groups and ten projects, assign two projects to each group, which accommodates eight projects, and then assign the remaining two projects to two groups that you reassemble. OR assign three projects to three of your groups and two projects that may take longer to mind map to one of your groups. You see what's happening here. We're just trying to get the projects mapped as expediently as possible based on the number of groups. You have flexibility here. *Capisce?*

- Because the group's next doodle destination involves ranking the projects, don't skimp on the time you allow the group to really elaborate on their mind maps. The more thorough an understanding each person or group has, the more informed their ranking will be. Mind maps can extend indefinitely, so if one group needs to get wild with the white space, just give them more paper or more whiteboard. Don't chop the branches before they grow. The group is building understanding. This is good.

- Please encourage the participants to actually doodle components or concepts related to

each project. Many of them will default to words only, but I've said it before and I'll bring it home again: Visual information gives us *different insights* from verbal information. Until we draw that bikini, for example, it won't be obvious just how much of the body it won't cover. I hope that example kept your attention, lusty people. Hee hee! Now on to the second game of our Planning Meeting.

GROUP INFODOODLE #2: FORCED RANKING

Goal of Forced Ranking:
To prioritize projects based on a thorough or sufficiently thorough understanding of each in order to determine which to pursue and which to either abandon or pursue at a later time.

Number of Infodoodlers Needed:
2 to 20.

Duration:
15 to 60 minutes.

Notable Assumptions:

1. That the people you need to conduct a valid ranking are present.

2. That the people ranking projects either (a) have a good enough understanding of each project to rank them, (b) have an ability to withdraw from ranking when or if they don't, and (c) are making an effort to overcome personal biases in order to get the best ranking for the group or organization as a whole. (Obviously, these are ideal circumstances. People are people, right?!)

3. Organizational leadership has given the

group the opportunity to choose projects based on their own assessment rather than execute projects mandated from above. (This is an exercise in false autonomy otherwise.)

Forced Ranking How-To

This next Infodoodle action is highly valuable because it forces a group to either embrace or kill their project darlings. It ruthlessly insists that the group assign merit or value to some projects over others. Not every project will survive, and only one will come out on top. Hence the term "forced." You don't get your cake and cookies, too. So here's how this game works.

Ask each person in the room to write the name of each project on an index card or sticky note three times. Everyone will need her own triple set of index cards for each project. So if there are five projects, Lorayne needs fifteen cards total, three cards that say Project X, three cards that say Project Y, three cards that say Project Z, and so on.

We're laying the groundwork for the participants to evaluate and rank each project based on the three variables established above.[13] When this game is through, they'll tally the points for each variable for each project and ultimately determine which projects bubble to the top. Stay with me. I'll show you how it works.

The first item each person[14] will rank is Features.[15] If there are six projects, she'll need to assign ranks of 1 to 6; if there are five projects, 1 to 5. No item can have equal weight assigned to it by any one person, and every item must be ranked. Explain that the group will rank Features based on *most to least valuable or unique*. So they'll assign "1" to the project with Features that are most valuable or unique and "5" to the project with Features that are least valuable or unique. Now that everyone knows the ranking rules, give the doodlers time to think quietly about the Features of Project X and rank its collective value relative to the Features of Project Y, then Project Z, and so forth. Let the people know that they're not being asked to rank Features one-to-one.[16] The question at hand is how the person would rank the overall project next to its peers based on the understanding of its Features mapped during the

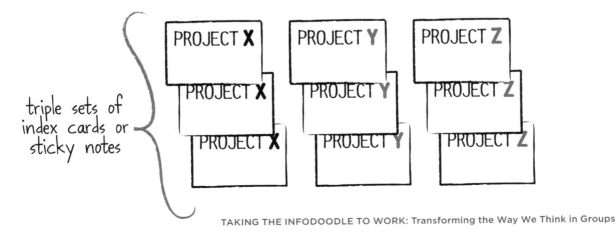

triple sets of index cards or sticky notes

first game. After a doodler considers the Features of all projects relative to the others, he should end up with individual sticky notes that show a forced ranking of 1 to 5 like the image shown below.

PROJECT FEATURES

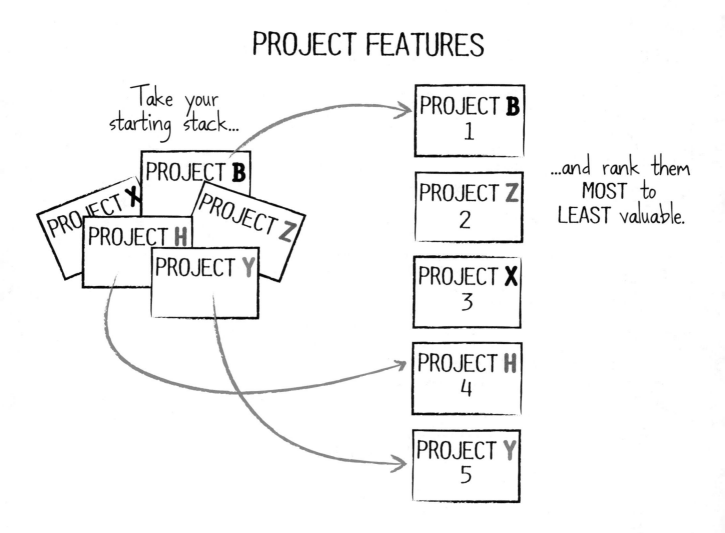

Take your starting stack...

PROJECT X
PROJECT B
PROJECT H
PROJECT Z
PROJECT Y

| PROJECT **B** |
| 1 |

| PROJECT **Z** |
| 2 |

| PROJECT **X** |
| 3 |

| PROJECT **H** |
| 4 |

| PROJECT **Y** |
| 5 |

...and rank them MOST to LEAST valuable.

When the group next ranks Benefits and then Challenges, ask them to go through the same sorting process, ranking Benefits from *greatest to least* and Challenges from *easiest to hardest*. So they'll assign "1" to the project with the greatest Benefits and to the project with the easiest Challenges to overcome, and they'll assign "5" to the projects with the least Benefits and with the hardest Challenges. Again, give the people enough time to thoughtfully make their considerations. This ranking could determine how they spend their time for the next two years because it's the setup for the final tally.

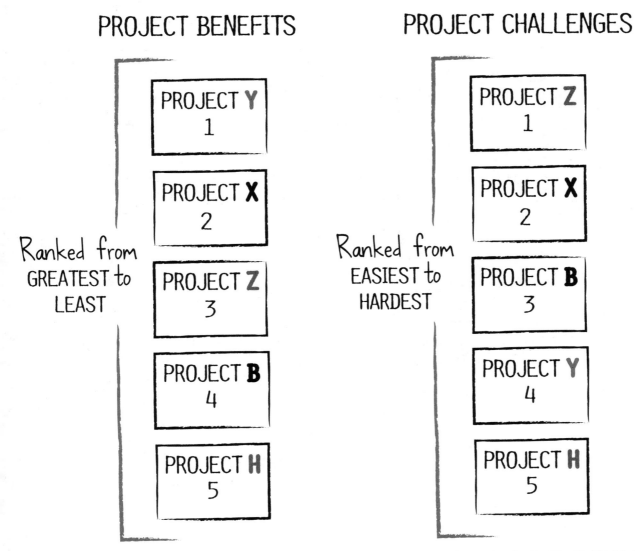

PROJECT BENEFITS

Ranked from GREATEST to LEAST

PROJECT Y
1

PROJECT X
2

PROJECT Z
3

PROJECT B
4

PROJECT H
5

PROJECT CHALLENGES

Ranked from EASIEST to HARDEST

PROJECT Z
1

PROJECT X
2

PROJECT B
3

PROJECT Y
4

PROJECT H
5

The last step to complete the game is to ask the group to post their rankings on the wall, as shown below. This gives the group a visual summary of everyone's deliberation (and it can be used for a deeper discussion later, if you choose to go there).

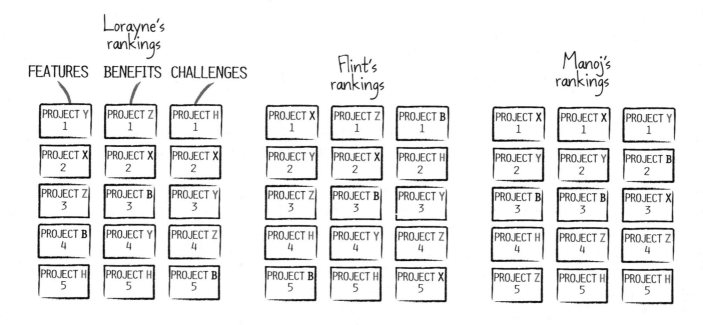

Lorayne's rankings

FEATURES	BENEFITS	CHALLENGES
PROJECT Y 1	PROJECT Z 1	PROJECT H 1
PROJECT X 2	PROJECT X 2	PROJECT X 2
PROJECT Z 3	PROJECT B 3	PROJECT Y 3
PROJECT B 4	PROJECT Y 4	PROJECT Z 4
PROJECT H 5	PROJECT H 5	PROJECT B 5

Flint's rankings

PROJECT X 1	PROJECT Z 1	PROJECT B 1
PROJECT Y 2	PROJECT X 2	PROJECT H 2
PROJECT Z 3	PROJECT B 3	PROJECT Y 3
PROJECT H 4	PROJECT Y 4	PROJECT Z 4
PROJECT B 5	PROJECT H 5	PROJECT X 5

Manoj's rankings

PROJECT X 1	PROJECT X 1	PROJECT Y 1
PROJECT Y 2	PROJECT Y 2	PROJECT B 2
PROJECT B 3	PROJECT B 3	PROJECT X 3
PROJECT H 4	PROJECT Z 4	PROJECT Z 4
PROJECT Z 5	PROJECT H 5	PROJECT H 5

The group then tallies the amount each doodler assigned each project for its Features, Benefits, and Challenges. You can conduct the tally systematically, working either across rows or down the columns and tracking the "points" each project received, like so.

Row 1	X (3)	Y (2)	Z (2)	H (1)	B (1)
Row 2	X (8)	Y (6)	Z (0)	H (2)	B (2)
Row 3	X (3)	Y (6)	Z (6)	H (0)	B (12)
	14	14	8	3	15

* I neglected to include rows 4 and 5 here because I don't believe I need to. I know you are capable of extrapolation around how to tally.

Or you can assign each project to someone in the group and ask them to add up how many points each project got. Either method leads to the same result, which is that the projects with the LEAST points are the desirable ones and the projects with the MOST points may need to end up on the chopping block.[17] After all your hard work this is a portentous moment because it indicates to the group which projects, from their perspective, seem to be most worthy of pursuit. These will also be the projects you take forward to the Infodoodle game that completes your Planning Meeting.

To close this activity, ask the group to illuminate their thinking on how this final ranking emerged. Was it based on what they perceive to be their expertise? Was it shaped by their awareness of what leadership will and will not allow? How much did they consider the organization's big picture versus a more limited view? Did the ultimate ranking result from a subconscious concern around time or resource constraints? You're the Infodoodle Leader! Ask your troops questions. Let the group's knowledge and experience shine some light on what they decided.

Best Practices for Forced Ranking

• This game is played with sticky notes or index cards, along with your requisite markers.[18] (You should probably get a holster for those as you'll need them for the rest of your Revolutionary life.) Because, remember, as Infodoodlers, we are masters of visual language as a trade and a craft, and as such, we use any tools available to help us display information.[19] A sticky note is just a square somebody made for us in advance. Just because we didn't doodle it doesn't mean our visual cortex doesn't recognize it as a legitimate square and therefore a component of visual language.

• Keep in mind two factors that affect the accuracy or validity of the ranking process: the asymmetry of information and the biases people have either for "pet" projects or for projects they want to see in a pet cemetery. With respect to the first factor, because people do not share the same brains, the odds of each person having the same measure of knowledge and the same perspective of each project in order to rank them is nil. That doesn't mean you should snort to the heavens and chuck the whole idea of ranking. The experience of this game still gives you a LOT of information. What can you learn from it? (Man, I wish you could talk to me right now.) Well, for one thing, you can get a pulse from your participants on what they consider important. You can make some guesstimates on why they consider this ranking important (or you can ask them). You can get insight into where they think resources or human capital is missing. You can understand how well they know their purpose and vision as a team. Force the ranking, friend. Even if later, you or someone else changes the ranking and shifts the projects to be pursued, you still harvested information like a mighty scythe.

• Since you and the group conducted discrete rankings for Features, Benefits, and Challenges, it's not a bad idea to take some time to review those rankings in isolation rather than based on the final tally. Maybe one project won decisively based on Benefits but suffered due to the Challenges it brings. It's possible your team still wants to brave any looming consequences and pursue projects

that have a higher ratio of risk versus reward. Did you ever think about that? Huh? Huh? At any rate, if you've got time in this meeting, do investigate the rankings that preceded the final tally. There's likely to be juicy information there, too.

- If your group size leans toward fifteen to twenty people, I'll tell you in advance that trying to rank anything with fifteen or more voices can be an exercise in nuttiness. If your group is largish, have them conduct a miniranking in small groups first, then tally those results with the large group afterward. One of the dangers as groups grow in size is that the opinions of the quieter types (you know who you are—you're my favorites!) can become lost in the shuffle, and the ranking can become unwittingly dominated by our more vocal comrades. If you're concerned about bias, small-group breakouts are one way to attempt to mitigate this problem.[20]

- You can dramatically shorten the duration of this game by conducting the ranking aloud yourself. Draw two project cards at random and ask your small group to agree aloud on which project should be #1 and which should be #2 (based on your first category, Features). Once they've agreed on that, draw another project card. Ask if it should be #1, #2, or #3 based on its Features. Get verbal group consensus each time. Draw a fourth project card and ask the same question. Repeat this process until all projects have been evaluated based on Features, Benefits, and Challenges. Then add up the points and voilà. The group has coranked projects as a unit rather than as individuals or small groups. This method may not be as thorough, but it is faster.

GROUP INFODOODLE #3: GAMEPLAN

Goal of Gameplan:
To map the steps required to make progress toward project completion, and to give visual consideration of what steps may need to be reordered, collapsed, conducted simultaneously, or removed from the process altogether. Can also serve as either a preliminary or a purposeful attempt to establish a project timeline and role assignments.

Number of Infodoodlers Needed:
Whoever's available and willing from your original group. You might also invite meeting "outsiders" who have explicit knowledge of project steps.

Duration:
30 to 60 minutes.

Notable Assumptions:

1. That the Forced Ranking game resulted in a usable assessment of the projects worth pursuing (consequently making this next game *not* a waste of time).

2. That the individuals or groups involved in game planning have a general sense of the steps required to execute the project.

Gameplan How-To

Now that the team has collectively prioritized the projects they want to pursue, you can move them skillfully into the last game. This exercise is beloved by my doodlers

fond of organization because what you see below is one of the least free-form diagrams on your legend.

Remember when we learned that some information has a visual DNA? Well, sequential project steps fit wonderfully inside of the Gameplan matrix, which allows for a guided, numeric plotting of one foot before the other. Because of its more rigid visual structure, the Gameplan offers a straightforward method of mapping an order of operations, which is what this game is all about.

To begin, assign the surviving projects to people or groups, then ask them to re-create the diagram below inside of their visual space. Their matrices need to be large enough to accommodate whatever size sticky notes they're working with, and they should allow at least ten to fifteen columns in case a project involves numerous steps.

Now, down the left side of the matrix, have them write each project name they're working on in its own row (tell them to doodle the project icons if they'd like!). If there's only one project per group or per person, they'll only need one row and multiple columns. However, if you think the groups will want to assign tasks to people, get more microscopic or detailed around project steps, and/or include a tentative timeline. It's cool if they add more rows because the rows can be used for that (as can any surrounding white space). Across the top of the matrix, ask them to write the word "Tasks."

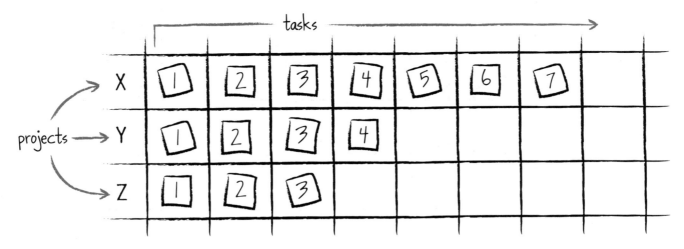

The goal here is to slowly build out the sequence of steps required to get a project done. There are no tricks to this game—it's straight-ahead planning, and it almost runs itself. What the Gameplan asks of the group is for them to put their heads together and visually break down each step of a project. By posing this question, you'll discover that the participants instinctively begin to investigate the necessity of the steps as well as their sequence. They start having discussions with themselves and each other about how *best* to bring the project(s) to completion. Most people can't comfortably fill in a project matrix without asking substantive questions of that movement from A to Z. In other words, the process will trigger the discussion. You as the meeting lead mostly just need to set the game up, then wander around, asking the occasional probing question and offering

encouragement. As you do, you'll likely encounter people asking if it's all right to add roles and timelines. Tell them it certainly is. For deadline-based projects, some teams will use a due date as a driver to help determine which steps are in and which are expendable. Assigning roles can also affect what pieces of the project come to life. Explain to the hardworking doodlers that they can accommodate those details by either creating extra rows above or below, or by using surrounding white space to add smaller sticky notes with comments or role assignments, as in the Infodoodle below.

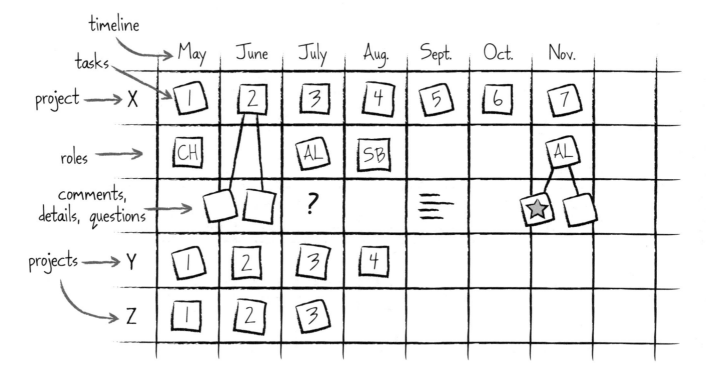

As Gameplan draws to a close, each group's final output should display all the high-level tasks (and perhaps many of the granular tasks) required to execute a project. In closing this game, invite groups or individuals to share their work. (But please don't ask them to outline the tedious steps of each project. What a snoozer that would be.) Solicit any insights they had about the best approach to project execution, and ask if any steps fell away, shifted, or merged with other steps. Their peers may want to hear what discoveries they made about doing what, when, because it might inform their own project planning going forward.

real-world Gameplan example

Best Practices for Gameplan

• Most organizations ultimately organize and carry out projects in a digital and shareable space. The Gameplan ends up being a large, physical mural and is largely designed to help groups think through steps and timelines before going off in hot pursuit of project completion. Odds are that your team has an established way of creating and sharing project timelines and milestones,[21] so ask someone in the group to be responsible for translating this information into your digital working document. She can take photographs with her phone and use them as reference, or move the mural itself into an office for reference while moving the content into an online document or shared project management system.

• Like Forced Ranking, the Gameplan can be conducted as a whole-group exercise, depending on the size of your group.[22] As the meeting lead, you can list the projects down the side of the matrix and work with the group to fill the steps in together. This works best with fairly simple projects and with the group's attention at a very high level of planning (in other words, avoiding the minutiae). You can also assign projects to individuals or small groups, ask them to do a quick, scrappy version of the project steps, and plot them along the appropriate row in the matrix. Then y'all can examine and modify their work together.

• If you have less than one hour for planning with your group, select which bit of the sequence above would be most valuable for the present situation. If you can't proceed with the Gameplan because you have a sneaking suspicion that your project priorities are out of whack, then take that time to just focus on the first one or two games. If your team isn't yet clear on the Features and Benefits of a project, indulge the Infodoodle exclusively for Project Mindmap and use the

output the next time you have people together. If everyone is crystal clear on the projects and how they rank relative to their peers, jump right into the Gameplan. These sequences aren't meant to be rigid—they're like our diagrams. They're here to guide you but not to lock you in. Use your wits to figure out what's best for the session you're leading. Power to the Doodle People!

So there's your Planning Meeting, friends, Infodoodlized for optimum engagement. If you conducted all three of these activities, you and the group could spend anywhere from one to four hours on this sequence. A lot of variables affect how quickly this flow can go, but it is *the sequence itself* that assures that the planning work of the group is done in a sense-making way. Too many of us bring people together ostensibly to "plan," but we have built no plan in order *to* plan.

We don't have that problem in Infodoodle culture. Infodoodlers structure our time so it serves us. We design both our space and our thinking. We use the Group Infodoodle to keep people interested and turned on. This is why everyone shows up to our meetings, does great work, stays until the end, and then tells all their friends about it.

PROBLEM-SOLVING MEETING

GROUP INFODOODLE SEQUENCE:

1. VISUAL STORYTELLING
2. F.A.B.I. GRID
3. EMPATHY MAP
4. HEURISTIC IDEATION
5. FORCED RANKING

Meeting Goal:

To solve the problem of new innovation around products, services, customer experiences, brand campaigns, etc.

GROUP INFODOODLE #1: VISUAL STORYTELLING

Goal of Visual Storytelling:

To expose the meeting participants to a topic outside of the business context in which they operate and possibly outside of the era in which they live. This presentation needs to lay the groundwork to ignite innovative thinking during the Infodoodle activities that follow.

Number of Infodoodlers Needed:

One presenter or multiple presenters, usually from outside the organization, and an audience size of four and upward.

Duration:

10 to 20 minutes.

Notable Assumptions:

1. That you can bring in a presenter from outside of the organization or invite someone internally to speak with depth on a topic that's distinct from the context in which everyone works.

2. That the speaker will deliver an engaging talk using visual and tactile aids. This needs to be visual and immersive storytelling, not a sit-and-listen experience.

Visual Storytelling How-To

When considering a speaker to kick off this Infodoodling sequence, look widely and choose wisely. The purpose of visual storytelling (for this meeting) is to spark thoughts about a topic beyond what the participants know *so that* they can apply new insights to old products or services, or design things entirely anew. You can choose anybody to talk about anything as long as they'll do so in an interesting and visual way.

Before you start surveying possible speakers—from both within the organization and outside it—consider what topics may serve the ultimate goal of the meeting, which is to stimulate innovations. Your instinct may be to choose a topic or expert that's close to the subject matter of the organization, but when it comes to radical innovations, the more distinct that two topics seem to be (say, telecommunications and caving), the better. It's extremely easy for people to get trapped in habituated thinking, so if you choose a topic that appears mysteriously unrelated to the work of the company, know that that will very likely *support* the creative process. You'll see how when we move to the other Infodoodle activities.

It's also important to consider how futuristic you want your topic to be. For many companies, the real challenge of this sequence lies in getting people to s-t-r-e-t-c-h the boundaries of what's possible. Bringing in a futurist or a cutting-edge trend watcher may be worthwhile to establish a truly imaginative experience. The decision is yours, of course, and the reality is

that innovation is available everywhere. It'll be the thinking process you lead for the group that makes the biggest difference.

Once you've considered a speaker or topic, next consider how to best deliver the "visual" in Visual Storytelling. Your speaker hopefully already has ideas, but you can encourage her to consider any or all (!) of the following: slides, videos, props, storyboards, improvisation, interactive audience participation, role-playing—anything that helps the audience see and understand the story more fully. We know by now that multisensory processes keep people present and interested, so don't sacrifice the experience or compromise the goal of the process in exchange for some hotshot über-cerebral speaker. The speaker's status and IQ are not the point—the content and experience she delivers is the point.

Here's one example of how a speaker could present using a visual display that evolves during a presentation.

You can see that some information is already in place, but the presenter can fill in blanks and add visual content and sticky notes as she speaks. She may also choose to include some "reveals" as she progresses through her talk. Reveals can involve peeling off paper or sticky notes that are covering information, turning around a flip chart that was facing away from the audience, or lifting a cloth under which an object was hiding. This way of presenting piques people's interest with preliminary visual information and holds their interest since they get to see the information either "appear" or be filled out. The mystery puts questions and intrigue into the minds of the audience, and we can hardly resist a question mark. That's one reason link bait[23] works so well.

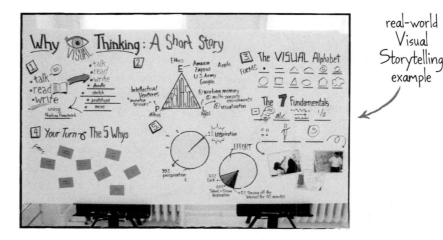

real-world Visual Storytelling example

Before the speaker opens, you'll need to alert the group to a simultaneous task during Visual Storytelling. Let them know that *while* listening to the speaker, they're responsible for capturing thoughts for the F.A.B.I. Grid exercise to follow. Each time they hear a Feature, Adjective, Benefit, or Idea discussed by the speaker (and you can define those categories for them), they should write it on a sticky note (one thought per sticky, please!). This input will provide the ingredients for Group Infodoodle #2.

Best Practices for Visual Storytelling

• Provide your speaker with a clear time frame. Think short, sweet, and powerful, with a talk and experience that's ten to twenty minutes long. Shorter than that and there may not be enough substance. Longer than that and people's attention can start to drift.

• Make sure the speaker understands the purpose he's serving. Let him know that his talk is part of a larger process designed to result in innovation. Speakers benefit from having a frame of the context since they can use the context to inform their content. Let the speaker know where and how he fits into the bigger gameplan. This will also alleviate any disorientation he might feel when the participants start writing on sticky notes during his presentation.

• Since the Visual Storytelling activity is one part of an innovation process, this particular experience should be designed to trigger curiosity and open-ended thinking. Select a speaker and a topic that's futuristic, unusual, surprising, or even totally unfamiliar to the group. The goal is to leave them open to possibilities. If they think they already know the topic, their minds close. Introduce a subject matter that explores futures or themes outside of what's "normal" for the group.

• Before the meeting, keep the speaker a surprise. If the participants know who's coming, they may look up other talks the speaker has given, thus compromising the value of wonder. Make the speaker's substance and style an unknown entity. The unexpected will keep people interested.

In Visual Storytelling How-To section, I noted that the participants will be asked to generate information on sticky notes simultaneously with the presentation. This means they need to pay close attention to what the presenter is saying so they have good data to plot in Group Infodoodle #2, the F.A.B.I. Grid.

GROUP INFODOODLE #2: F.A.B.I. GRID

Goal of F.A.B.I. Grid:
To break down and display elements of the presentation so this granular information can be used for constructive or combinatorial creativity (a.k.a. mash-ups or remixes) during the Heuristic Ideation Technique.

Number of Infodoodlers:
Everyone involved in the meeting who heard the opening presentation.

Duration:
Occurs simultaneously with Visual Storytelling (which should be between 10 to 20 minutes). You can allow 5 to 10 additional minutes working in silence postpresentation.

Notable Assumptions:
None to write home about.

Mind the overlap! Remember that the content for the F.A.B.I. grid is produced concurrently with the Visual Storytelling part

of the program. Each person listening to the Visual Storyteller is instructed to capture the Features, Adjectives, Benefits, and Ideas that are inspired by the talk, writing one thought per sticky note. This means you'll need to explain this before the Visual Storyteller begins, and it also means you should clearly define each category up front. "Features" involves characteristics of the technology, industry, or trend being described. If a presenter is discussing the future of video gaming, for example, Features may include "avatars," "haptics," or "massive multiplayer." "Adjectives" should capture descriptors that bubble up during the presentation. Adjectives involving caving, for example, might be "unpredictable," "dangerous," or "travel-intensive." The adjectives people write don't need to be explicitly stated by the speaker—they can be adjectives the participant thinks of while listening. "Benefits" should detail value-based contributions of the technology or industry being discussed. If the talk is on medical technology, Benefits might include "mobility," "data capture," and "real-time alerts." Anything the topic includes that's significant to its customers, or even to society at large, counts as a Benefit. Last is our category "Ideas." Some of your creative thinkers may come to the session with ideas based on the broad meeting goal, or they'll be rapidly generating them based on the presentation. We want to capture these preliminary ideas so they can be stirred into the innovation soup. Like all the other categories, one Idea per sticky note.

To proceed with this Group Infodoodle, display a simple grid drawn beforehand. Establish the white space—be it multiple flip chart sheets or artist's paper on a wall—and divide it into four sections. (You can also use a whiteboard, but keep in mind that sticky notes and whiteboards don't always play well together. The group can post notes on a whiteboard grid, but don't be surprised if some of them flutter to the ground. Some of the sticky notes will end up traveling on purpose, however, since the group may peel off a few to use in the remaining Infodoodle actions.)

With your grid established, in large letters, label one section "Features," one "Adjectives," the next "Benefits," and the final one "Ideas." (You know you can also draw pictures for these items.) This space is where you'll consolidate what the group has come up with during the course of Visual Storytelling. The most important thing about this visual structure is that you have enough room to gather the group's thoughts and that the separate sections (and possibly their definitions) are visible to everyone.

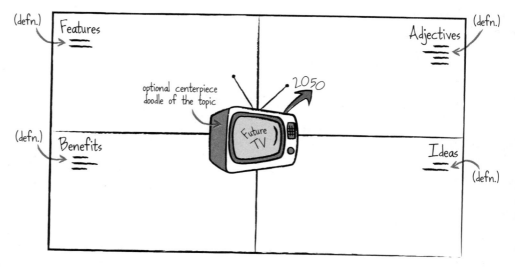

After listening to the Visual Storyteller and capturing thoughts as they go, your group will need a bit more time to quietly consider what they've heard. Encourage them to continue writing down Features, Adjectives, Benefits, and Ideas that the talk may have inspired. Then ask everyone to bring up their sticky notes, posting them in the corresponding quadrants of the F.A.B.I. Grid. Advise them that if they notice comments similar to their own, they should feel free to cluster notes together. This way, obvious themes will begin to emerge.

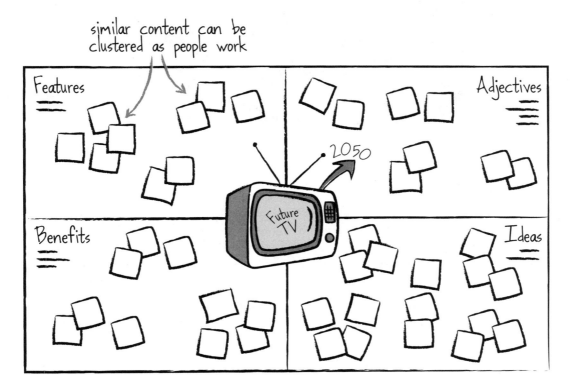

Once the quadrants are filled, lead a brief discussion around each quadrant. Make note of those Features, Attributes, Benefits, and Ideas that are repeated—but give focus to outlier thoughts as well. Unique and unusual sticky notes may end up being where real innovation blossoms.

Close the game by acknowledging the Visual Storyteller (if she's still present) and give the participants an opportunity to voice any thoughts about what they heard, particularly as they relate to new ideas the topic may have sparked. They know the context is about innovating, so if there's any energy on that, let that dialogue open now. Then explain to them that the next exercise will have them thinking like the person they're about to design for. (Onward to the Empathy Map!)

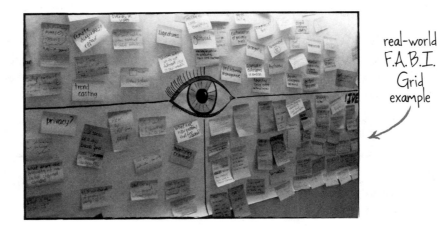

real-world F.A.B.I. Grid example

Best Practices for F.A.B.I. Grid

• The large grid on display should include the words "Features," "Adjectives," "Benefits," and "Ideas," and ideally, it would have an icon or doodle in the center of the white space reminiscent of the topic. You can also write the definitions of each category on the grid. The visual serves as a reminder to you and your group of what needs to be done during Visual Storytelling, and it informs them of how to categorize content.

• Don't let the group get hung up on overlap among the definitions of Features, Adjectives, Benefits, and Ideas. People writing about television could think of "recordable" as being both a Feature and an Adjective. The categories don't need to be black-and-white, because they can all be used to inform the larger creative process as the group moves through it.

• If an individual or individuals in the group seem particularly adept at grouping and clustering similar thoughts and sticky notes within each quadrant, by all means empower them to do so. It will help in identifying themes and lines of thought.

GROUP INFODOODLE #3: EMPATHY MAP[24]

Goal of Empathy Map:
To intentionally understand and map what your clients or customers might be experiencing and frame up what is of value or interest to them, as a way to solve problems and prime for the next activity.

Number of Infodoodlers Needed:
Can be done with volumes of people, as long as they're broken up into smaller groups of approximately 3 to 6.

Duration:
15 to 20 minutes.

Notable Assumptions:

1. That the group has enough information or insight about current or prospective customers to produce a useful Infodoodle.

2. That the category of customers has been determined beforehand, or will be determined quickly before the Infodoodle begins, if it's best to map multiple customer types.

Empathy Map How-To

When setting up any Infodoodle exercise, you'll need to explain its purpose. In this case, the purpose of the Empathy Map is to focus attention on the customer or end user of a product or service, prior to attempting to design something new with her in mind. Developing what design thinkers call a "persona" is a way of temporarily getting into someone's head, to consider her needs, context, behaviors, preferences, etc. The Empathy Map is a reliable tool to shift the perspectives of Infodoodlers because its very nature requires that we anchor our default view to someone else's view and look through her lens of experience. We once led an Empathy Map exercise that positioned the CEO of a large company as the "customer," and it was clear that many of the people in the room felt the immensity of this person's responsibilities for the first time.

Understanding another human being, even for a moment? Priceless.

Start by determining which customer(s) the group is being asked to consider. Are they innovating for VPs in large tech companies? Are they designing for public school teachers? Who is the center of this world? Once they've established their persona(s) or been assigned one, ask the group to give this person a name and title. If there's relevant demographic or psychographic information, let them know they can include it on the map. (And if there's a real and representative customer someone knows and can identify—Ishita Paintal in Austin, Texas—that can make this process all the more authentic. You can even bring photographs of real people and post them up.)

In a large white space, ask the group to choose one person to draw a big circle in the center and add eyes, ears, and mouth to complete what will become the head of their customer. (If you're wondering if it's acceptable to add hair, eyeglasses, or jewelry, the answer is *bien sûr*! Someone can draw a whole person if he'd like.)

Next, divide the space surrounding the head into six sections and label the areas "Thinking," "Seeing," "Hearing," "Saying," "Feeling," and "Doing." (It's a nice touch to align the sections with the parallel body parts—top of the head, eyes, ears, mouth, and the spaces where the heart and hands would be.) You see where we're headed with this—to a place where empathy is possible for a person in whose shoes the group may never have walked.

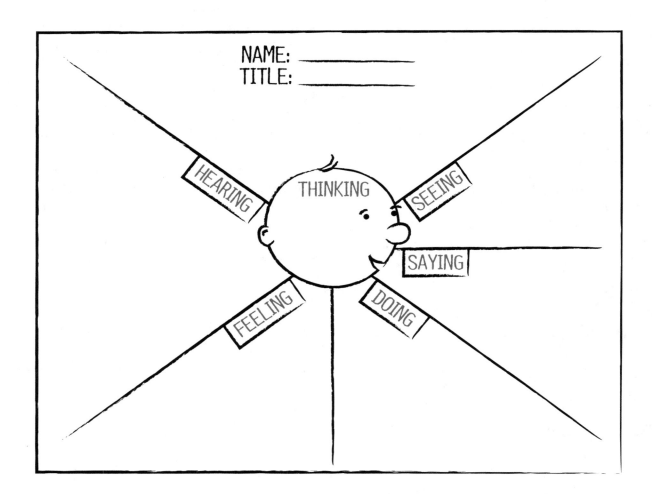

The goal is to populate this map with information about this person. Ask the group to inhabit this person's point of view as they move from category to category. In this person's work, what does she see? Does she see a marketplace that's getting more competitive? Does she see customers unsure of where their loyalty lies? How does she feel? Overwhelmed by the immensity of some task before her? Excited to be leading in a certain space? What are people telling her? What action is she taking relative to the information coming in? The Infodoodlers should be asking questions to get a fuller awareness of the "head's" experience. This will give them personal customer context to guide the robust innovation process, which happens next.

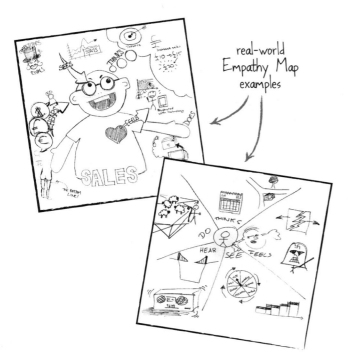

real-world
Empathy Map
examples

Best Practices for Empathy Map

• If your group is composed of ten or fewer people, this Infodoodle can be done all together in one good-sized white space. Bigger gatherings can be divided, with three to six people in smaller groups. Each smaller group should have at least their own flip-chart-sized paper to work with.

• If multiple Empathy Maps will be created, you can assign different personas to each group to explore, or simply allow them the freedom to choose a personality they feel is a potential customer. The entire group can "get to know" each different personality through a brief report-out if need be.

• As with many Infodoodles that invite multiplayer participation, tell your folks not to wait to get consensus on what the customer is experiencing. Each person can either write directly in the space or on individual sticky notes, and a conversation about the content can ensue after the information has been populated. A follow-up conversation is often where the outline of a customer can become clearer.

• This Empathy Map experience is intended for a quick, high-level orientation to customers so a product or service can be designed with them generally in mind. You can, of course, conduct more rigorous and prolonged activities investigating customer needs, behaviors, and preferences, and techniques for deeper dives into customer profiling are available online and in many books on design thinking involving customers or stakeholders. This Infodoodle aims to loosely orient the groups to people relevant to their innovation process, not to rigorously examine each persona's ins, outs, and milieu. Getting to know people thoroughly can be an entire Infodoodle sequence all its own.

• Including details about the customer can be a double-edged sword. At times, demographic and psychographic information helps result in a product that really speaks to the needs of specific populations. That said, too much detail can be restrictive and have a dampening effect on the innovation process (e.g., attempting to design a product for mothers in their twenties who live in food deserts may be too narrow a task). Also, people are complex, not easily reduced to statistics, and their

preferences aren't necessarily clear based on age, race, location, ethnicity, job title, etc. Be aware of whether those details are helping to inspire thinking or inhibiting it in various groups, and adjust the specifics if it feels appropriate.

- A variation on the six categories for the Empathy Map can involve switching them to reflect five different categories: "Cognitive," "Physical," "Cultural," "Social," and "Emotional."[25] Cognitive aspects involve how people associate meaning with products or services they interact with, or how they may think about them in their lives and work. Physical aspects relate to what's in a customer's physical environment or how she kinesthetically engages with an object or product. Cultural aspects include an investigation of norms, values, or beliefs and how those manifest in behavior. The Social category involves how people behave, interact, communicate, coordinate, and work together using some product, service, or tool or in the context of a social sphere. And the Emotional aspect queries how people feel based on the frame your group chooses to peer through and what triggers those emotional responses. The group can consider and document each of these categories to have an entirely different experience with the Empathy Map.

- When the activity ends, keep the Empathy Map(s) up and visible during the course of the remaining work. Everyone should feel comfortable "checking" innovations by referring back to the map(s) to assess whether an innovation would plausibly serve a particular customer.

GROUP INFODOODLE #4:
HEURISTIC IDEATION TECHNIQUE (H.I.T.)

Goal of Heuristic Ideation:
To combine disparate elements, features, benefits, and ideas in order to innovate around products or services, systems or processes.

Number of Infodoodlers Needed:
However many you've got on hand.

Duration:
15 to 90 minutes, or as much time as needed to produce volumes of ideas to be ranked around viability and innovation next.

Notable Assumptions
None that we need to discuss at this juncture.

Heuristic Ideation How-To
This Group Infodoodle is a powerhouse for innovative thinking. You'll be floored at the ideas that come spilling forth when people engage in the basic act of combination and recombination. Remember the time spent earlier in the sequence on capturing Features, Benefits, and Ideas?[26] This is where that work comes into play.

To start, ask the participants to quick-doodle a matrix in a large white space. Depending on how much time you have, you can give the matrix as many rows or

columns as you'd like. The purpose of the matrix is to provide a space in which the participants can collide concepts from the topic the Visual Storyteller introduced them to with features or attributes of a current product or service. It sounds simple, and the mechanics of the game are simple indeed. The power comes from the creative thinking that results from these mash-ups.

The matrix will need variables along the x- and y-axis. It's not important which axis you choose to label—the collision points are where the juice is. Along one axis, ask the group to select one product or service (or ad campaign, for that matter) they want to innovate around and delineate some of the features of it. It's preferable to use sticky notes for this so you can easily switch them out, but it's not critical.

Along the other axis, ask the group to select Features, Benefits, and Ideas that interested them or that seem to suggest creative possibilities, and post them. These can be plucked from that original F.A.B.I. Grid or created anew. There's no huge need to be meticulous on selecting these items, although some groups will take time and possibly even get stuck on doing that. Let them know that the prospects of innovation are tucked away abundantly in the hybrids, so honestly, you could throw in the word "fairy," and it wouldn't wreck the experience in the slightest. It just might shake it up a bit.

It's collision time. As a small group, the participants should consider each square where row meets column and start the rapid generation of possible innovations. A hypothetical example: Say the group is looking at one tool used in caving (flexible ladders) and one product built by their company—a digital tablet. The question being posed to them is, what are the possibilities when you attempt to take elements, components, uses, or characteristics of a flexible ladder and layer or embed those things into or onto their digital tablet? What could a flexible ladder offer to an upgraded or revolutionary version of that device?

At first, people can be stumped. It's like asking how a clown might help you grow out your hair. Whaaaat? Encourage them to DIG IN. Make up prospects as if they were children. No judgment. No expectations. Just inventiveness in its unadulterated form.

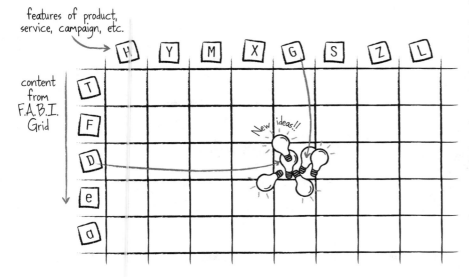

features of product, service, campaign, etc.

content from F.A.B.I. Grid

New ideas!!

Here are some newfangled ideas I came up with:

· A tablet with an interface that gets more sophisticated as the user gets more experienced (i.e., as the user goes up the ladder of learning)

· A tablet that bends and flexes without breaking or compromising viewing quality

· A tablet that collapses into itself on hinges

· A tablet that folds into various boxy shapes so you can stand on it (DON'T judge me)

· A tablet that bridges gaps in close-knit communities of programmers, sensing when a programmer needs a snippet of code for a certain task and offering different options when she appears stuck

I think you see how the challenge is not in constructing a new possibility. The challenge is in being willing to. Because I've worked with groups in many contexts, I know that some of you are assessing the viability right now. You can't help it. But do not dismiss ideas out of hand. That is not what knowledge-seeking Infodoodlers do. Consider that each of these five ideas can be further examined for a seed of an idea that could actually pass go. Understand that the matrix is utterly agnostic about the variables you choose to combine. For the example, I chose a specific product. But players could combine even the most minute details about that product to innovate inside of those spaces. You could combine touch-screen scrolling with ladders, email notifications with ladders, typefaces with ladders, on-/off-switches with ladders, *any aspect of a digital tablet* with ladders. This Group Infodoodle is limited by nothing other than the imagination. So get to it.

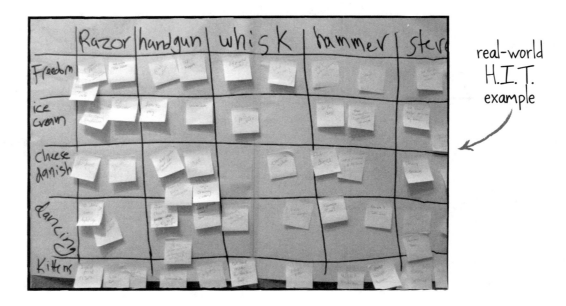

real-world H.I.T. example

Best Practices for H.I.T.

- Do not have one person in the group hold the sticky notes and write down one idea at a time. Everyone should have a set of sticky notes and be rapid-firing and writing or doodling ideas like a machine gun—from the obvious to the goofy to the mundane. The viability or usefulness of an idea will be determined later. ANYTHING goes during the idea-generation process, and nothing is to be discarded at the onset.

- Adjust the matrix size depending on how much time you have. A 4-by-4 matrix can yield, at minimum, sixteen innovations. A 9-by-9 matrix, at minimum, ups it to eighty-one. Typically, you'll yield much more than the minimum, however, because each person will generate multiple possibilities inside of each collision space. (True, there will also be collision spaces where no innovations show up.) Gauge how much time you want to spend on H.I.T., and if you decide it can be fairly lengthy, build in breaks and "walkabouts" for people to take. Creative thinking burns serious calories, so people will very likely need to reboot during a longer process.

- Ask the group to avoid predicting the combinations. Many types of thinkers (including engineers, accountants, and economists) love to anticipate the outcome of a combination before it comes to life. This bleeds all the fun out of the rapid generation of ideas and imposes structure around an experience that actually requires unfettered, unpredictable thinking in order to succeed.

- If you notice that the group isn't generating really radical innovations—believe me, it can be hard for any group—interrupt the flow temporarily and introduce a technique called "Break and Build."[27] Break and Build trains people on perceptual and constructive creativity, which is the deliberate use of nuanced perceptions and the combination of those nuances to build something new. To facilitate Break and Build, ask the group to think of one product or service they need to innovate around (e.g., cloud consulting) and then give them two random nouns (e.g., taxi and frying pan). They can then produce mind maps for the two random nouns, breaking them visually into many smaller elements and then using combinations of those elements to transform the product or service and give it greater value. "Taxi" could break down into "yellow," "driver," "transportation," "wheels," "moving," etc. "Frying pan" could denote "nonsticky," "heated," "heavy," "shiny," "affordable," etc. The idea is that when the nouns are deconstructed, each piece deconstructed can be applied to the product or service, turning it into something it wasn't before. This exercise really opens people to the idea that innovations are innumerable and can be tucked inside of "atomizable" systems, systems like a frying pan. Tell the group to go for quantity first. They'll get to quality, but first they must produce, produce, produce.

- Do not try to get consensus around whether something is a "good" idea or outcome. This slows the process dramatically and has the unfortunate effect of injecting paranoia into the group's thinking process.

- Consider even those innovations that at first seem absurd. I mean this, people! Patients with peptic ulcers used to have parts of their stomachs removed because the prevailing wisdom for decades was that ulcers weren't an infection and therefore antibiotics would never work. We *don't know* everything! We need open minds—even when a suggestion is considered laughable.

- After looking across the matrix for promising combinations, the group may want to take some time to develop fast prototypes or sketches of the new item. Give them time to do that if you've got it.

- Organizational culture tends to come into sharper focus when a group is asked to get creative. This activity is where you may witness the relative openness and trust the group is lacking. Be keenly aware of any stifling dynamics and adjust members of a group if any seem to have too many "black-hat thinkers." One or two members of the group oriented toward critique can seriously suffocate ideas being born.

- Don't hesitate to ask leadership (or over-bearing management) to take a break during this Infodoodle since their presence very often has a dampening effect.

- Because this game asks people to really turn up their neurological hot spots, you may need to model the behavior you're asking of them. Be ready and willing to generate multiple subpar ideas on the spot in front of the group so they understand that quantity is a desirable attribute in this process.

- When the group gets stuck, wander by each smaller group and introduce a random word. Tell them to evolve some of their innovative concepts using this random word.

- Once the group has generated a variety of innovations, you might pose this question for them to consider as they segue to the last stage of the Infodoodle sequence: What would someone hire this innovation to do?[28] Reframing the conversation around the use and application of a product or service, rather than on designing toward perceptions about customer demographics, often opens up a whole new base of customers to sell to, which in turn makes more innovations possible. It's a great way to reframe the discussion and trigger more insights and ideas before the session's end.

- While I'm reluctant to acknowledge this last point, the type of thinker involved in this Infodoodle can dramatically affect the outcome. It's faster to have a smaller number of wickedly creative, risk-taking people than to have a larger number of people who've spent almost no time coming up with new ideas. The capacity to innovate is undoubtedly available to all of us, but creative thinking is like a muscle, and there are people who've been exercising that muscle more purposefully and more often than others have. Be aware of your expectations for the group. It's best to base them on people's actual experience, not on what you determine they should be able to do. Generative, constructive, and combinatorial creativity is often easier for people who have practiced.

- Regarding the notion that generative thinking comes easier to some people, give participants mental and physical breaks. After they've been engaged with H.I.T. for a while, allow them to restore the glucose and oxygen they've burned so they can have another fruitful go at it. Pushing the imagination, like any creative endeavor, gets tiring. No need to insist on what may start being rapidly diminishing returns.

GROUP INFODOODLE #5: FORCED RANKING

Goal of Forced Ranking:
The goal is to zero in on ideas that are strikingly innovative since the ultimate purpose of the Problem-Solving Meeting is to design something new and intriguing around a product, service, experience, etc. You know this Group Infodoodle already since it was the second exercise described for the Planning Meeting. I'll quickly describe its use in the context of this Infodoodle sequence and then you can go on about your day.

Number of Infodoodlers Needed:
Involve the group you started with. They don't necessarily need to be involved in ranking (more senior people could undertake that), but they'll at least need to be present to explain some of the thinking behind the innovations.

Duration:
15 to 60 minutes.

Notable Assumptions:
Same as before.

Forced Ranking How-To

At this stage, the group will have (hopefully) generated a plethora of new ideas. Recalling the mechanics of Forced Ranking the first time, you'll need some criteria by which to rank these ideas. Since there will likely be a good amount of ideas to evaluate, it's probably best to ask each small group to choose three to ten ideas that really stand out before putting them in the pot for ranking. (You may also elect to do some clustering and/or removing of truly outlandish ideas—they will be there.) As you know, you can choose any criteria appropriate for your goal. You could choose ease of production as your criteria; you could choose patentability, level of creativity, anticipated ROI, or all four. Simplify or complicate the ranking process as you wish, but know what raises and lowers the value of each idea for your group or your organization, and conduct the Forced Ranking based on that.

Ladies and gentlemen, you've (very likely) successfully hosted a Problem-Solving Meeting focused on the problem of innovation. Believe it or not, it didn't require hiring "creativity experts" or calling in whiz kids. You just needed a sequence of visual and experimental actions that would guide the brains of those around you to a place you hoped to be. Congratulations, you wildly innovative Infodoodler.

DECISION MAKING MEETING

GROUP INFODOODLE SEQUENCE:

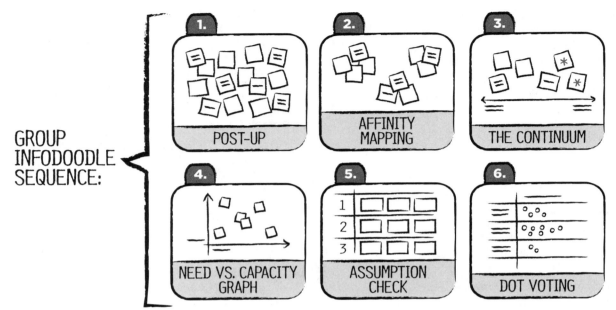

1. POST-UP
2. AFFINITY MAPPING
3. THE CONTINUUM
4. NEED VS. CAPACITY GRAPH
5. ASSUMPTION CHECK
6. DOT VOTING

Meeting Goal:
To investigate topic areas or project ideas in terms of the associated opportunities, and to build consensus on which topics should be funded[29] and pursued within an organization, department, or team.

GROUP INFODOODLE #1: POST-UP

Goal of Post-Up: To generate a variety of ideas about the opportunities presented by each topic or project. (These ideas will seed the activities that come next.)

Number of Infodoodlers Needed: Can be conducted with one individual or with a very large group—even with hundreds and hundreds of people![30]

Duration: 5 to 7 minutes per topic area or project idea.

Notable Assumptions:

1. That each topic or project actually has worthwhile opportunities associated with it. (I know, duh. But organizations can and do spend time evaluating possibilities that would ultimately result in the pursuit of an undesirable outcome. Don't think I haven't seen it.)

2. That the participants have enough information about each topic or project to generate at least one associated opportunity.

POST-UP

Post-Up How-To

The Post-Up is one of the most essential Infodoodle actions, so pay close attention to how it works because you're going to use it eleventy billion times.[31] It's extraordinarily simple, and once you and your group do it, you'll never need to pay attention to these instructions again. Here it goes.

Give everyone in the meeting access to his own set of sticky notes and a marker. Let them know the first topic area or project idea they're evaluating in terms of opportunities, and ask them to silently consider and write down as many associated opportunities as they can think of in the time allotted. Ask them to write only one idea per sticky note (this is so the next activity in the series can function properly). If people choose to doodle or draw, make sure they accompany visual language with verbal language, for clarity. This activity should be done (mostly) in silence so that you end up with a full measure of the varying perspectives of the group.

When they're done generating sticky notes,[32] ask everyone to approach a white space or wall and "post-up" (hence the activity name) all of their content. Each individual idea needs to be visible, so no sticking the notes entirely on top of each other, please. It creates an unnecessary undo.

When this Group Infodoodle is done, you should have a visual space that looks roughly like so:

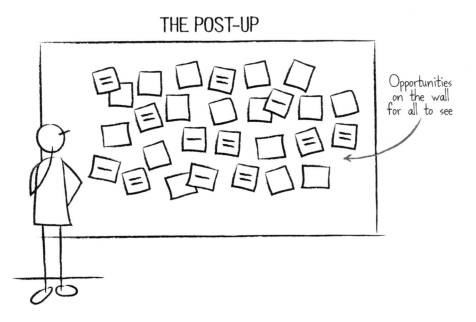

THE POST-UP

Opportunities on the wall for all to see

Repeat this process as many times as necessary to generate opportunities for each topic open to discussion. But post the sticky notes created every time you lead this activity *in a different visual space* so the opportunities around each topic don't intermingle. Intermingling would create an information traffic jam nobody wants to be in later. I'm showing you what I mean below.

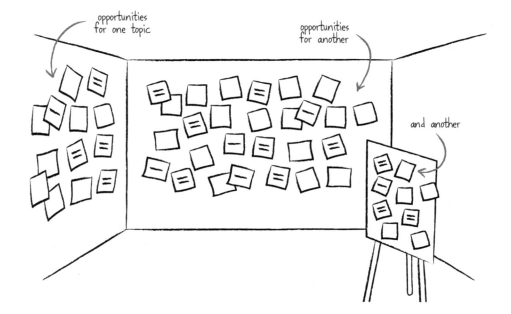

opportunities for one topic

opportunities for another

and another

Think of this Infodoodle as you and the group putting all your cards on the table so you can see what everyone's holding. The Post-Up gives an informational fullness that's needed to make sharp decisions later. And the more generative it is, the more confident the group can be that no game-changing input was left out.

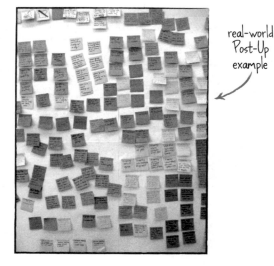

real-world Post-Up example

Best Practices for Post-Up

- This activity—like all activities in which volume blesses future modules of the sequence—is about quantity, not quality.[33] So ask the group to work with some level of haste, and recommend that they avoid thinking critically about their work. In the Post-Up, they just go-go-go. The goal is to generate a mountain of data that serves as the foundation of the process to follow.

- Don't let the group attempt to build consensus on the information they're generating before it is written or posted. Getting agreement takes an inordinate amount of time and is wholly unnecessary since this activity is not about evaluating or comparing ideas. Ask people to think on their own and to generate bits of information simultaneously with their peers.

- You can aid the sorting process of the game that follows the Post-Up by asking people to post their content the second they're done generating it. In other words, you can encourage some preclustering of the data if you manage the flow of people coming up to the wall to post. People often finish writing down ideas at different times, so ask someone who's finished to come up and spread her different ideas along the white space. Then the person who follows can post his ideas loosely parallel to any similar ones. This is helpful timewise because when the posting happens all at once—with everyone approaching the wall at the same time—there's usually not an ordered grouping of information. But if you allow for or even encourage a slower trickle of people to post, this oftentimes gives people a chance to place their information in generally related areas. If it doesn't happen and everyone charges the wall, no biggie. The next game takes care of finding the affinities.

GROUP INFODOODLE #2: AFFINITY MAPPING

Goal of Affinity Mapping:
To identify and cluster similar ideas.

Number of Infodoodlers Needed:
Anywhere from 2 to 5 participants performing the clustering for each topic area or set of project ideas; any more than that and it starts to feel crowded. If there aren't many to cluster, the rest of the group can watch the process unfold—there's a lot of good information that comes from observation, too, and they'll likely course-correct on occasion for those clustering.

Duration:
As long as it takes to establish meaningful clusters of ideas—usually between 10 to 20 minutes depending on volume and diversity.

Notable Assumption:
1. That the information on each sticky note is straightforward enough to cluster accurately. (If you find any sticky notes on which the content is vague, ask to whom they belong and request an explanation before carrying on. Modify the sticky note to refine its contents.)

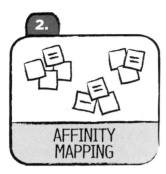

2.

AFFINITY
MAPPING

Affinity Mapping How-To

Like the Post-Up, Affinity Mapping is key to so many Group Infodoodling sessions that you're going to need to make it a part of you. Put it in your pocket and don't lose those pants. For thinking purposes, being comfortable mapping like to like (and identifying differences) is always going to end up being useful.

At this stage, you and the group have plotted the landscape of opportunities around a topic or topics. Now you want to start making some sense of this information, and you do this by grouping like with like. It really is as easy as it sounds. Put similar ideas next to their brethren and sistren.[34] You'll end up with an Infodoodle looking something like this:

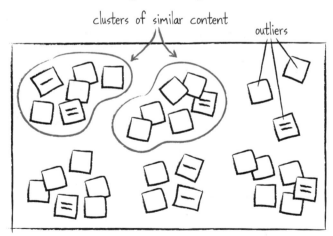

clusters of similar content

outliers

To close this Infodoodle, work with the group to determine what emergent categories would best represent the families of information. You're taking the group through an Infodoodle sequence, remember,

and leading them to make good decisions, which is the purpose of the meeting. To pull the process forward as a skillful Infodoodler can, we always want to put the closing content of an activity into a form that'll be appropriate for what we do next. So summarize the clusters with headline categories and write those categories on larger or different-colored sticky notes above the clusters. Use language that is generally agreed on by the group. And make it meaningful; the Continuum is calling.

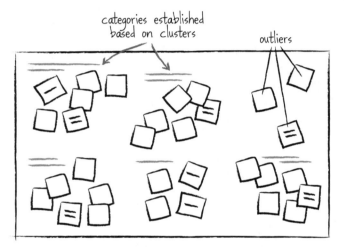

categories established based on clusters

outliers

Best Practices for Affinity Mapping

• Not all opportunities are created alike, so don't worry about outliers or seemingly "off" information. Just find a family for it that's close enough to similar, or establish a "wild card" area. When you move into the Continuum, don't forget to bring along any wild cards because they may have valuable insights that were unnoticed by the group at large.

- Although it's not part of this Infodoodle to track or add up the frequency of recurring opportunities, you do inevitably end up with a visual summary of how many people see certain opportunities around a topic or project. If you so choose, you and the group can make note of *how many people* saw the same opportunities. (Whoa! Twelve of you think that skywriting is a good idea.) This may add an additional layer of awareness as to how salient the opportunity is, at least from the point of view of the group.

- If you have a good-sized group and you want them all to be at least partially involved in the clustering process, you can ask for a short break and perform a preliminary clustering for everyone to return and reflect on. In this way, you've served the group by advancing the clustering process but leaving them to determine the strength of your categories. Usually, a group of fifteen or twenty can stand in a semicircle around the visual space and call out changes they'd like to see. When they do this all together, as the meeting lead you can sense whether or not any category switches would be approved of by most of the people.

GROUP INFODOODLE #3: THE CONTINUUM

Goal of the Continuum:
To evaluate the emergent opportunities on a continuum of least significant to most significant.

Number of Infodoodlers Needed:
Can be conducted with one individual or with a group of up to 20 or so. If you're working with multiple topics, ideally there'd be breakout groups of 2 to 4 people, each assigned to one topic or its associated projects.

Duration:
10 to 30 minutes.

Notable Assumption:
1. That the group has a good handle on what "significance" means relative to the opportunities to be plotted. (Or, if they don't, that they'll figure it out together during the session.)

The Continuum How-To
A continuum is a short and sweet visual way to organize one's thoughts around a criterion. Because you're a formally trained ass-kicking Infodoodler, you know that this is a multiuse visual tool, and you can assign any criterion you want for plotting along a continuum. You could choose project intensity (low to high), probability of success (0 to 100 percent) or perhaps bullsh*t factor (mild to extreme). You can pick your lens to look through and then plot it. You can also spread multiple continuums around the room or stack continuums atop each other. Like many of the Group Infodoodles you'll discover in this chapter, a minor tweak can give them new functionality, and a simple element of visual language (like a line!) goes a long way to kick-start cognition.

To work this activity as the meeting lead, doodle a simple horizontal line in your white space (we're working large-scale, so make it big, at least four to six feet long). Label one end "least significant" and the other end "most significant." Then, using the emergent categories you and the group established

from Affinity Mapping, begin to plot the opportunities along this line. Just stick 'em on the wall according to the group's attitude about where they belong. Yes, there will be discussion around this Infodoodle, and that's good. Thoughts that the group vocalizes should help everyone home in on the best placement for each opportunity.

least significant most significant

When each opportunity (or each emergent category) has been evaluated and plotted along this line, this activity has been successfully conducted. Tell all those who worked on this Infodoodle how much you appreciate their contribution. Because whether they're conscious of it or not, they are slowly but surely shape-shifting their knowledge universe to understand something more fully. Isn't that a part of how good decisions are made?

Best Practices for the Continuum

• Feel free to write and doodle thoughts that the group associates with the topics or opportunities. The Continuum doesn't have to be pristine. (In fact, an aversion to pristine white space is understandable.) Add some of their reasons around why one thing is more significant than another. Ask provocative questions about their logic, and visualize the responses in the white space. The more elaborate the visual output, the better informed the thinking can be as they move toward the meeting goal. Make a quick mind map around a sticky note. You know how to do this.

• When this game is run freely with a group comfortable with each other, you will almost

definitely find that on occasion there'll be a "tie" for significance or outright disagreement about it. This is perfectly natural. If there's a tie, plot the sticky notes parallel to each other—no problem. If there's outright disagreement and no consensus appears possible, post the same category or opportunity twice, plotting it on opposing ends. People are allowed to value information differently. It doesn't impact the overall drive toward the meeting goal, and it reflects honestly the perspective of the group, which is of the utmost import in Infodoodling work.

• If you and the group want to take this opportunity to stop some of the categories or opportunities from moving into the next

Infodoodle activity, you're free to do so. Choose which opportunities toward the "less significant" end of the spectrum won't survive. The next thinking activity involves evaluating opportunities further and for different criteria, but if they're not worth the group's time and effort, remove them from the radar. Parse before pursuing process.

• Every group in the real world is composed of people who approach evaluation differently. Some people may find that "significance" is too vague of a criterion and they'll want to know how significance is measured. Is it measured in terms of revenue? In terms of customer satisfaction? What does significance really mean? Tell those people to pipe down. (Kidding!) If you find that your group wants to get specific about significance, let them do it. Choose two or three "drop-down" criteria and have them develop icons to show them. (Revenue is a dollar sign; customer satisfaction is a smile; etc.) They can then code their sticky notes with those icons and plot the different opportunities accordingly. No sweat. Whatever you do as y'all work, don't get rattled if people need another layer of detail. Use your visual-thinking mojo to figure out how you can make it possible.

When this work is through, you and the group will have made one more step toward the outcome of a successful decision-making meeting. And it's very possible that you're enjoying yourselves! This is why I love the Group Infodoodle with all of my might. How many activities can we pursue at work or at school that allow us to socialize, visualize, and analyze at the same time?!

GROUP INFODOODLE #4:
NEED VS. CAPACITY GRAPH

Goal of Need vs. Capacity Graph:
To get a reality check on what topics (and opportunities) can responsibly and effectively be pursued given the desire in the marketplace and the organization's current realities.

Number of Infodoodlers Needed:
Can be conducted with one individual or with a group of up to 20 or so. Any more than that eyeballing the axes and people aren't able to get close enough to the graph, which is complicated and hard to see from a distance.

Duration:
10 to 30 minutes.

Notable Assumption:
1. That enough people in the group have a sense of either the customer need or the market need to plot the sticky notes with some accuracy. This same assumption is made with respect to capacity. (This is a generally safe assumption, but the assumption itself is based on the premise that the right people have been invited to the meeting. But we don't, in fact, always do that.)

NEED VS. CAPACITY GRAPH

Need vs. Capacity Graph How-To

You know we Infodoodlers are into visual structures that pack of lot of punch with simple lines, so here's another one for you that you'll use over and over again: the x/y graph. As with the Continuum above, you can always change the variables based on what you want people to think about and discuss. For this activity, we're using "Need" and "Capacity,"[35] but in another meeting you could use "Impact" and "Effort," or "Cost" and "Value." Any two variables that help you see a topic through specific peepholes.

To start this Infodoodle, return to your ever-present white space and draw two lines, your x-axis and your y-axis. We're going to map either the original topic areas OR the specific opportunities related to each (your choice)[36] on this graph. What you're all doing now is slowly coming to grips with

the reality of pursuing certain possibilities in your organization. This game is about reckoning the need in the marketplace with something to offer relative to the organization's actual capacity. This is a useful mental exercise because you and the group may find that there's a huge opportunity associated with a topic but no internal structure to bring it to life. For example, an online gaming community may be fantastic for helping your diabetic customers meet their health goals, but you might not have game developers on staff. The realities of organizational life don't always accommodate the pursuit of every wish, so we work with what we can actually do, and often with what we're already good at. This is the challenging but essential core of decision making: People have to choose.

Best Practices for Need vs. Capacity Graph

- Change the variables on the axes if you need to. You're not locked into the suggestions I make, and you likely know best what this team needs to be considering. I've placed you inside of an Infodoodle sequence that will support a decision-making process, so

you can trust that greater arc and experiment (within reason) inside of it. So, if you think the group needs to look at different variables on their x/y graph, you have my blessing.

- Involve the group in building their own axes. If you're working with a group size over twenty, you don't need to feel responsible for directing the thinking process for this activity. Set up the ground rules, and let small groups build their own axes. They can plot various topics on their own and then circle or star the topics that hit the sweet spot (in this game, the sweet spot is high need + high capacity). Once they've filtered down their options, you can pluck those sticky notes off the wall and repost them into a graph visible to everyone. Once you do, you'll likely need to have another conversation about where the winners should be plotted among themselves, but that's okay. At least the groups have winnowed down the options and can start assessing from a smaller pool of choices.

- Be aware at what level the plotting on the axes is taking place. Some of you may prefer to evaluate and decide on broad topic areas (like smoking prevention, mobile technology, or digitizing libraries), so you'll want to use this graph tool to contemplate a decision at a more strategic level. Others of you will be working at the project level, so you'll want to evaluate the diverse options inside of those broad areas and map *them* according to need versus capacity. You'll know as you plan the meeting which approach would be better for the group. Are they looking to do some major decision making around the company's programmatic direction, or do they want to hold those strategies steady and decide on the projects supporting them from below?

- Both the Continuum and the Graph are simple on the surface. But dig into these techniques with real curiosity, and you and the group will find that there's much richness in these basic structures. Do not underestimate or shortchange the conversation they allow you to have. Ask people participating to share their thinking around why they view a topic or project a certain way. Doodle it, write it, or say it, but don't miss the opportunity to sift through information with the group so that the substance can be on display.

When this Infodoodle is done, the group will have looked at the topics or projects from a variety of angles, which is the responsible thing to do before deciding to make any moves. It's like examining someone you're dating for his marital appeal. You need to *know* things. You need to ask questions. You need to evaluate your own system to see if he'd be a good "hire." Then, and only then, can you move toward making a decision with confidence. This is what the group will do using this technique.

When this activity is done, you'll feel assured that the group is moving in the direction intended for this Decision-Making Meeting. But just when we start to feel safe, sneak attacks can trip us right at the finish line. This is why we need Group Infodoodle #5, the Assumption Check.

GROUP INFODOODLE #5: ASSUMPTION CHECK

Goal of Assumption Check:
To avoid charging forth without questioning underlying assumptions. (We all know what happens to "u" and "me" when we assume.)[37]

Number of Infodoodlers Needed:
All of the same people you involved in the last activity.

Duration:
15 to 60 minutes.

Notable Assumption:

1. That the group is grounded on what an assumption is and that they're capable of sniffing them out—even the sneaky ones.

Assumption Check How-To

This Group Infodoodle is about teasing out biases or hidden premises in the participants' analysis so that the pursuit of topics or projects is as smart as can be. You can make this exercise as rigorous as you'd like, and the grids doodled can accumulate as many columns as necessary to be satisfyingly thorough to your people. Two things, however, must happen first.

First, define the word "assumption." Of course we all use this word (usually to call out other people), but few of us have dissected it to clarify its meaning. To open this Infodoodle, ask the group how they would define an "assumption" and ask them for examples.

If need be, offer a definition—an assumption could be defined as information accepted as true without "proof"[38]—and doodle it somewhere people can see it.

Second, you'll then need the group to draw table(s) so that the assumptions embedded in their previous analyses can show up and be seen. Ask the group(s) to quickly sketch, in a large, visible space, something that resembles this:

Together, you'll dig up beliefs that may not be routinely questioned and look for doubt in places where it may not typically exist.

Remove from your previous graphs the sticky notes showing projects that look like they'll survive the ultimate review. If your variables were need versus capacity (i.e., if you didn't adjust them for another angle), then you'll pluck the sticky notes hovering in or around the top right corner. Place each sticky note down the side of the new table(s), giving each its own row, because they'll all be subject to the Assumption Check.

Once the sticky notes are selected and on display, ask the group to consider the current analytic lines surrounding the content and to write them down for all to see. As always, depending on how many topics or projects there are to analyze, you can produce multiple tables and assign the review process to either one large

group or smaller subgroups, or you could assign one project per person and rotate individuals for nonsimultaneous but collaborative assumption checking. You (and the group) can figure out what'll work best. The purpose is to articulate all or as many premises as possible that are currently accepted as true.

Once the presumptions have been laid along the row, lead the groups or ask them to self-lead in challenging each assumption, asking why it "must" be true and whether it remains valid under changing conditions. They can capture their comments and visuals in the white space above and below each column to create a more elaborate landscape of information.

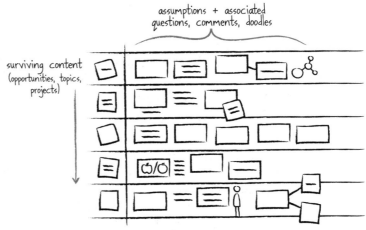

Once the people have had a solid amount of time to investigate hidden layers of bias or mistaken belief, the last step is for the group to refine the rows of key assumptions. They can do this by removing or modifying sticky notes, leaving behind only those that "must be true" or those in which they have a "high degree of confidence" to sustain a viable analytic line and lead to better decision making. This is the last important step in a sequence that ultimately results in pursuing work that matters most to the success of a team or organization. If you'd like, you can ask a member of the group to restructure the table—clear the decks!—leaving only those topics or projects that survived the assessment. The table(s) could eventually look like this, to make them spanking clean for Dot Voting.

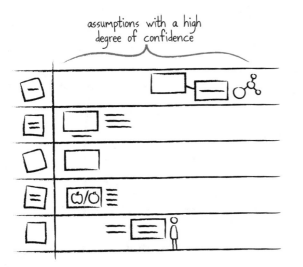

Best Practices for Assumption Check

- Recognize that as the meeting leader you have the choice to decide how substantive you want this analysis to be. If you think the group may have pie-in-the-sky tendencies or is otherwise lacking awareness in certain areas, you might deploy some hard-core questions related to the content they laid out. Questions like:

 > How much confidence do you have that this assumption is correct?

 > What explains the degree of confidence?

What data or circumstances could undermine any of these assumptions?

Could any of these assumptions have been true before but are less reliable now?

If enough assumptions prove to be wrong in any given area, would it significantly alter the decision that's made? How so?

What new factors were identified during the activity that need further analysis?

- I mentioned earlier that you can add as many columns as you'd like. You may want to have a column designating degree of confidence or a column that indicates what information, if gathered, could undermine the validity of an assumption. You truly have at your disposal the possibility of expanding or contracting this Infodoodle to your heart's content. Every group is different; every topic ranges in complexity. Before the session (or spontaneously within), give some thought to just how far you want to go with this activity before you lead them to the final move: decision making.

- Before the meeting starts, think of people participating whom you know to be excellent at breaking down and identifying assumptions in arguments—your critical thinkers. You might want to distribute these folks' talent among subgroups. Facilitating a critical-thinking process is a valuable add from individuals who can bring that skill to the table.

- If you have time and it's conducive to the way you broke out groups, rotating the groups and asking them to review and edit each other's content is often a good idea. Multiple minds invariably help spot something someone else may have missed.

- This Group Infodoodle can tease up a significant amount of exploration and discovery, particularly if the group decides to ask the hard questions. Don't rush the process. You'll have participants with varying amounts of experience and expertise, and the newer folks could use the time to learn something from their "elders." It's also beneficial to be comprehensive during this process, as it's the last stop before direct decisions are made.

GROUP INFODOODLE #6: DOT VOTING

Goal of Dot Voting:
To make group decisions on what programs, projects, or topic areas will be funded and implemented.

Number of Infodoodlers Needed:
The entire group you're working with—everyone who's been involved through the process gets to vote.

Duration:
5 to 20 minutes.

Notable Assumption:
1. That everyone's vote is created equal: 99.9 percent of groups are filled with motley crews that have different expertise, experience, power, awareness of the topic, etc. But in this application of Dot Voting, we make no attempt to correct for this skew. We stabilize the system with equal representation. One = one.

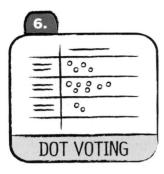

6.

DOT VOTING

Dot Voting How-To

If you cleared the previous tables of flotsam, you may be starting with a visual structure that looks like the one you most recently saw. If the groups left their white spaces scrappy, that's okay, too. All that's needed here is area for the groups to "voice" their desires in a visible space. Send in the dots.

Contrary to popular belief, you don't need actual sticky dots to perform this operation. You just need the capacity to *make* dots, and that's afforded to all of us via markers or pens. (Those kind of dots also do us the favor of not falling off.)

Remind the group of this meeting's overarching goal, which is to make serious decisions about what the team, department, or organization will put its focus on and its budget behind. At this point, they've considered the significance of projects or programs relative to a chosen baseline, the need of the populations or customers they serve, and they've checked any assumptions that might derail the decision-making process. These people are more ready to vote than the most attentive of citizenry. (When's the last time you checked your biases before choosing a candidate? Hmmm?)

From now on, it's simply go time.

This Dot Voting technique assigns one vote per project to each person. It's a democratic process, and it removes the prospects of one person's vote counting more than another's and of one person voting numerous times for one project. You'll need to have in mind before you begin how many projects you're asking them to vote for. If your organization can't realistically pursue eight projects, there's no real need for people to spend their time distributing eight votes. Choose the appropriate project number (you could throw in a couple of extra dots per person just to see what projects survive) and give the group time to vote silently, walking around the room if there are multiple white spaces set up. Be available for questions that may arise as they take on this last, decisive Infodoodle. As I often remind people, the Doodle is no joke.

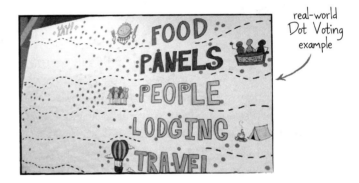

real-world Dot Voting example

Best Practices for Dot Voting

- If one person = one vote doesn't suit your fancy, you can assign greater value to votes distributed to leadership, if they're involved in the meeting. Be careful not to weight them so much that the other votes become superfluous, and if you go that route, let other people know what's happening and why.

- Take care influencing the group's decision, subtly or overtly. If people sense preferential projects, they may vote on them to satisfy cult of personality or to avoid expressing any outlying opinions. If you truly want the process to be judicious, save your enthusiasm

for certain programs (and ask the C-level people to do the same) for later.

- If you can, let people walk away from the data for a while. It's not always a quick-and-dirty process to decide on the direction of your team or department. You can wait to vote after letting people sleep on it. If you think it will result in a better set of decisions, well then, good thinking.

FEED-FORWARD MEETING

It sounds like "feed-forward" might have something to do with the proper care of livestock or the safe way to merge onto a highway, but for our purposes a Feed-Forward Meeting involves a speaker presenting new information or a status update to an audience. We'll refer to this as "telling a story," even if it expands what you might consider a story. A story does not have to be a fictional account that starts with "Once upon a time . . ." Those weekly project reviews you have at work are Feed-Forward Meetings involving story, and so is the president's annual State of the Union address (although that one involves millions of people and is likely more stressful to deliver). The president conducts *his* feed-forward sessions predictably well, however, since he's supported by expert speechwriters and storytellers (not to mention hair and makeup people). The rest of us are left to our own devices when it comes to crafting and presenting content. And unfortunately for most, it's almost impossible to make it through a lifetime of school and work without being asked to deliver *at least* one presentation. This means we can all be served by having a foundation on which to build a narrative sequence for telling a good (or even a decent) story to an audience at work or school.

To that end, in this section, we're going meta. I want to give you a reliable strategy for designing presentations on *any* topic so that you can use it every time you're faced with the feed-forward double-dog dare. For experienced story crafters, this process is instinctive (like designers building infographics and architects building houses, they see that there are naturally occurring steps), but for the record, I'm using the framework from Nancy Duarte's book *Resonate*. I elected to do this because (a) her steps are succinct and clear, and (b) I love Nancy. So much, in fact, that I'm including a picture of her here so you all can see her beautiful face.

Now, I gave you a hint of this process earlier when you saw the image that says "BIG IDEA." Look familiar? Infodoodlers never forget what we see! Let's learn about the specifics.

Nancy Duarte, storyteller and presentation designer extraordinaire

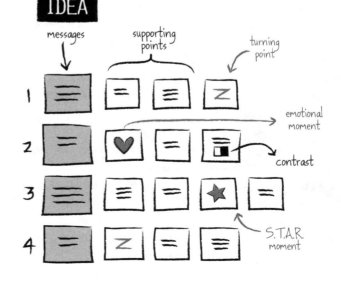

Goal of Feed-Forward Meeting:
To deliver valuable or needed information to an audience while actually keeping their attention.

Number of Infodoodlers Needed:
One (the presenter) who can then invite others (I'd say up to five) to offer valuable, relevant comments and feedback on the content before the meeting itself.

Duration:
15 minutes to 3 hours for the initial design process, with the understanding that you can and will likely return to refine it many times.[39] Your presentation itself should be anywhere from 5 to 60 minutes. (If you present longer than one hour without a break, your words are falling on deaf ears.)

Notable Assumption:

1. That you're at the point where you have a Big Idea, and you know your content well enough to generate sufficient messages and supporting points, including related anecdotes and statistics. You can leave your sticky notes on the wall (I've refined my own talks on my office wall for as long as four months!) and continue to plot your story and fine-tune it over several weeks. But you need to be able to build something useful as a starting point.

Feed Forward How-To

To begin this process, you must know your main idea. This is the billboard message, the

big point that people are showing up to hear. If you don't know that, drop the doughnut and figure it out

because your Big Idea is the guiding force for the remaining narrative structure. Got it? First step. BIG idea.

Once you have your Big Idea, your second task is to generate as many ideas and as much evidence as possible related to that Big Idea. This is the stage where you use sticky notes or index cards to blurt out anything that comes to

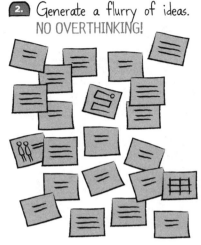

mind related to the Big Idea. Just write it, doodle it, or both. Most of you will do some instinctive culling of content at this point, but *please* try hard not to let the judge take over. Stories, the spine of presentations—even presentations about weekly projects—need their flurries of information to emerge unencumbered so they have the chance to be more whole in the end. So we must first let their many shades of truths come forth so we can mold them. I promise—you can evaluate the truths and refine the facts later. But during step 2, let it rip.

Once you've let it rip, you'll find yourself in the stage where most people (erroneously) want to begin: filtering. NOW we filter because now you've generated enough ideas to start curating them. Here is the stage where it's not only okay for the judge to enter, it's critical. In step 3, you'll assess your flurry of ideas and select which ones are worthy, valid, and compelling enough to remain in your story. This is

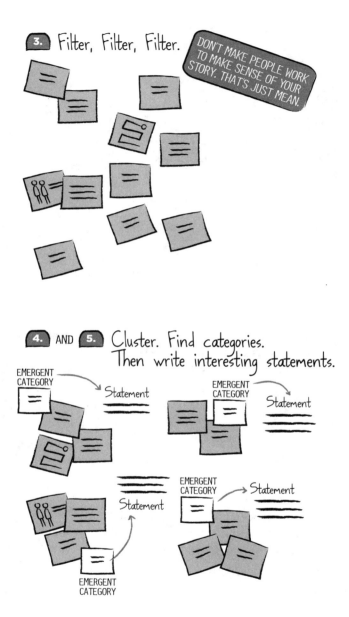

3. Filter, Filter, Filter.

DON'T MAKE PEOPLE WORK TO MAKE SENSE OF YOUR STORY. THAT'S JUST MEAN.

4. AND **5.** Cluster. Find categories. Then write interesting statements.

EMERGENT CATEGORY — Statement

EMERGENT CATEGORY — Statement

Statement

EMERGENT CATEGORY → Statement

EMERGENT CATEGORY

where you—eek!—kill your darlings, because it's one of the best things you can do to honor your story. Every idea you generated is not precious. And, as Nancy has so eloquently advised, good presenters don't make our audiences work to discern what matters. We get ruthless about removing those ideas that are not clearly and directly related to the Big Idea. So tear down, delete, destroy for the sake of a feed-forward experience people will want to show up for.

Moving along to steps 4 and 5. I'm combining these steps because step 4 is gravy. It involves doing what our Affinity Mapping exercise taught us: clustering similar ideas. So using the ideas you've filtered down, cluster them accordingly and find the emergent categories or topics that best represent each cluster. If our Big Idea is "The sky is falling," we might see categories bubbling up such as "Atmospheric Troubles" and "Apocalypse Survival Strategies." Make sure the emergent categories are both mutually exclusive of each other AND all-encompassing of the substance of your Big Idea. You want them mutually exclusive so you don't repeat yourself, and you want them all-encompassing so you don't forget to include something major and lose credibility with your crowd. Once you've determined your categories, you're then going to turn those single words or short phrases into a statement that has some oomph. These are the messages you'll carry forward to steadily build your Big Idea. So, for example, to deliver my Big Idea that the sky is falling, an example of a powerful statement related to the emergent categories might be "Survival strategies will be included as basic curriculum in schools across the nation." (I'm unclear as to how I ended up on this topic, but let's just work with the alarmism for now.)

You can see that we're systematically building a story that has some sense to it.

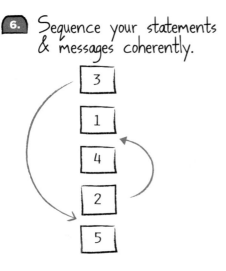

6. Sequence your statements & messages coherently.

Step 6 is about sequencing for even better sense-making. It wouldn't be logical for me to introduce survival strategies without first telling the audience what they'll need to survive, right? Message order matters, like building a proof in geometry. The goal here is to arrange your statements into a narrative that has impact. You can leave some messages until the end, for suspense, or you can stack them like building blocks if a straight chronology is required. Either way, this step is as essential as every other step, because it requires you to consider in what order you're overturning rocks for the listener. Infodoodlers in presentation-design mode must consider what knowledge the audience has and what knowledge they need, in what order, to help them fully take something in. And this takes work. The stones don't turn over for you. (Unless you're using the Hover Charm.)[40]

Once you've arranged your statements into an order that feels logical and interesting, go get yourself a sandwich. Those first steps are glucose-draining, and you'll need fuel because you've just turned a corner toward gathering and shaping the evidence.

Step 7 is all about bolstering the statements you're making. Any critical-thinking audiences will need substance to back up your declarations, *especially* if the story you're telling expands their horizons or asks them to explore or believe something outside of their current frame of mind. To help myself determine how I might convince you that the sky is falling (despite the fact that I don't *actually* want you to take that home), I look to Aristotle's Appeals—an easy-to-remember triad of three powerful means of persuasion: ethos, pathos, and logos. A rhetoric student could write a dissertation on this triad, but we've got doodles to do and stories to tell. So I'll quickly summarize these three tools so you understand how to infuse them into your storytelling.

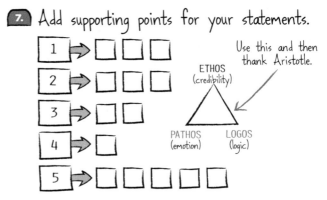

7. Add supporting points for your statements.

Use this and then thank Aristotle.

ETHOS (credibility)

PATHOS (emotion)　　LOGOS (logic)

Ethos involves an ethical appeal. We're more willing to suspend skepticism if a credible expert (or multiple experts) backs up a presenter's statements (it helps, obviously, if the presenter is credible as well). Ethos = trustworthiness, and it can come in the form of a quote from a reliable source or an endorsement by a prominent figure. Somebody with good character supporting your statements can go a long way in a presentation.

Logos involves just what you'd think—the use of reason. This was Aristotle's preferred method of persuasion and it's one we see most often in office environments. The use of rational thinking is a powerful technique, and

it's also relatively safe for the audience. It doesn't usually ask them to take great philosophical leaps, and it uses research and statistics to support an argument. Logos gives a story an intellectually grounded and logical appeal.

The third tool, pathos, involves an emotional appeal. An emotional appeal uses content that tugs on the heartstrings or disturbs or moves the audience in some way. When Bill Gates made the public case for tackling malaria through innovative philanthropy, he released mosquitos into the audience saying, "There's no reason only poor people should have the experience."[41] A pathos-laden move, indeed.

Knowing human beings, I would argue that pathos is the most powerful form of persuasion, whether we're conscious of this or not. I know we like to believe our logic rules the cognitive roost, but I'm long past the days where I'm beguiling myself about that. My brain's executive center is but a pinpoint on the surface of what is largely an emotional mind. Logic as we understand it is our newest evolutionary development, and it requires the most physiological effort to access.[42] That said, take your audience's orientation into account. Even if biochemists are like everyone else—swayed subterraneously by the outbursts of the amygdala—they still like to believe they make the majority of their decisions rationally, so appeal to the forefronts of their minds. Avoid sentimentality with an audience of people who pride themselves on their highly developed cerebral cortices.

That was your godspeed version of Aristotle's Appeals. Use them all at will to support and develop your presentation. They'll always show up, in some form, as you develop your supporting points, so you might as well be able to recognize them when they do. And as you progress, label your sticky notes with *E*s, *P*s, and *L*s (or hearts and number signs, as shown at right) to create a code to show and understand what persuasive tools you're relying on the most. A really good feed-forward experience braids the three of them together, making a powerful, well-rounded case to an audience. Now let's feast our eyes on turning points.

Step 8 is about making sure your presentation has clear turning points. ALL stories, movies, or talks have a three-part structure we know and love (or hate because it can be hard to build), and that structure is your Beginning, Middle, and End. It's the bread-and-butter narrative arc they taught us about in high school. And the transitions that move an audience from the beginning to the middle and from the middle to the end are the turning points. Turning points are the ingredients in stories to keep the story in

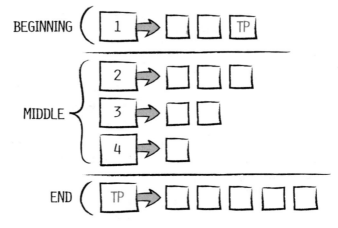

8. Add turning points to the presentation.

The sky is descending rapidly upon us. It will wreak all sorts of havoc, requiring that we store canned goods and stop online shopping.

PIVOT!

The good news is that humans perform best under pressure! We can use this opportunity to reprioritize and design a world we've never seen before.

BEGINNING (1 ➡ ☐ ☐ TP

MIDDLE { 2 ➡ ☐ ☐ ☐
3 ➡ ☐ ☐
4 ➡ ☐

END (TP ➡ ☐ ☐ ☐ ☐ ☐

motion. They are the pivot upon which the action changes course. Turning points can happen when the bottom of a current reality drops out ("Despite record sales this year, we're going to let a hundred of you go"), when the facts swivel your head around ("Two billion people on Earth lack clean water"), or when the "hero" of your story gets called to action ("Luke just learned the sky will fall in eleven days"). I think you're starting to understand why you'll need to include turning points in your forward feed. Think of them as the hinges on a door. Without their presence, nothing new can open up.

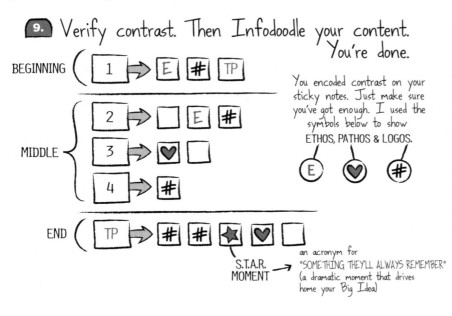

9. Verify contrast. Then Infodoodle your content. You're done.

BEGINNING

MIDDLE

END

You encoded contrast on your sticky notes. Just make sure you've got enough. I used the symbols below to show ETHOS, PATHOS & LOGOS.

S.T.A.R. MOMENT → an acronym for "SOMETHING THEY'LL ALWAYS REMEMBER" (a dramatic moment that drives home your Big Idea)

Having explored turning points, you are now at the final destination for having the most effective feed-forward sessions of your life. You need only take the last two steps, and I've sandwiched them together so you'll continue to like me. The last hurdles involve verifying the contrast of your appeals (all this takes is a quick survey of your sticky notes since you've already codified them) and then, without further ado, the Infodoodlization of your work. Check it out.

Contrast is another storytelling device that keeps the listener engaged and helps the story to develop without stagnating. To verify that you've embedded a decent amount of contrast in your presentation, take a look at it. At this point, you likely have already codified it on your index cards or sticky notes. As I mentioned above, I use hearts, number signs, and capital *E*s to display my diversity of contrast in Aristotle's Appeals. But use any symbols you like. (And notice that in the image above there's a reference to a "S.T.A.R. moment." This is a trademarked Duartian storytelling device that involves a moment in your presentation so profound that it's unforgettable.[43] They can be a challenge to build into, say, a feed-forward meeting about cardboard, but do consider a S.T.A.R. moment if there's any opportunity to use one to drive your message home.)

If you're satisfied that you've covered the range of appeals or you feel like you've chosen the persuasive tactics that'll suit your audience, then by all means, march forth with a process that by now you're much more familiar with: visualizing the information. I'm making an assumption here that your presentation will move into a slide deck. This means that each idea can be represented by a slide, and each slide can be made

into an Infodoodle. If my assumption is flawed and you're not planning on building a slide deck, well, that's no threat to our feed-forward meeting. Since you're a stand-up Infodoodler, you have the following alternative options:

1. Build a large-scale Infodoodle with the story displayed as one long form in any white space available. Use it as a presentation tool to take people through your messages.

2. Sketch the ideas on a deck of sequential index cards with your talking points on the back. Sit at a table and show-and-tell them one by one.

3. Doodle your work on many pages of a flip chart pad and tell the story as you turn the pages.

4. Build a large-scale storyboard and display it like a graphic novel around a room.

You don't need no stinking slide deck! You have the tools that matter, which are the skills to design an effective presentation AND to make it clear visually. You can take that anywhere and apply it to any topic. The supplies available and the subject matter don't dictate the output of your work. The process does. And your process totally rocks.

To summarize this section, I'd like to acknowledge that we've all sat through feed-forward sessions or presentations wondering if we blew some sort of brain fuse. When a presenter is murky or meandering, we often think we must be missing something. But I'm here to tell you that it's unlikely that YOU are the one who's lost. It's infinitely more plausible that the presenter either didn't have the time or the interest to construct a compelling presentation, or she didn't have a story-design process to create something that makes sense. But almost everyone faces a day when he or she

needs to tell a story, whether it's explaining something challenging to a child or explaining something urgent to a company. I give you this process so that you can make what you say matter to the people giving you their time and attention.

FEEDBACK MEETING

Of all the meeting types, Feedback Meetings can be the most difficult. This may be because feedback meetings, unlike their meeting brethren, involve information about an employee or teammate's *personal* performance. Their purpose is not to evaluate, innovate, or optimize conditions external to an individual. Their purpose is to share job insights and observations with a real, live human being so that she has the opportunity to grow. Feedback Meetings should also make the context and purpose of her professional development clear and relevant to the vision of the organization. She needs to understand how she fits in and contributes to that vision.

Ideal Feedback Meetings successfully discuss an individual's strengths, contributions, and areas of improvement in such a way that those insights can actually be received and acted on. This means that these meetings are a two-way street. They ask for certain behaviors from both parties. The person offering feedback should be able to exhibit characteristics like fairness, sensitivity, objectivity, and honesty. The person receiving feedback would preferably be open, attentive, and willing to absorb commentary without collapsing or using defensive tactics to avoid learning how to improve. This is a tall order at times, but leading effective Feedback Meetings elevates work conditions and experiences for everyone.

Goal of Feedback Meeting: To offer credible observations and insights on behavior and performance to an employee in service to his ongoing improvement, while reducing the possibility of discomfort, denial, or backlash. Also to customize growth opportunities appropriate to the skills and circumstances of that individual for a more optimal future performance.

GROUP INFODOODLE SEQUENCE:

1. EMPATHY MAP

2. PERFORMANCE POWERHOUSE

3. TRAINSTORM

Goal of Empathy Map:
To convey to the person receiving feedback that his work context fundamentally informs the insights and observations he's receiving.

Number of Infodoodlers Needed:
Most commonly two, with the possibility of including multiple higher-ups or allowing nonsimultaneous input from multiple higher-ups.

Duration:
10 to 15 minutes.

Notable Assumption:

1. That the boss or authority figure has been fairly consistently tracking an employee's performance and has her best interests in mind (i.e., work politics and/or hidden agendas are not influencing feedback).

1. EMPATHY MAP

Empathy Map How-To (Quick Refresh)
Because of the potential for "stickiness" in Feedback Meetings, the Infodoodle sequence you'll find here is designed to signal to the employee that the higher-up is on her side, committed to her growth and transformation. This is why the Empathy Map is the opening Infodoodle.

You've seen this activity before, and it will continue to come in handy since so much of our work and lives require being able to see things from another person's point of view, whether it's a customer, a teammate, an employee, or a family member. Empathy Mapping in the context of a Feedback Meeting is a very powerful way to open because it sets up the conversation as one that deliberately shows awareness of someone else before you ask something of him.

Opening with empathy makes it much more possible for an employee to hear what the boss has to say. So run this module with care. And if you're a really progressive boss, you could work with the employee to produce an Empathy Map of *your* circumstances with respect to this person's individual and team performance. Allowing someone to see behind your own closed doors is another technique that can leave them responsive to your suggestions on how they work.

The Empathy Map funnels nicely into the second Group Infodoodle, Performance Powerhouse, because it can soften the employee's defenses and generate curiosity around areas of improvement.

GROUP INFODOODLE #2:
PERFORMANCE POWERHOUSE

Goal of Performance Powerhouse:
To demonstrate that (a) feedback isn't arbitrary and is based on specific, relevant criteria; (b) that the employee's potential is ongoing and doesn't require an urgent, overnight shift; and (c) that the organization is invested in her individual learning, rather than applying a one-size-fits-all approach.

Number of Infodoodlers Needed:
Most commonly two, with the possibility of including multiple higher-ups or allowing nonsimultaneous input from multiple higher-ups.

Duration:
15 to 30 minutes, depending on the number of criteria and the depth of conversation you want to have.

Notable Assumptions:

1. That the information gathered about the employee is unbiased enough to feel legitimate.[44]

2. That the meeting leader has worked with the employee long enough to give thoughtful feedback or, if he hasn't, that he acknowledges that his view is limited and subject to inquiry, or establishes that it is reflective of the views of people who have worked with the employee fairly consistently.

Performance Powerhouse How-To

If performance data is embedded in documents, it can lose some of its oomph because it doesn't really live in a person's mental or visual space. Visualizing performance on a large scale has the effect of giving it a fuller scope and a richer experience. Every employee, student, or teammate receiving feedback should have his own infomural that can evolve and display improvements (or lack thereof) over time. The display is a simple visual structure that shows criteria used for evaluation, level of performance, and time. It can look like this:

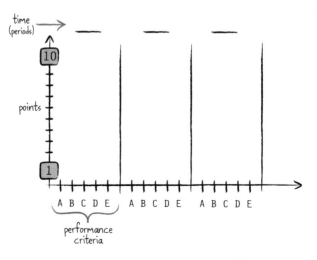

The x-axis underscoring each column should list criteria your organization uses to gauge employee performance. These are entirely up to you. They can be metric-based (number of daily sales calls, online video views) or more qualitative (team interactions, presentation quality). I've shown 1 to 10 as the "points" scale, but obviously you should apply whatever scale, grading system, or categorization your org prefers. Along the columns across the top, map time. Adjust the time frame to be appropriate to the employee's presence, using months or years (or both) depending on the length of the employee's relationship with the company.

The infomural should be kept for repeated use over time. It will ultimately plot changes in the employee relative to desirable criteria and becomes a visual dashboard of an employee's ongoing development. During the meeting, your job is to clarify the criteria, give examples of how they might manifest in work life, assign points or a grade to the employee, and, if you like, solicit his perspective on those criteria and assignment. You can have the points plotted visually prior to the meeting, or you can add them in the presence of the employee if you prefer to keep him focused on one criterion at a time. (People will "read ahead" if the data is there.) The experience should leave the employee with as few questions as possible around what's expected of him and why it's important. Give straightforward, substantive information in the interest of the employee and the organization's growth.

Since the Performance Powerhouse module is buttressed by two supportive Infodoodle activities, it bookends the evaluation with positive experiences. This serves the primary goal of the Feedback Meeting well because it enhances the prospect of the employee's taking in the observations offered and making them effective.

Best Practices for Performance Powerhouse

· Use typography or word pictures to write the person's name on her infomural, and give that person an icon that represents her best or aspirational self. Taking time to personalize the visual shows respect for her individuality and for her role in the organization. It takes little effort but shows thoughtfulness on your part.

· Using that same visual inspiration, draw images to represent each criterion and write a brief explanation underneath. Visual language brings the infomural to life, giving it richer layers of meaning and encouraging more of an interest in revisiting it.

· When you come together for this meeting, put performance expectations inside of a bigger picture. People struggle to find the motivation to develop a certain skill if it's unclear how that skill serves a larger purpose. Give the employee context for what you're seeking. Help her understand how her developing talent is linked and adds value to a bigger system and vision. Use your newfound Infodoodling skills to show her the system itself, by sketching it beforehand on her personal infomural. A visual explanation of her influence and significance relative to the company's vision can work wonders on her drive to succeed.

· Achievement categories that resonate with the culture of your company may be a good idea. If you work at an IT company, let people upgrade from being a software novice to an open-cloud expert to a rock-star coder. Whatever naming custom you choose, you

might be surprised by how much people (particular the coming generations) respond to "titles" that give their accomplishments a bit more meaning than a simple checklist or point system—i.e., people aspire to be "computing ninjas" and "market trend virtuosos" more than they aspire to be a "5."

· Give the employee the option of detailing content on the infomural related to each criterion. He can add thoughts or perspectives on how he may be stuck on sales performance or ask questions to be considered at a later date. The infomural can be a living document—one that allows for the presence and contributions of the employee to be reflected back as well.

· A typical Feedback Meeting is about offering a valid performance review to an employee. But feedback is tricky because (a) the balance of power isn't equal—a reality that can affect the sincerity of an employee's motivation as well as her perceived control over her own fate—and (b) the vast majority of us aren't truly amenable to feedback unless it's presented in a way that feels constructive, fair, and empathic. Start this process by plotting on the graph the behaviors that someone does well. Give her specific examples as to how her excellence showed up, then move to areas of improvement. When people know they're appreciated from the beginning, they're more likely to stay open.

With Performance Powerhouse under your belt, the two of you are poised to move constructively into the last Infodoodle, which ties up the experience with a bow because it's the space in which you and the employee together craft the learning arc for future elevated performance.

GROUP INFODOODLE #3: TRAINSTORM

Goal of Trainstorm:
To give the employee a sense of autonomy and purpose over the direction and substance of his future training. To support self-directed and self-selected learning experiences, in cooperation with and with guidance from management.

Number of Infodoodlers Needed:
Same two.

Duration:
15 to 20 minutes.

Notable Assumption:
1. That your organization allows and provides for custom training. If there's neither willingness nor budget for that, hopefully the employees can explore internal training appropriate to enhance their strengths and opportunities.

Trainstorm How-To

At this stage, you and the employee are both aware of areas of improvement because they've been plotted on her personal infomural. (You may even have chosen to quick-sketch a visual of the company's system to show how her professional development influences that system!) Trainstorm uses this same infomural to capture prospective—and, eventually, agreed-upon—options for managing the improvement process. With Trainstorm, the employee has the opportunity to up-level the specific performance

areas ranked lower on the desirable scale. So if your grading scale is numeric (for example, a scale from 1 to 10), you and she will start with those areas that are, say, a "2" or a "5," unless there are particular areas with more urgency due to a direction the organization is going or a project the employee's team is about to take on.

Open this experience by explaining that you and the employee will brainstorm together ways to improve areas of performance weakness. Remind her that the purpose of the Feedback Meeting is to understand where someone can improve and then do something to support her during that process. This is where solutions and effective steps are made explicit.

Determine how many criteria you'd like the employee to work on for the next few weeks or months. Keep the number only slightly ambitious. We're all limited in what personal improvements we can take on at one time, so ask the employee which area(s) she'd be interested in addressing first, and let her know if there are any you'd like her to focus on. Once those are established, you can begin the process of exploring and choosing how to shift those areas.

Let's say the two of you have elected to improve communication skills. The next step is to brainstorm ways the employee can make a change in that area. Ask him to suggest ways to do that, and capture those suggestions directly onto the infomural, surrounding the point plotted for the criteria. Add your own suggestions and repeat this process for each chosen area of improvement.

Once the options are on the wall, discuss them. Is "finding a mentor" more of a viable option than "taking an online course"? Is it more effective to "shadow a good communicator" than to "read books on communication"? Consider the availability, cost, and effectiveness of each training option and circle the ones you select together. Here's a quick list of options in case either of you get stuck:

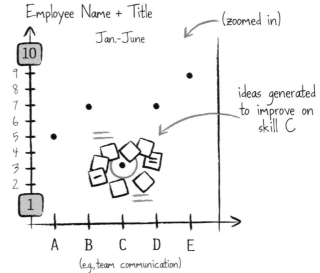

· Attend a conference, workshop, or training (online or in-person) related to the desired improvement area

· Start an internal "book club" that focuses on pertinent subject matter

· Observe people who excel at the skill being developed and journal about those observations

· Register for relevant online courses

· Get a "performance buddy" and have regularly scheduled check-ins to encourage continuous attention to and improvement around the issue

· Start an internal weekly "lab" or "school" where people experiment on a topic together in order to learn from each other

- Invite an expert to come to your company and give a talk on the subject

- Request a coach who can guide an individual employee or a team via remote conferencing

- Find one best practice and apply just that practice for a week, or month, or however long it takes to be integrated into work behavior

Options for learning are endless, so stay open to diverse techniques. Make a plan with the employee for follow-up and implementation so these options have traction. When you next come together for a Feedback Meeting, you'll plot changes in behavior and performance, and you can discuss how and if certain techniques had an effect on the outcome. If reading worked better than an online course, for example, keep that in mind for that employee. The employee's individual learning style will become clearer, and you can both use that knowledge to inform future training options.

Best Practices for Trainstorm

- Give employees achievable, concrete steps to take to improve performance. It can be overwhelming to be asked to "be more creative" without any specific things to do in order to achieve that. Be explicit around expectations and what the behavior would actually look like when in effect.

- Have training suggestions available for an employee to choose from. For example, be aware ahead of time of options or best practices that exist for her to embrace continued learning. Bring information on different types of workshops, curricula, webinars, or coaching that would address the challenges specific to

each employee. Offer them as possibilities, but also invite the employee to make her own suggestions about training she'd like to have.

- People will very likely never score a "10" in every criteria. Be sure and communicate that the individual doesn't need to drive toward perfection or to use the top notch as a measure of her value. Incremental improvements are the norm in terms of shifting behavior, so assure the employee that slight but discernible upticks are the goal—not some perceived flawlessness. Let her know you accept ongoing limitations, and that you have some yourself.

Regarding Feedback Meetings, an important idea to remember is that people respond better, especially over the long term, to systems of motivation beyond a carrot-and-stick approach. Humans are complex creatures, and we're more inclined to engage in consistent personal improvement when we feel a sense of perceived progress and a perceived control over that progress. We thrive and perform best when we have a sense of autonomy, mastery, and purpose. The Infodoodle sequence for the Feedback Meeting accommodates our deeper, intrinsic motivation. You'll have given the employee context for how her development impacts a larger vision, and the employee can see in one visual display how her performance is (or is not) progressing over time. She can clue into stagnation, but more importantly, she can remain motivated by incremental gains that she can see over time—perceived progress. She can also influence her own growth through the process of brainstorming and selecting specific training—perceived control and autonomy.

The experience of getting feedback from "superiors" can be a challenging one for even really

confident people, but this sequence softens the process, warms the person to observations made, maps the expectations, *and* puts her in the driver's seat so she can steer her own work life. Done well, this feedback session is a win-win-win for everyone.

COMBINATION MEETING

Combination Meetings are the last of the six meeting types, and by now, you are an uncontested ace Infodoodler. There is no meeting, no gathering of minds, that you can't doodlify and make a thousand times more effective. Because you're a doodle professional now, for our Combination Meeting—a meeting that can have a wide variety of goals—I'm won't be designating a specific sequence. This is the part where you can completely take the reins and apply what you've learned on our long Revolutionary road. There is *one* thing I can give you that will set you up for success, however, and it is this perspective from your loving Pragmatist:

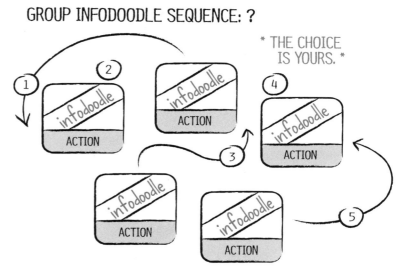

GROUP INFODOODLE SEQUENCE: ?

* THE CHOICE IS YOURS. *

A gathering of people (often referred to as a "meeting") is simply an aggregate of energy. At its most basic structure, it is just that. With your newfound skills, you'll bring to this grouping of energy:

· Simple visual language and structures
· Thought experimentation
· An order of operations, a sequence, that moves that energy toward a desirable goal

It is no longer mysterious how Group Infodoodlers help teams harness intelligent thought, and the Infodoodle sequences play a *major* role. The sequences form the causal chain of visualization activity that enhances the performance of the individual and the performance of the collective brain. They are vital to a successful group process.

As you design Combination Meetings (and, really, every other kind), keep in mind that the results of one activity should move seamlessly into the onset of another. For example, understanding a customer (Empathy Mapping) happens before designing for that customer (H.I.T.). Evaluating viable projects (Need vs. Capacity Graph) takes place before voting on them. These sequences are not arbitrary. They're reflective of an instinctive, organic process that emerges when human beings take on problem solving in a meaningful and informed way.

Know a meeting's goal; then you can determine what Infodoodles, in what order, will plot an effective creative and intellectual path. All you need now is more practice and more Infodoodle activities at your disposal.

For those, I recommend the Internet. There are Infodoodling activities galore. Search for them using phrases like "visual thinking," "facilitation games," "mind tools," and "design thinking." I also recommend the following books—great works that came before in service to the pursuit of better thinking. Mind you, few of them have the application of visual language embedded into their techniques, but you're schooled enough to imagine how you can weave the Doodle into anything. You are now a four-star general of whole-minded visual thinking. Go forth and experiment. Mash-up, link-up, remix, hybridize, design your own Group Infodoodle experiences. Combination Meetings will stand and salute when you walk by.

· *Gamestorming: A Playbook for Innovators, Rulebreakers and Changemakers,* by Dave Gray, Sunni Brown, and James Macanufo

· *The Innovator's Toolkit: 50+ Techniques for Predictable and Sustainable Organic Growth,* by David Silverstein, Philip Samuel, and Neil DeCarlo

· *101 Design Methods: A Structured Approach for Driving Innovation in Your Organization,* by Vijay Kumar

· *Innovation Games,* by Luke Hohmann

· *The Thinker's Toolkit: 14 Powerful Techniques for Problem Solving,* by Morgan D. Jones

· *Rapid Problem Solving with Post-It Notes,* by David Straker

· *Visual Meetings: How Graphics, Sticky Notes and Idea Mapping Can Transform Group Productivity,* by David Sibbet

· *Lateral Thinking: Creativity Step by Step,* by Edward de Bono

· *Creativity Workout: 62 Exercises to Unlock Your Most Creative Ideas,* by Edward de Bono

DOODLE SPACE (to summarize something you've just learned)

MARCHING TOWARD VISUAL LITERACY: The Doodle Revolutionary's Call to Action

TAKING IT BACK TO WORK

Where are we now, Revolutionary? You have a complete visual-language tool kit; you have chops at subtraction; you have skills at diagramming; you have Infodoodle sequences; you have the motivation to keep going. Now I'm going to guess what stumbling block many of you are about to encounter.

I call it "the Shadow."

The Shadow is the hand-wringing, risk-averse naysayer that appears when we know we're on the verge of doing something great. It's the well-meaning but misguided creature who, right when the butterfly leaves the palm of our hands, shreds one of its wings. Better safe than sorry, it hisses. Then it murmurs mercilessly in our ears:

You're not an expert meeting leader. You're not comfortable leading a group process at all, much less one that involves doodling. I mean, doodling? What could that possibly be good for other than mindless art? And what if your session fails? What if the Infodoodle technique isn't effective and you get picked on for trying? Your company culture isn't interested in things perceived as fun, or unusual, or expansive. You're no Revolutionary. Don't stick your neck out. You can't draw. You can't create. Go back to your words and spreadsheets and your standard group work. Tell your team to interact and brainstorm like they always have. It may be plodding, but at least it's functional and not provocative. You're safe with words, and there you have nothing to lose. So DROP the Doodle. It's not worth it.

You know this guy is trouble, right? He means well, but he knows not what damage he does. I want you to look at his face, calmly, even compassionately, and tell him this: "Shadow, I hear you. And I know that your intentions are good. Thank you for your work to protect me from social harm. In this instance, however, there is no danger. Nothing is unsafe about the Infodoodle. In fact, my team and I are going to get a huge benefit from pursuing this kind of work. We'll empower our minds to explore possibilities in a way that's been missing for a very long time. It's going to be an incredible journey. And when I need your cautionary contribution, I know you'll be available for me. Because you're my Shadow and you always show up for your part."

The Shadow is real and natural for all of us, so don't try to beat him down. He'll just come back stronger. Better to acknowledge his existence (even recognize that he serves a valuable purpose when he's not giving you bad advice) and step forward] into the light. Into the benevolent, brilliant light ofthe Doodle.

Now, because I am your friend, I will not lie to you: If you do implement some form of Infodoodling in a meeting, it is possible that you'll get all manner of reactions to your efforts. You'll get snickers, whispers—and if you're in one of *those* cultures, maybe even outright laughter. There will always be people standing in the way of real change. If you want to live in a world where those people win, where they get to use crappy, ignorant tactics to shut down growth, thinking, creativity, and innovation, then you have all the freedom in the world to make that choice. You can return to your words and numbers and spreadsheets and keep doing the work that you're doing. I'll still respect you because I know that what I'm asking you to do is not easy.

But if you're ready to be a Revolutionary, if you're a person who knows that our minds have much more potential and much more to contribute when they're released from our preconceived and ill-informed notions, if you're a person who wants permission to think freely, who wants to use all of the equipment you have, then here are a few guidelines to help you manage the concerns you'll inevitably have about going forth and bringing visual language to your workplace.

Establish the primary meeting leader. If you personally are not comfortable leading a session, find someone in your organization who is. Define your roles and expectations with that person before the meeting.

Invite the right people. Who you invite to a meeting is equally as important as what you ask them to do. Make sure you've invited people who know the content being discussed, who can make decisions around what to do (or at least connect meaningfully with people who can), and who are participatory or can be coaxed into being participatory. If the appropriate people aren't present, y'all might as well just go to happy hour. That said, if you can't invite the *perfect* group but you can invite one that's pretty close, the Infodoodle does offer compensation. It's much easier to get a helter-skelter group to be productive when they're all given something to focus on and DO. The structure created by visual space and the sequence of activities will certainly help guide the meeting

to a place better than a traditional get-together, so it can counteract not having the ideal group in attendance. My serious advice to you is to rally the right troops ahead of time. Otherwise, you run the probable risk of squandering scarce time and energy, and around the world, people frown on that.

Establish your expectations for group behavior. Presumably you're working with adults, so they don't need to raise their hands to use the bathroom. But that doesn't mean they don't need guidance on what kind of behavior is and isn't ideal relative to this specific Infodoodling session. Many of them will never have experienced a meeting that applies visual thinking, so offer them an explanation that makes sense and get their verbal agreement on what they're being asked to do. Keep your "rules" to five at the most. More than five and it starts to feel like they've joined the military. A couple of rules I often recommend include "If you don't understand something, speak up," "Suspend the need to critique until it benefits the process," and "Listen when others are speaking (not everyone likes to shout, but everyone likes to be heard)."

Conduct practice Infodoodle games with a small, trusted team before you apply them. You can host a "group" Infodoodle with two people if you're not comfortable trying a sequence in a meeting first. Exploration is valuable since there are a variety of factors that shift and sway the outcomes of each activity. Some of these include the number of people you ask to work in small groups, the method of voting or ranking, the time allotted for each activity, how certain groups are selected, and how the output of one game sets up the input for the next. If you take the time to conduct short pilots or prototypes and actually experience how the Infodoodle games might unfold, the meeting will be better for it. And so will your confidence level going in.

Plan your meeting. Know the sequence and the reason for each Infodoodle activity. People will want to know what they're doing, and some will want to know why. The visual agendas can be taken straight out of the book, or if you're comfortable, you can pull in some techniques you already know OR you can think of ways to doodlize the ways in which you already run your meetings.

Set the room up so that it cues people to the visual aspect of the work. Put Doodle-friendly white space up in the room before people arrive. Write and draw the names of the Infodoodle sequences, and go ahead and doodle diagrams in advance. When people walk into a meeting room and there's white space, colorful sticky notes, markers, and visual structures visible, they know it's not going to be business as usual.

Have the right information at hand. Whether that information is in a slide show, in a report, or in a person, bring what you need to be able to discuss what needs to be discussed. Not showing up with the right information to explore cripples what's possible from the onset.

Prime the group with a warm-up Doodling or Infodoodling exercise. Don't ask people to doodle cold turkey. Give them some context for how you're asking them to work, and then select a short (and even fun) activity that will open them to the concept and to each other. Find useful books or go online. The Improv Encyclopedia, available for free online, is an excellent source for short opening activities.

Remember what you discovered in the first sections of this book. Doodling is thinking in disguise. If you need to psyche yourself up before the first meeting (and I promise you, it gets easier and richer every time you try), flip through what you've learned in this book. Don't let the Shadow take you over. The Doodle is your comrade. Salute it even if your knees are knocking.

Know that each Infodoodle activity is meant to be flexible and adaptable. The guidelines I've given you for each game in this chapter are based on my experience and expertise. But I am only one person. I want to explore the Group Infodoodle with confidence and abandon. I want you to push the boundaries of what I've described. Change the variables along x- and y-axes. Make a game ten minutes instead of thirty. Take an aspect of a thought experiment and put it inside of another. Add a random element to the mix. The purpose of the Group Infodoodle is to give people thinking spaces inside of which a shift in their typical cognitive pattern becomes possible. Since that is the ultimate goal, the methods you use to do it become infinite. You and your team live in the knowledge universe. Help them explore it with everything you've got.

Dear Revolutionary,

We have come so far together, and now we arrive at the end of this road. But there will be many more miles to go. Nothing short of a cultural revolution is necessary to overturn the myths around Doodling and elevate it to its proper place in society. To honor that mission, this closing Manifesto was written for Doodlers everywhere. It is a call to action to join the movement. See if its messages resonate with you, and use it to help advocate for the Doodle wherever you need it to thrive.

THE DOODLE REVOLUTIONARY'S MANIFESTO

TO DOODLE

- ~~to dillydally~~
- ~~to monkey around~~
- ~~to make meaningless marks~~
- ~~to do something of little value, substance, or import~~
- ~~to do nothing~~

FALSE.

TO DOODLE

: to make spontaneous marks with your mind and body to help yourself think

TRUE.

We, the Doodlers of every nation, in order to form a more perfect world, establish semantic truth, promote whole-minded learning, provide for the struggling knowledge worker and student, enhance educational well-being, and secure the benefits of the Doodle for ourselves and our posterity, do ordain and establish this Manifesto for Doodlers everywhere.

Contrary to popular belief, **THERE IS NO SUCH THING AS A MINDLESS DOODLE**.

The very act of creating a Doodle necessarily engages the mind. Doodling IS thinking; it's just thinking in disguise. This Manifesto, therefore, intends to disrupt society's myths that—intentionally or otherwise—conspire to keep the Doodle down. We as Revolutionaries will illuminate the truth about Doodling and set the record straight after decades of misinformation. Because we, the millions of Doodlers around the world and the billions of Doodlers throughout history, know the impressive power of this universal act. And on this day and each day forth shall the rest of the world know, too. No longer will the Doodle live in a house of ill repute. No longer will simple visual language be underestimated, underused, and misunderstood. Forevermore, we acknowledge the Doodle, in all its varied forms, as a tool for immersive learning. We wield its power deliberately and without restriction, in any learning environment we see fit.

We hold these truths to be self-evident:

- ✓ That doodling is as native to human beings as walking and talking;
- ✓ That human beings have been doodling in the sand, in the snow, and on cave walls for more than thirty thousand years;
- ✓ That we are neurologically wired with an overwhelmingly visual sensory ability;
- ✓ That doodling ignites four learning modalities—auditory, kinesthetic, reading/writing, and visual—and dramatically enhances the experience of learning;
- ✓ That doodling promotes concentration and increases information retention;
- ✓ That doodling supports deep, creative problem solving, insight, and innovation;
- ✓ That doodling has been an ever-present tool, a precursor and a catalyst for the emergence of intellectual breakthroughs in science, technology, medicine, architecture, literature, and art;
- ✓ That doodling is and has been deployed by some of the best and brightest minds in history;
- ✓ That doodling lives outside of elite realms of high art and design and is a form of expression free and accessible to all.

Because of these truths of the Doodle, we hereby **DECLARE A DOODLE REVOLUTION.** We defy the modern definition of doodling and take the definition into our own hands. What we believe to be a fair and just definition of the Doodle is as follows:

> **to Doodle:** to make spontaneous marks with our minds and bodies in order to support thinking; to use simple visual language to activate the mind's eye, engage multiple learning modalities, and support creativity, problem solving, and innovation.

We believe that education around the power of Doodling is essential for a brighter future, and awareness will necessarily lead to its enhanced use. As Revolutionaries, we have designed an advanced method of applying and deploying the Doodle: Infodoodling.

to Infodoodle: to intentionally track auditory or text-based content and translate it into words and pictures; to use both text- and picture-based language to clarify and communicate concepts; to explore and display complex information using a union of words and pictures, as a solo effort or with a group.

The practice of Infodoodling is for a complex and unpredictable future—one that will warrant knowledge of and proficiency in the building of visual displays. We believe that the opportunity to learn and practice Doodling and Infodoodling should be available to all people, so we will no longer tolerate the crippling of our native Doodling abilities in order to adhere to antiquated perceptions. We insist that the People be shown the value and real-world applications of both techniques.

To reach this lofty goal, we demand that teachers, bosses, and authority figures cease and desist any suspicion and disapproval that stigmatizes Doodling. We assert our belief that Doodling is most appropriate where society perceives it as least appropriate: in situations with high information density and high accountability for learning. Today, we liberate the Doodle and elevate it to its proper place in our world. We take up our pens, pencils, and markers and deploy Doodling—sophisticated and simple—wherever we deem it necessary. We will wield the power of the Doodle, and for this, we will not apologize. We will take the Doodle back and then put it to work.

Viva la Revolución!

I made you a promise at the beginning of this book. I promised that the Doodle Revolution would bring the possibility of higher-order thinking, the prospect of greater insight, the chance for deeper creativity, and the path to better problem solving. When this promise is fulfilled it will be because of you. You chose to explore a space where both hemispheres of your mind—left and right—are awakened. You chose to activate the fuller potential of what's possible. That choice will lift all of us from our myths and misinformation and result in a better future. One day, we'll all look back and marvel at a time when we used to rely almost exclusively on text, numbers, and verbal language at work and at school. Until that day comes, you as a Revolutionary will light the way. You, your tools, and your talent will be the agents of change. The path to visual literacy—a path that contributes to the creative and intellectual advancement of humankind—will be built by brave and noble people, just like you.

Sign the Manifesto: http://sunnibrown.com/doodlerevolution/manifesto/.

Love! Sunni

FAMOUS LAST WORDS

ACKNOWLEDGMENTS

As with any act of creation, there are always individuals who, wittingly or unwittingly, contribute deeply and uniquely to that effort. It is not possible to acknowledge every person who's guided, inspired, or supported me during this long and often arduous process, but I am deeply and eternally grateful to the following individuals—more so than could ever be expressed using a device as limited as language.

To my former executive producer and beloved friend Amber Lewis, for being an extraordinary anchor and a spiritual midwife for this book. So rarely is one blessed with an experience and friendship like ours. I cherish it, and I could never, ever thank you enough.

To my husband, Chet Hornung, for enduring, listening, and loving throughout the years this project took. You are a small miracle and the most brilliant, handsome man I have ever laid eyes on.

To my brother Rocky Brown, for supporting me unconditionally, without asking for anything in return, and for being one of the most important and loving influences in my life.

To my family, Mom, Joe, Christy, and Cassie, for shaping who I am with love and, occasionally, logic. Wink!

To Kristin Moses, for having the courage and the talent to make the book a true visual artifact, and for being an exquisite designer and lifelong friend.

To Fran Magee, for being genuinely enthusiastic and evangelistic about my work, and for letting me live like a hermit crab in her home for weeks as I climbed mountain after mountain to build this book.

To Jonas Koffler, for being the blissful wizard to my dark pragmatist. May you have more naps while you hustle and flow.

To my Zen teacher Flint Sparks, for embodying and demonstrating what it means to live with an open heart, open mind, and open hands.

To Peg Syverson and the Appamada Community, for being a constant resource to renew, uplift, and connect. I take refuge in each and every one of you.

To Erik Kuntz, for being meticulous, talented, and so very patient, and for being the longest-serving team member—with me from the very first day, seven years ago.

To Stacy Weitzner, for being a glowing presence, a constant learner, and arguably the most mature person on our team.

To Kevin Leahy, for being a high-gamma brain and a crack researcher, bringing data-driven legitimacy to the many claims I make about the Doodle.

To Nancy Duarte, for being a powerhouse mentor and a deeply inspiring friend. We "country" girls can certainly survive (and thrive) with style.

Acknowledgments (*continued*)

To June Cohen and Chris Anderson, for giving the Doodle Revolution the oxygen it needed to find and support more of its people.

To Jessica Hagy, for being an authentic, brilliant weirdo and an unexpectedly dedicated friend. Next stop: coauthorship!

To Steven Pressfield, for his profound and deeply resonant works of literary art.

To Dan Roam, for advancing the visual-thinking field with such intelligence, creativity, and joy. You are an absolute delight.

To Dave Gray, for being so talented at visualization that I actually envy how your mind works.

To David Sibbet and the folks at the Grove Consultants International, for being among the very first applied visual practitioners in the United States.

To Fernando de Pablo, for being a bold and entrepreneurial Infodoodler as well as a gracious contributor to the Revolution.

To Ted Weinstein, for expanding everyone's pies and for being a guiding force as I stumbled through the fog of this process.

To Emily Angell, for her tireless attention to the editing process, and for her good nature and patience along the way.

To the Skeptics, without whom this book would have had no one to rail against and no one to help me so effectively sharpen and hone the arguments that contradict you. Giggle!

To Doodlers and nontraditional learners everywhere, for your unyielding commitment to visual and kinesthetic language against many odds. You are brave and true.

Doodlers, unite!

NOTES AND SELECTED CITATIONS

Chapter 1—Doodling Is Thinking in Disguise

1. Literacy is a remarkably difficult concept to define. The illustration reflects an operational definition intended specifically for measurement purposes that was formulated during a UNESCO international expert meeting in June 2003 (http://unesdoc.unesco.org/images/0013/001362/136246e.pdf).

2. We seem to be even less competent at interpretation than we think we are, at least in terms of fidelity to what is actually before our eyes. The Harvard Medical School professor Moshe Bar is doing fascinating research on visual cognition and prediction, so I'll summarize his work in my own clumsy fashion. Dr. Bar's research suggests that the human brain is continuously occupied with generating predictions that will approximate the relevant future. So our brains seem compelled to link visual (and other types of) sensory information to representations in memory, deriving and applying analogies from associated stored content. What this means to me is that (a) our brains are remarkably efficient machines that seem to be less concerned with accuracy than they are with anticipation, and (b) we are in a constant dance of actively shaping what we see. In other words, we see and perceive either what we want to see or what we expect to see based on what Bar calls "pre-sensitized representations." It's plausible that everything, my fellow humans, is a projection *and* prediction of the mind.

3. For a fascinating overview of how our Phoenician alphabet lost its picture elements, read Appendix A: "How We Lost Half Our Mind" in Dan Roam's book *Blah Blah Blah: What to Do When Words Don't Work.* And for a delightful romp through visual language over the centuries, try Chapter 2 in Robert Horn's book *Visual Language: Global Communication for the 21st Century.* Whichever you choose, you'll wish you grew up learning pictographic and logographic writing systems like Chinese or perhaps the fun-for-all-ages Ancient Egyptian.

4. Wait until you discover Sylvia Fein's studies of children and the origins of visual language. In her book *First Drawings: Genesis of Visual Thinking*, she demonstrates that children around the world develop visual language *in the same predictable order.* It grows natively from our minds and hands, opening up like a flower.

5. I studied journalism, linguistics, French, Spanish, and public policy. You do not get more wordsy than that.

6. In Steven Pressfield's epic book *The War of Art*, the enemy of creative expression and accomplishment is called "Resistance." You'll see a Doodle I did for Steven in Chapter 2.

7. Cases for your future investigation: architect Frank Gehry's precursors to every building he's designed, inventor Steve Wozniak's illustrations of the Apple I, the famous Southwest Airlines napkin sketch, and the discovery of Fibonacci's sequence.

8. I have a dear friend who's Persian, and she says that in Farsi, "doodle" is reminiscent of a word that sounds like "du-del," which means "a little boy's penis." I think we all saw that definition coming.

9. See the work of David Shrigley. The *New York Times Magazine* published a piece on Shrigley called "The Art of the Doodle" in which he was described as "master of the incompetent line."

10. See the work of Jon Burgerman. His rapid visualization is often described as doodling, and he acknowledges that he does not plan his composition before he begins his large wall paintings. He does his "drawing and thinking at the same time" and lets his pen guide him. Burgerman also said something rather charming that should be quoted: "Doodling is a hard master if you want to take it seriously. It's a piece of pie if you just want to mess around though." Bless him for recognizing the versatility of this tool. http://jonburgerman.com/info/faq.

11. You might also ask if a scribble can be profound, to which I would decidedly answer *yes*. The scribbly, calligraphic work of the artist Cy Twombly was frequently derided by critics, but he ultimately came

to be regarded as one of the most important figures in a generation of artists working to move beyond Abstract Expressionism.

12. If you remain skeptical, just Google the world "doodle." You'll get results that are so broad you'll start wondering if there's anything left in the world to rely on.

13. Or nine or twelve, depending on whom you ask.

14. Dan Mitchell, "Silicon Valley's different kind of power walk," *Fortune*, November 15, 2011. http://tech.fortune.cnn.com/2011/11/15/silicon-valleys-different-kind-of-power-walk

15. Some of the most memorable involve walks with John Sculley, VP and later president of PepsiCo, who eventually was aggressively courted by Jobs to become Apple's CEO. The relationship was intense, as were the challenges the two faced, and according to Walter Isaacson's biography, Jobs often invited Sculley on long walks when they were at crucial decision points.

16. "The Lost Tapes of Steve Jobs," *Fast Company*, May 2012, 80.

17. Walter Isaacson, *Einstein: His Life and Universe* (New York: Simon & Schuster Paperbacks, 2007), 14.

18. Jacques Attali is a practicing economist, distinguished scholar, prominent technocrat, and adviser and close friend of the former French president François Mitterrand. He also happens to write books about jazz in his spare time.

Chapter 2—The Doodle's Radical Contributions: Power, Performance, and Pleasure

1. Jackie Andrade, "What does doodling do?" *Applied Cognitive Psychology* 23, no. 3 (February 26, 2009).

2. Well, everyone except Ed Cooke, Grand Master of Memory at age twenty-three, who divulged the secret of his seemingly impossible ability to recall information: "The general idea with most memory techniques is to change whatever boring thing is being inputted into your memory into something that is so colorful, so exciting, and so different from anything you've seen before that you can't possibly forget it." I couldn't have said it better myself, Ed.

3. The methods of loci and mnemonics.

4. Dr. Scofield's story and related research: http://

hermes.mbl.edu/publications/pub_archive/Botryllus/Botryllus.revised.html.

5. Before you ask, no, Dr. Scofield didn't capture these metrics. She didn't realize how revolutionary she was being at the time.

6. Shaaron Ainsworth, Vaughan Prain, Russell Tytler, "Drawing to Learn in Science," *Science* 333 (August 26, 2011), 1096–1097.

7. As stated by Dr. Shaaron Ainsworth: http://medicalxpress.com/news/2011-08-doodling-science.html.

8. From Wikipedia: http://en.wikipedia.org/wiki/Visual_learning.

9. The book *Brain Rules* by Dr. John Medina describes how our brains are actually not capable of seeing letters as we understand the concept. Our brains interpret letters as images. This is partly why most of us can't memorize an entire page of adult-level text—the density chokes us up—but we can memorize a series of hundreds of photographs.

10. The theory of Universal Grammar—generally attributed to Dr. Noam Chomsky—is important to note here. It's a linguistic theory asserting that the ability to learn grammar is hardwired into the brain. That said, while it may be a genetic instinct to distinguish nouns from verbs or functional words from lexical words, humans still need external data and exposure to actually make comprehensive language acquisition possible. Stated simply, language has to be taught.

11. It may even contribute substantially to people's ability to make decisions, interpret information, and solve problems. There's a very interesting field of research in social and cognitive psychology called "embodied cognition," which examines the use of our bodies in the thinking process and asserts that the motor system heavily influences conclusions we reach, decisions we make, perspectives we have, etc. The connections between body and mind still have many boundaries to be explored, but the theories get interesting quickly. For example, some robotics researchers speculate that true artificial intelligence would only be possible in a machine that has a body complete with sensory and motor skills. The suggestion is that intelligent thought itself cannot exist without a movable, physical form. Based on that idea, the talking human heads in jars on Matt Groening's *Futurama*, having lost the connection to their physical bodies, would have seriously compromised creativity and intellect.

12. I know popular opinion believes it to be seven, and the length of telephone numbers is often held up as supporting evidence. This "magical seven" idea is based on Miller's law, described in an article published in 1956 in cognitive psychology. But more thorough and recent studies suggest that estimate of seven was too large. According to Nelson Cowan in *Behavioral and Brain Sciences* 24 (2001), pp. 87–114, the specific number is 2.5 +/- 1.5, depending on the interactions between characteristics of a task and individual differences. Some studies have lowered the number even further (Garavan, 1998; McElree, 1998, 2001; Oberauer, 2002; Verhaeghen & Basak, 2005), stating that our focus of attention can only accommodate a single item at a time.

13. February 2004: http://www.ted.com/talks/lang/en/sergey_brin_and_larry_page_on_google.html.

14. Specifically, the premotor and motor cortices (for physical grip and movement), the dorsolateral prefrontal cortex (for opening the mind's eye and the imagination), the ventrolateral prefrontal cortex (for vetoing parts of what the imagination has opened), and the amygdala and basal ganglia, including the caudate nucleus (for engaging an emotional response).

15. From *Visual Language: Global Communication for the 21st Century*, by Robert E. Horn, p. 234.

16. Ibid.

17. Some examples of whiteboard cultures I've seen in person include the offices of Zappos, Google, Facebook, Square, XPlane, HomeAway, Disney, and Steelcase's Workspring.

18. To clarify, white space doesn't have to be white. (And I'm sensing that a joke from Baratunde Thurston would work well here.) By "white space" I mean large-scale writable and drawable space in which people can express, visualize, and reflect on their thoughts. It can take a variety of forms, including flip chart paper, chalkboards, sticky note walls, pin boards, foam board, glass dry-erase walls, IdeaPaint, etc.

19. Rule #4 in Dr. John Medina's book *Brain Rules: 12 Principles for Surviving and Thriving at Work, Home and School*, describes with some detail the steps that occur in the brain when a person tries to focus attention on changing stimuli. Here I'm including the steps and summarizing them so you understand the basic process. Step 1: Shift Alert. Once we decide to focus on a task, blood rushes to the anterior prefrontal cortex. This is a signal to the brain that it's about to shift attention. Step 2: Rule Activation for Task #1. The signal has two goals: first, to locate neurons capable of executing the task and second, to issue an order to awaken the neurons. Once that occurs, the task is initiated. Step 3: Disengagement. If another task arrives while we're engaged in the first task, our brains must disengage from the first task to respond to the second because the "rules" to conduct the first task differ from those of the second. So we disengage. Step 4: Rule Activation for Task #2. In order to respond to the "rules" of the second task, we go through step #1 again, looking to find and awaken the appropriate neurons for the second task. Once we do, the second task is initiated. Amazingly, these four time-consuming steps occur in sequence *every time* we switch from one task to another. This is why multitasking isn't really possible, because ultimately the brain works sequentially, switching from task to task rather than attending to them truly simultaneously. According to Medina, "The best you can say is that people who appear to be good at multitasking actually have good working memories, capable of paying attention to several inputs one at a time." See http://brainrules.blogspot.com/2008/03/brain-cannot-multitask_16.html.

20. Ibid.

21. The distinction is between a resource that our brain automates for us (reacting to a hostile facial expression) and a resource that we forcibly deploy (giving our attention to a boring lecture, for example). Daniel Kahneman, author of *Thinking, Fast and Slow*, describes situations like these as relying on two distinct systems. As he writes it, System 1 "operates automatically and quickly, with little or no effort and no sense of voluntary control." System 2, on the other hand, "allocates attention to the effortful mental activities that demand it, including complex computations."

22. This is one part of two visual book summaries I doodled inspired by Steven Pressfield's life-changing book *The War of Art*. I had already created a list of points Steven made in his book that were important to me, so I used them as the triggers for content. Part I and II were both completed in one sitting, and I used calligraphy pens and ink without the crutches of pencil marks, erasers, or Wite-Out. The images were spontaneous, as were the fonts and the placement of the content. It eventually made its way to Pressfield himself, and he loved it. Swoon!

23. I already know there will be a throng of people defending their rampant use of technology. Go ahead and defend it. But get educated on both sides of the conversation. Read Sherry Turkle, Jaron Lanier, and Nicholas Carr. Then read Jane McGonigal, Clay Shirky, Kevin Kelly, and Ray Kurzweil. But let's not pretend that a calorie is a calorie. There are 100 calories of Doritos and 100 calories of Brussels sprouts. Technology is not one thing, so don't get all reactionary because I said its use can cause stress and isolation. It sometimes can and it sometimes does. I feel stressed and isolated just typing this footnote.

24. The hippocampus is a part of the brain's limbic system, and it plays a significant role in consolidating information from short- to long-term memory, as well as supporting spatial navigation. Damage to this area has been associated with all sorts of pathologies, such as Alzheimer's, schizophrenia, severe depression, epilepsy, and variations of amnesia. The following research on the relationship between stress and a shrinking hippocampus saddens me deeply because it relates to soldiers, especially combat soldiers, whose suicide rates, according to *Time* magazine, increased by 16 percent in 2012 compared with the previous year. Sapolsky's quote: "Most of the recent PTSD imaging studies have found atrophy only in the hippocampus; the rest of the brain is fine. The damage, however, is not trivial. For example, Tamara Gurvits, Roger Pitman, and their colleagues at the Manchester VA Medical Center and Harvard Medical School have studied combat PTSD patients and reported that one side of the hippocampus was about 25 percent smaller than expected. Twenty-five percent! That's like reporting that an emotional trauma eliminates one of the four chambers of the heart." R. Sapolsky, "Stress and Your Shrinking Brain," *Discover* 20, no. 3 (1999), 116–122. http://helios.hampshire.edu/~cjgNS/sputtbug/416K/Endo/sapolsky-stress.pdf.

25. I want to acknowledge that this link is contested because the epidemiology is hard to prove, but the report "Posttraumatic Stress Disorder and Risk of Dementia Among US Veterans" is intriguing. Conclusion of this study: "In a predominantly male veteran cohort, those diagnosed as having PTSD were at a nearly 2-fold-higher risk of developing dementia compared with those without PTSD. Mechanisms linking these important disorders need to be identified with the hope of finding ways to reduce the increased risk of dementia associated with PTSD." K. Yaffe, et al., *Archives of General Psychiatry* 67, no. 6 (June 2010).

26. Interestingly, an intense focus on a task can cause situational blindness. In other words, a doodler can get so enthralled in his process that he becomes oblivious even to stimuli that would normally attract attention. (Some of you may be familiar with the famous "Invisible Gorilla" video by Christopher Chabris and Daniel Simons. If not, Google it.) And I'm certain that anecdotally we all have experiences with situational blindness. As a young child, I read about ten decent-sized books a week. I used to get so lost in the pages that I would forget to eat, situationally blinded by my reading.

27. The "knowing network" is a phrase coined by my friend Kevin Leahy, a former attorney and diligent researcher of all that is brain. He has a program and curriculum called Mind Athlete that he's been developing and delivering for years.

28. Georges St-Pierre is a mixed-martial artist from Canada and the current UFC Welterweight Champion (destined to retire as the best pound-for-pound fighter in the world!). Known as "Rush" and "GSP" to those who love him, he's shown repeatedly how important visualization is to his success. As a staple in his preparation, he visualizes himself winning and also mentally practices by imagining himself getting out of tight situations. And as coach on the television show *The Ultimate Fighter*, he made his protégés role-play the next day's fight activities, even arranging an entrance walk while teammates cheered. But this wasn't for the TV drama. GSP does the exact same thing before his own fights because he's purposefully elevating the potential for his win.

29. Phelps stated that he's been visualizing "the perfect swim" since he was seven years old, and he is now the most decorated Olympian in history, holding nineteen medals.

30. http://www.tangsoodoworld.com/articles/The_Mental_Training_of_Chuck_Norris.pdf.

31. One fascinating set of stories about healing through visualization can be found in V. S. Ramachandran's book *The Tell-Tale Brain*. In it, Ramachandran describes patients with phantom limbs, and he discusses his treatment of discomfort, pain, and even paralysis in limbs that no longer exist. As an experiment, Ramachandran used the simple technology of mirrors to make the patients' brains believe that the limbs existed again. Once he had induced "seeing is believing," the patients were able to trick their brains into thinking that the limbs existed and that they were

functional and without pain or paralysis. He called the technique "mirror visual feedback" (MVF) and said that he himself was surprised to discover the effectiveness of it. It worked with the phantom-limb patients, with stroke patients, and also with patients experiencing generalized, chronic pain. It seemed to be effective due to the powerful visual sensory feedback given to the brain by the mirror. Because of the visual illusion created by the mirror, the brain began to reorient itself according to a lack of pain rather than to the persistent presence of pain.

32. There are various anecdotes of POWs using visualization to facilitate their grips on reality. The most famous involves Major James Nesmeth in a golf-related story that had an early appearance in a book by Zig Ziglar. But as obvious as it sounds that POWs would use visualization to survive (and later even thrive), the sources for most of these stories aren't credible. One credible source stands out, however, detailed in a PBS documentary called *This Emotional Life*. It involves POW Bob Shumaker, who spent eight captive years being isolated and tortured in various North Vietnamese prisons—including the infamous Hanoi Hilton. Shumaker details one of the techniques he used to stay sane and even hopeful, which involved intensive visualization of the house he would build upon his return home. Shumaker knew the house in his imagination intimately, down to the number of bricks and nails in the entire structure, as well as the exact feet of lumber. I also think it's noteworthy to discuss Viktor Frankl, the Austrian neurologist and Holocaust survivor, who famously relied on visualization to endure his brutal circumstances. Frankl used the power of his frame of mind to become an objective observer of his own imprisonment, watching the proceedings as if he were a scientist reporting on what he saw and imagining a university audience listening to his explanations. This allowed Frankl to see and experience an alternate reality so that the one he was temporarily in would be bearable. Frankl also repeatedly visualized his wife's face in order to maintain substantive contact with the feeling of loving and being loved. This is all on record in his writings.

33. From Oprah's "Lifeclass" interview with Jim Carrey. http://www.youtube.com/watch?v=nPU5bjzLZX0.

34. From G. Yue and K. Cole, "Strength increases from the motor program: Comparison of training with maximal voluntary and imagined muscle contractions," *Journal of Neurophysiology* 67 (1992), 1114–1123. And another

great read on how mental exercise increases muscle strength from M. Reiser, et al., "Strength gains by motor imagery with different ratios of physical to mental practice," *Frontiers in Psychology* 2 (2011), 194.

35. In effect *RE*-seeing established memories and experiences.

36. I referenced Moshe Bar's work on prediction and visual cognition in Chapter 1. His video "The Proactive Brain" would be good to revisit at this juncture (www.youtube.com/watch?v=yeY8qnZaUBU).

37. Some illuminating information supporting the comments from boxes 2 and 3 in the flowchart relating to how memory works: D. Schacter, *The Seven Sins of Memory* (New York: Houghton Mifflin, 2001). Also, D. Schacter, et al., "The Future of Memory: Remembering, Imagining, and the Brain," *Neuron* 76 (November 21, 2012). And for good measure, D. R. Addis, K. Knapp, R. P. Roberts, and D. L. Schacter, "Routes to the past: Neural substrates of direct and generative autobiographical memory retrieval," *NeuroImage 59 (2012)*, 2908–2922.

38. There is, of course, a cautionary tale here, which has to do with the word "desired." The brain's network of knowing—those established memories that contribute to what you repeatedly experience—can also empower negative habit loops. So it's important to purposefully imagine desirable outcomes rather than letting our negative experiences run amok.

39. For the record, we can use visualization for undesirable outcomes as well, and we probably do this more often. *Training* our minds to envision positive outcomes is an extremely worthwhile pursuit, even if it's not our default.

40. Located predominantly in the temporal lobes.

41. Please note that one of these names for neural networks—the imagination network—isn't a common nomenclature (though there is a well-written reference to it here: http://rstb.royalsocietypublishing.org/content/364/1521/1263.full), but I wanted to use that term for the purpose of understanding because some of the accepted names of neural networks make their function less clear. For example, "salience network" is an accepted term for the network that segregates the most relevant of internal and external stimuli in order to guide behavior, but you wouldn't necessarily surmise that from the word "salience." Also, please note that there are three other networks that seem to be involved in the imagination network. They are

the default mode network (when the imagination is in daydream form), the memory network (which includes the hippocampus and the integrative cortex areas in the back of the brain, as well as the medial prefrontal cortex), and the working memory network.

42. The default network is the network most of us live in most of the time. It's the network turned on when our focus is not on the external world, a world that requires more intense focus, empathy, and navigation. Marcus Raichle and colleagues bravely presented this network formally for the first time in a landmark 2001 paper: M. Raichle, et al., "Inaugural Article: A default mode of brain function," *Proceedings of the National Academy of Sciences* 98, no. 2 (2001), 676–682.

43. To *know* is a very nebulous concept, and it likely involves more regions of the brain than I've listed here. This example is just to emphasize the overarching idea that not all parts of the brain are on all the time and different parts become active relative to different activities happening.

44. From page 22, Chapter 2 ("Expertise and the Mental Simulation of Action," by Sian L. Beilock and Ian M. Lyons), of the *Handbook of Imagination and Mental Simulation* (2009), edited by Keith D. Markman, William M. P. Klein, and Julie A. Suhr: ". . . the explicit ability to mentally simulate an action without overt execution is often termed motor imagery (Decety, 1996a, 1996b). What is the relationship between motor imagery and execution itself? According to psychophysiology and neuroscience work of the past several decades, there is a functional equivalence between action execution and the mental simulation of action (e.g., see Decety & Grezks, 1999; Jeannerod, 1994). That is, motor imagery and execution share common neural substrates (Decety, 1996a; Jeannerod & Frak, 1999). For example, when individuals are asked to imagine themselves writing, increases in regional cerebral blood flow (rCBF) are seen in prefrontal brain regions, the SMA (supplementary motor area), and the cerebellum—similar to the activation patterns found during actual writing movements (Decety, Philippon & Ingvar, 1988)." On page 31 of Chapter 2 the researchers go on to say that due to the neurological overlap between motor imagery and execution "Motor imagery has been widely used as a rehabilitation technique for stroke and other patients who wish to regain finer motor control in certain tasks (for a review, see Dickstein & Deutsch, 2007). Motor imagery has also been used to train surgeons in complex surgical procedures (Hall, 2002; Rogers, 2006), to promote the learning and retention of complex

athletic tasks (Driskell, Copper & Moran, 1994; Feltz & Landers, 1983; Martin, Moritz & Hall, 1999), and for the transfer of motor skills. Mentally simulating an action, as reviewed in this chapter, is thought to activate the neural substrates involved in action production. It is perhaps not surprising, then, that simulation of certain actions benefits subsequent performance." So you can begin to understand how the brain responds powerfully to visual mental rehearsal and uses it to influence performance. You might also see how doodling and Infodoodling, which involve visualization and preconscious, semiconscious or conscious mental programming of next actions, can offer a boost to steering toward a desired possibility or performance. It's about practice. Doodling and Infodoodling also often involve direct physical movement, which makes them an even more significant partner in enhancing a preferred outcome. Because of their multistimulus access, doodling and Infodoodling fire up rehearsing, planning, and motor execution networks of the brain all at once in a multiplex, symphonic, imagination+action combination—even more neural networks than mental rehearsal alone.

45. You may recall that it can also be a musical, kinesthetic, and mental exercise as well.

46. I restrained myself when writing the section on doodling and possibility. I wanted to explore mirror neurons, which are neurons (confirmed to be present in macaques and having strong but controversial support for their presence in humans) that fire both when an animal does something herself and when that animal sees another animal performing the same action. There's evidence that these neurons fire when a person *imagines* himself doing something and when that person is actually doing something. This is explosive because it suggests that we can and do create our realities by using the mind's eye (and other sensory networks in the brain). What we see may very well be what actually exists for us. Based on mirror neurons, my plan was to couple their promise with Heisenberg's uncertainty principle, which is the theory that all potentials or possibilities exist side by side simultaneously. With those two together, I wanted to propose that we can manifest alternate realities based on what we have seen and what we choose to see, through purposeful visualization, drawing, doodling, painting, etc. I like to think that, eventually, quantum physics will bear this out, but my more intellectually somber friends reminded me that I don't want to look insane. So I elected to discuss the knowing network, which is nowhere near as far out.

Chapter 3—Doodle University: Exploring the Foundations of Visual Language

1. Of course I've gotten better with practice, which is part of the purpose of the book, but I remain an individual who would be mocked by anyone enrolled in art school. And I have no problem with that.

2. I also have students who are light-years ahead of me in terms of their ability to draw. I'm happy for them, but if they think this makes them teacher's pet, they'll learn quickly that I'm not bowled over that easily. Our work is about the *thinking*; it is not about the drawing. And moreover, an ability to draw can actually hinder someone's progress in class. People who can draw struggle with two challenges: First, they tend to focus on the drawing and lose track of the content around which the thinking is supposed to take place, and second, real drawers usually struggle to simplify their work, having spent so much time elevating their skill. But quick, simplistic renderings are essential for effective Infodoodling, so their work involves deprogramming and moving toward simplicity.

3. B.A.S.H. is a doodle game kids used to play before the rise of video game mania. The acronym stands for Boat, Airplane, Ship, Helicopter, and the object of the game is to destroy your opponent's "fleet." It's played with a piece of paper and pens. The two players draw islands in the middle of the "ocean," and their different vessels embark from a home base and try to land on the opponent's base, destroying each other in the meantime by flinging a strategically placed line through the different vessels. There are other rules I won't go into, but suffice it to say that B.A.S.H. taught me a valuable lesson about how to make straight lines in order to kill things.

4. Obviously, there were other variants of the fundamentals of visual language before Dave's existence. What he did, however, was survey the literature and derive the twelve letters (six forms, six fields) that he believed would best accommodate the universe of possible combinations. This alphabet has been invaluable to both me and my learners, so for that and other things Dave has contributed to my life and work, I am thankful.

5. By this I mean that the alphabetic letter is the smallest distinguishable unit (called a grapheme) in a written language, just as the "letters" of the Visual Alphabet are the smallest distinguishable units of a Doodle. In spoken languages, the smallest distinguishable unit is called a phoneme. The difference between graphemes and phonemes is the difference between the letter *s* and the fricative sound *sssssss*.

6. In case you were wondering, the loop does make a small enclosure, but it does not, by nature, fold back in and reconnect with itself.

7. In case you've not encountered *La trahison des images* (*The Treachery of Images*) by René Magritte, it is a famous, thought-provoking painting depicting a tobacco pipe, under which are the words, in French, "This is not a pipe." Magritte was a Belgian surrealist artist interested in ideas involving the perception of reality. The piece is trying to get the viewer to think about capturing an object itself in a painting—obviously an impossibility. He wanted the viewer to recognize that a visual representation is an illusion, one that can never be as emotionally satisfying as the real thing.

8. In Chapter 4, we'll move into visualizing abstract concepts like "strategy" and "justice." Right now, let's start with the object nouns. They're generally less intimidating.

9. For a delightful series of books that demonstrate the accessibility of drawing using the Visual Alphabet, read Ed Emberley's *Drawing Book* series that includes titles like *Make a World*, *Book of Animals*, *Book of Faces,* and even *Book of Weirdos*. You'll start to wonder why we weren't reading these books in kindergarten right along with the Hooked on Phonics series.

10. Tom Gauld is a Scottish cartoonist and illustrator who has written and illustrated books like *Guardians of the Kingdom*, *Three Very Small Comics, Hunter & Painter,* and *The Gigantic Robot*. The lunatic pictured above is part of a limited edition print called "Characters for an Epic Tale." And no, I am not quite cool enough to have one. But I did get Tom Gauld to email me a high-resolution version of the lunatic, which is good enough for me.

11. Ed Emberley is an American artist and illustrator best known for his charming children's drawing books. Mr. Emberley is famous in Infodoodling circles, and like me, he believes that everyone can learn to draw, and probably should.

12. Dave Gray has an inordinate amount of work to peruse on his website, davegrayinfo.com, and under his Flickr handle, dgray_xplane. This character walking was pulled from his piece "What Ignites Your Creative Energy?"

13. Dave Gray shared these with me many moons ago. They are probably remnants of art school that we unartistic mortals can actually use.

14. Charles Schulz was actually very proficient at drawing an elaborate human form. But his characters in *Peanuts* feel very accessible and loose. So I'm not dissing his technical skill; I'm applauding it for being so welcoming.

15. I'm unsure of the origins of this tool. I sometimes attribute it to Lynda Barry, the American author and cartoonist, but I can't say with certainty that she actually invented it. It may be like cockroaches or prostitution, having been with us since the dawn of time.

16. When a person is searching for faces, the division of labor between the hemispheres seems to involve first the left brain evaluating an image based on how face-like it is and then passing the determination of whether or not it's a real face to its friend, the right brain. The right brain makes the call as to whether the face is real or just a matter of pareidolia, a psychological phenomenon wherein a stimulus is perceived as significant (read: the Virgin Mary's face on toast) when it is not. According to *Wired* magazine, distinguishing real faces from illusory faces is one of the first known examples of the left and right sides of the brain taking on different roles in high-level visual-processing tasks. http://www.wired.com/wiredscience/2012/01/brain-face-recognition.

17. Mary Harris "Mother" Jones was an American schoolteacher who lost her husband and four children to yellow fever in one epidemic. After moving to Chicago and setting up a dressmaking shop, she again lost everything to the Great Chicago Fire. Her journey ultimately led her to become an extraordinary labor and community organizer, being so effective at rallying "her boys" that then-president Teddy Roosevelt called her "the most dangerous woman in America."

18. The phrase *"cadavre exquis"* is French, and it translates into what you might expect, "exquisite corpse." French surrealists were drinking one night—surprise, surprise—when the original parlor game emerged. It involves the collective assembly of words or images drawn in sequence without the other participants knowing what the whole piece looks like. Over time, the founding game has taken many twists and turns, and now you'd even recognize its origins in collage and children's books wherein heads, torsos, and legs can be mismatched to make new characters.

19. This game was inspired by Doodlers Anonymous, a permanent online home for spontaneous art.

Chapter 4—Infodoodle University: Mastering Visual Thinking

1. For those of you familiar with the work of Tony Buzan, Personal Infodoodling is akin to his Mind Mapping method, although it allows for variations in visual structure well outside of the Mind Map centerpiece with content radiating outward.

2. Obviously, it's impossible for subjective interpretation to be left out of this process. The Infodoodler is human, after all. But she's being paid to accurately reflect back to the audience the themes, messages, action items, and expressions of the speaker. So unlike in Personal Infodoodling, she cannot add to, modify, or enhance the verbal information she's capturing to make it more meaningful to her. For example, if a legislator says, "We are totally committed to removing genetically modified organisms from the U.S. food supply" (although I've never heard a legislator say that), the Infodoodler should capture as much of that phrase as possible in the time she has and avoid adding any extrapolations to the mural like "bullsh*t." Her role is to listen, summarize what the speaker said, and then visualize.

3. Two of these devices you have already learned: faces and figures.

4. There are different imagined percentage breakdowns of a creative process that results in something insightful. Is it 10 percent inspiration and 90 percent perspiration? Is it 5 percent luck, 8 percent staying off the Internet, and 87 percent effort? Whichever model you prefer, the reality is that the brilliant creative moment we all hope for is a direct descendant of concerted effort. This is why Thomas Edison said, "Opportunity is missed by most people because it is dressed in overalls and looks like work."

5. This list is derived from two sources: my own work and observations in the field and from Tony Buzan's *The Mind Map Book: How to Use Radiant Thinking to Maximize Your Brain's Untapped Potential.* (London: BBC Books, 1993).

6. Tony Buzan is a British author and educational consultant considered to be a modern-day pioneer of visual note taking with his Mind Mapping technique, developed in the 1970s. Tony Buzan with Barry Buzan, Ibid., 46.

7. French is pretty unfriendly with respect to spelling, too. All of these suffixes sound the same or are extremely close to being the same: *-os, -ot, -eau, -eaux, -eaus.* Seriously? Yes.

8. Millennial text speak for "No one's home later? What do you mean by that?"

9. The hip-hop culture didn't invent what's called "sensational spelling" (I think Kellogg's Froot Loops people beat them to it), but it has done a good job of glorifying it for effect. Think of phrases like "playa hata" or "what the dilly yo," and think of artists like Ludacris, Phanatik, and ?uestlove.

10. A charming site brought to you by the smartasses of the Internet, lmgtfy.com stands for "Let me Google that for you." I assume this site is in response to those people who ask or email inane questions of the people around them rather than just looking up the shite themselves.

11. There is on occasion a correlation between spelling skill and general intelligence, but this is not causation. And the correlation is often a projection of intelligence because it involves the assessment that someone is a good speller. It's akin to how we associate above-average height with leadership. There is likely a chance correlation between height and leadership, but often it's because of the perception that they're related. A person's height is not indicative or predictive of leadership qualities, and I would not vote for a public servant based on his tallness. Sorry, Lincoln.

12. Called "leading" by graphic designer types.

13. Called "kerning" by graphic designer types.

14. Called "tracking" by graphic designer types.

15. I'm not saying that all ladies are soft, but you'd be hard-pressed to try and disassociate us with that adjective.

16. Stephanie Pappas, "Funky Fonts May Help Students Learn," *Live Science,* January 13, 2011. http://www.livescience.com/9296-funky-fonts-students-learn.html.

17. See bancomicsans.com.

18. The Graphic Jam game was inspired by an activity of the same name created by Leslie Salmon-Zhu, cofounder of the International Forum of Visual Practitioners.

19. Academy Award–winning director of a documentary film that completely ripped my pants off: *The Fog of War: Eleven Lessons from the Life of Robert S. McNamara*.

20. Full quote from Errol Morris, "Liar, Liar, Pants on Fire," The Opinionator, *New York Times*, July 10, 2007:

"Without a caption, without a context, without some idea about what the picture is a picture of, I can't answer. I simply cannot talk about the photograph as being true or false independently of beliefs about the picture. A captionless photograph, stripped of all context, is virtually meaningless. I need to know more." http://opinionator.blogs.nytimes.com/2007/07/10/pictures-are-supposed-to-be-worth-a-thousand-words.

21. It's worth noting that Infodoodling can also illuminate the presence of ambiguity. In other words, sometimes people aren't even aware of how ambiguous some aspect of their organization is *until* they doodle it. Then that ambiguity becomes clear. Ironic, isn't it?

22. "Intertwingularity" is a term coined by "IT sociolosopher" Ted Nelson to express the complexity of interrelations in human knowledge.

23 From Theodor Nelson, *Computer Lib: You Can and Must Understand Computers Now/Dream Machines: New Freedoms Through Computer Screens—A Minority Report* (South Bend, IN: privately printed, 1974).

24 Theodor Nelson, *Computer Lib/Dream Machines,* rev. ed. (Redmond, WA: Tempus Books of Microsoft Press, 1987).

25. Speed is often a component of a successful Infodoodle, generally any time auditory content is tied to the creation of one. During a Group Infodoodle, you often get the added luxury of the participants having hems, haws, gaps, and breakout sessions that allow you to tighten and add information. But in a real-time Personal or Performance Infodoodle, sometimes that train just leaves the station and you're hanging on for dear life.

26. See Dave Gray's visual-thinking Flickr stream for a slew of examples of how effective black-and-white Infodoodles can be: http://www.flickr.com/photos/davegray/collections/72157600017554580.

27. The use of color is most effective in Performance Infodoodling, which is the only form that includes the goal of creating something pleasing to the eye. Color is next in line in importance in Personal Infodoodling because it allows the Infodoodler to add layers of meaning that can support her own learning process. Color is least important in Group Infodoodling, which has no aspirations to be pleasing to the eye.

28. If you're interested in color and its meaning across cultures, you might enjoy David McCandless's book *Information is Beautiful*. In it, he includes a color wheel

infographic that shows which colors are associated with which emotions around the world. McCandless also offers a number of visualizations from this book here: www.informationisbeautiful.net/visualizations.

29. There's some variation in this process depending on which type of Infodoodle you're pursuing, but generally speaking this sequence takes place in some form every time. If you're burning for specifics, this process is most likely to occur in off-air Personal Infodoodling and Group Infodoodling. This is because these subtypes allow time for modification and sharing. Performance Infodoodling and on-air Personal Infodoodling both happen so quickly, in real time, that the chances of you harnessing the perfect visual structure for the content you're capturing is slim unless you're working with very common structures like pie charts, bar charts, or hub-and-spokes.

30. It's a grandiose statement, I know. But if you use the Infodoodle to support your own little world, that's still a world. And you saved it.

31. Rick Hanson, neuroscientist and author of *Buddha's Brain: The Practical Neuroscience of Happiness, Love and Wisdom*, has an interesting take on why this is: Our brains have a very strong survival drive. So it's often in our best interest to avoid taking risks that could result in physical (and, more importantly, social) harm. Our amygdala (often in partnership with the thalamus and the back portions of the parietal and temporal lobes) therefore tends to hyperinflate threats, because at the end of the day most of us would rather be safe than sorry, since in the game of survival, being "sorry" usually meant being dead (or, worse, being exiled, since that meant being isolated and then dead). So, while we love and admire fearless pioneers and death-defying risk-takers, most of us don't actually want to do what it takes to be one of them. Safety first!

32. This is true for all categories of Infodoodling that happen live. There are exceptions worth noting when an Infodoodler is engaged in off-air Personal Infodoodling. For example, an Infodoodler might start with a map of, say, Africa, and then create an informative Infodoodle with offshoots of interesting facts and figures. She might start with a doodle of a plant and then appropriately label the flora and add captions about life cycle. In these cases, images can precede words quite comfortably. Another perfectly plausible approach to experiment with images preceding words is to attempt to doodle a structure first and then see what words or insights emerge from

it. The last example will yield comical results for our purposes, but it's a very good procedure to try.

33. Human-computer interface.

34. From *Steve Jobs* by Walter Isaacson, p. 111.

35. For example, a speaker may hope to captivate an audience by showing a dramatic photograph, one that ignites a conversation and shifts a point of view. An advertiser may intend to move a viewer to an emotional rather than an intellectual state, to put the viewer in a sensory realm in order to influence his next action. Alternately, a facilitator hoping to tease innovations from a group may start by asking the participants to build a collage that shows rather than tells the essence of a challenge.

36. The "muscles" I'm referring to are cognitive muscles. And when it comes to doodling and drawing, cognitive muscles have a parallel in what some would call "muscle memory," which is a form of procedural memory that involves imprinting a motor task, like typing, into your memory through repetition. If, for example, you repeatedly draw a rose, your ability to draw roses gets better with practice. This is because you're establishing a "muscle memory" for drawing roses, and actual muscle memories are enhanced by what we might call "cognitive muscle memory." Research suggests that upon seeing a rose, your brain creates a visual imprint or memory that represents what you now know about the size and shape of a rose. When you're doodling, your motor, visual, and somatosensory cortices are all chiming in to keep that doodled rose aligned with the rose that you see. So in effect, you're flexing muscles physically and mentally and keeping them strong. These are the core muscles, both mental and physical, of the improving Infodoodler.

37. Yes, I'm aware of stenographers, but they're using shorthand, and nobody knows anybody who can read it.

38. Recall our working-memory discussion from the section about the Doodle providing cognitive power.

39. One of the immediately discernible benefits of doodling is that it gives people something to do with their hands and eyes, which often has the effect of quieting internal chatter and focusing the mind.

40. Much of the "credit" for determining those percentages is placed on a model of learning through audiovisual media by American educationist Edgar

Dale, along with a graphic he published in 1946 that's now affectionately called the "Cone of Experience." There are no percentages present on Dr. Dale's original graphic, and there was no research used to generate it. Dale made this clear himself. While the figures are hopeful, like much of folk wisdom, their proof lines are tenuous at best. Still, those percentages have a compelling ring of truth to them, which is why we keep circulating them.

41. This quote is really an English interpretation of an ancient Chinese adage (from the fifth century BC) attributed to Confucius: "What I hear I forget, what I see I remember, what I do I understand."

42. Statistic invented on the spot.

43. Really good Performance Infodoodlers do research prior to an engagement. We study the organization we're working with, their products and services, their competitors, their press. We look for acronyms and jargon. We do the work of immersing ourselves in their worlds as best we can before we dive into their worlds. Like a competitive athlete or martial artist, we bone up on who we're playing with to make the game that much better.

44. It also means knowing your teachers. Which ones talk quickly and make no sense? Which ones are slow and droning? Which ones don't lecture but create interactive experiences? You can alter your approach based on whom you're dealing with.

45. I have worked in scores of these meetings, but I did not come up with the six meeting types. Michael Doyle and David Straus wrote a timeless book on (visual!) meetings called *How to Make Meetings Work: The New Interaction Method*. It came out in 1976 and, in my opinion, creamed *Robert's Rules of Order*, which is the authority in the United States on meetings and parliamentary procedures of deliberative assemblies.

46. "Feed-forward" refers to those meetings where new or updated information is being presented.

47. Strategic planning sessions happen at different levels of organizations—team, managerial, veeps, C-level, and board level—but the metacategories and goals of these meetings are similar.

48. Usually, the most unpredictable meeting content comes from feed-forward and combination meetings. This is the nature of these sessions because the first type involves infinite possibilities for content and the second involves goals that can be significantly varied.

Not to worry, however—the tips cover how to handle these, too.

49. Most of us don't immediately go into listening mode unless there's a situation that warrants it, like when we have a friend in need or when someone is going on and on about how great we are. So at the onset of a listening session, there's often a natural, gradual transition during which our inner voice grows quiet and we slowly move into an open listening space. As you get better at listening, this actually becomes a flow state, where the listener becomes a frictionless channel through which information flows.

50. There's a great Zen expression that says, "If you want to be miserable, think of yourself. If you want to be happy, think of others."

51. Before my team and I go to work as Infodoodlers, we often do preliminary research on the topic and the field we're responsible for visualizing. So if NASA hired us to visually facilitate a conversation on jet propulsion systems, rocket planes, or interstellar precursor spacecrafts, we'd take the time to find out what these things actually look like and we'd establish a simple visual version of them to use in the session. This is to (a) represent the topics of discussion as they actually exist visually and (b) to indicate to the client that we come prepared. We do this same preliminary research on company jargon (all companies have their internal code words) as well as organizational acronyms because, again, when you're working live it is best to arm yourself with knowledge so that you get less tripped up when the pace heats up.

52. I designed my TED talk exactly like this, actually. It took me four months to Infodoodle, and it was displayed on my wall so I could walk by and edit over time. I based this presentation design process on the outstanding work of one of my friends and mentors, Nancy Duarte. Her book *Resonate* details this approach beautifully and visually on pp. 142–143. FYI, the term "S.T.A.R. moment" was coined by Nancy, and it stands for "something they'll always remember."

53. I made this diagram legend by overlapping diagrams from Duarte Design and a codification system from XPlane. These are the two companies that have most heavily influenced my work. If you want a fuller version of diagram options, get Nancy's book *Slide:ology*. It has a beautiful two-page spread featuring a much more elaborate spread of diagrams *and* a different way of looking at them. If you're like me and diagrams turn you on at the cellular level, you will have a complete nerd moment when you see her pages. Gaga!

54. Keep in mind that what you're about to learn is the least spontaneous form of Infodoodling. Much of your work will be improvisational, so I'm offering you these mini architectures in the hopes that they become part of your visual language so you can canoodle with them later.

55. They also occasionally represent the WHEN in the event of a timeline displaying, say, Genghis Khan's reign of terror.

56. Professor Edward Tufte crystallized this on p. 10 of his book, *Visual Explanations: Images and Quantities, Evidence and Narrative.*

57. If you're interested in a larger, more legible version of this infographic, you can find one in the Wikipedia Commons: http://en.wikipedia.org/wiki/File:Minard.png.

58. If you've never seen this triangle, I recommend that you think about it. It quickly illuminates the counterproductive roles people sometimes play when there is a perceived victim in a situation. For edification, you should know that the roles are not fixed—people switch—and the behavioral influences go in both directions from all three corners. So at times we all play persecutor, rescuer, and victim, and the drama is endless. The best way to break this cycle is to leave the triangle completely.

59. Dave Gray.

60. Dave Gray.

61. Designed by Satori Sol Wagner.

62. Describing a company as "connected" is inspired by Dave Gray's book *The Connected Company.* The book discusses the distinctions between how organizations used to behave versus how their behavior is shifting in today's marketplace. Some of the distinctions Dave made in the book are in the comparison map; others are labels and adjectives I've ascribed based on my perspective.

63. The first bar chart that we know of appeared in the 1786 book *The Commercial and Political Atlas*, by William Playfair. Playfair was a jack-of-all-trades and a pioneer Infodoodler. He brought us the pie chart, the bar chart, *and* the line graph. If he were a couple of decades older, he probably would have hung out with Charles Joseph Minard, the man who gave us the compelling information graphic on Napoléon's disastrous march to Russia in 1812.

64. To see the full page of what Mike refers to as his "sketchnotes," see here—http://www.flickr.com/photos/rohdesign/6363688953/sizes/o/in/set-72157628051682643—or find his profile on Flickr and have a good time perusing all of his work.

65. Both Romanesco and the more traditional version.

66. I mentioned Nikola Tesla earlier. He's an individual whom I believe could see visual structures automatically and profoundly. Einstein may have exhibited a capability comparably as strong as Tesla's—he's alleged to have had an exorbitant amount of glial cells relative to the average person. But the rest of us? We work at it.

Chapter 5—Taking the Infodoodle to Work: Transforming the Way We Think in Groups

1. As you proceed, you may notice that five of the nine games in this particular sequence are not described in this chapter. This is because my intention is to show you what a sequence looks like, not to elaborate on every game under the sun. My job is to empower you with the Group Infodoodle method so that you know how to select your own games and plug them in to solve any problem you're facing. It's the teach-a-person-to-fish mentality.

2. IdeaPaint is a single-coat, roller-applied whiteboard paint that transforms almost anything into a dry-erase surface.

3. People often ask me about Group Infodoodling in digital environments because of the reality of remote working and distributed teams. Many of them want to hear that remote facilitated Infodoodling can be as effective as analog environments. Instructional designers, software engineers, and educators galore are working to solve this challenge, but for now, in my opinion, the technology remains far too clumsy to approach simulating a face-to-face Infodoodling session. Modern humans are still physiologically primal, which means that ambient, immersive learning is usually much more effective for us in a three-dimensional world with multisensory, social, tangibly interactive inputs. That doesn't mean you shouldn't experiment with digital Infodoodling. It's one of the options we now have, and it continues to improve. It brings both benefits and consequences to teamwork and learning, and is worthwhile to explore as you would explore any other experimentation that affects creating and thinking.

4. The assumption I'm making here is that the classrooms, lecture halls, and conferences are run in the traditional way: with a speaker, teacher, or

professor leading the learning by speaking. There *are*, although more rare than I'd like, interactive and immersive classrooms and conferences. If you find yourself in one of those, the best thing to do is to enjoy the embodied learning experience available to you and to Infodoodle what you've learned as you go or after it's over. Don't miss the opportunity to learn by doing. It's a precious gift, and you should thank the teacher or conference organizer who made it possible.

5. The sequences won't all have three actions to perform. Some will have three, and others may have five. But you get the idea.

6. In my experience, verbal instructions coupled with demonstrations provide a better method of helping people understand what they're going to do. Auditory direction alone is generally insufficient. That said, when you demonstrate, tell the students that your technique is not some gold standard. In visual work, there's a wide berth for other people to exhibit their approach to an exercise as well as their personal style. Give them guidance; then let them fly.

7. Or, if you must, print.

8. If you have two people, break the group into individuals; with five people, make two groups (two and three) or three groups (two, two, and one); with twenty people, make ten groups of two or four groups of five; etc.

9. If you're one of those people who anticipate output before the work begins, the answer to your burning question is YES, there will be overlapping and potentially redundant information displayed across the maps. As you astutely surmised, some Features will feel like Benefits, and some Challenges will drive the emergence of a Feature. Don't worry about categorical rigidity. Just make the damn mind map. We're filling in the dots from multiple angles.

10. If you choose the latter, however, you'll need to ask the groups informed on specific projects to be the voice for ranking those projects when that game comes up. You'll also need to be conscious of any inherent biases individuals might have when ranking projects and ensure the integrity of the ranking accordingly. Biases will likely occur naturally if you're working with siloed or cross-divisional teams, but the skew may be stronger if in this activity you elect to have only certain groups, rather than all groups, review certain mind maps. So beyond a possible political bias, you're inserting another potential bias into the system simply because only certain segments of your meeting population will be informed on those projects, so the bias is based on access to information. You can handle this dynamic, dear leader, but I feel obliged to bring it up.

11. This is reminiscent of the ever-handy World Café facilitation technique. Look it up, lovebug.

12. That is, unless you chose to expose *some* groups to *some* projects, as I mentioned in another endnote around here somewhere.

13. Features, Benefits, and Challenges, in case you forgot already.

14. Or small group if you prefer to have the participants rank as a small group and then contribute their consensus vote to the large group.

15. There is no reason why I chose Features to rank first. I just did. You can choose a different category to start with.

16. Some people will be tempted to do that, but when we're looking *across* disparate projects, we have to compare apples to oranges qualitatively. It's too murky to try and compare, say, an application's rigorous security feature to the query feature in another application. We're thinking in B-R-O-A-D strokes in this game.

17. Some of you may notice that, at least for the three rows we added up, Projects X and Y were tied. This doesn't represent the final tally for this example (since I excluded rows 4 and 5 in the addition process), but ties do come up in Forced Ranking. If this happens, get verbal consensus on which project bests the other, OR take both projects into the last game. Another option is to define an additional criteria by which they could rank the tied projects, and repeat the tallying process. It's unlikely the projects will tie again.

18. Index cards can be used if you're displaying the results on a large table where everyone can crowd around.

19. This includes Play-Doh, pipe cleaners, rubber bands, photographs, duck feathers, Fig Newtons, WHATEVER. Visualize it!

20. Another way to mitigate it is to be aware of the quiet types in your group and specifically ask them for their contributions. I've noticed that most introverts prefer an invitation to speak and will accept it fairly comfortably when it's offered. So take notice of them and draw them out on purpose. As Susan Cain, the

author of *Quiet,* assures us, because of their silent observational skills, introverts can often be very powerful contributors.

21. Perhaps y'all use online project management software like Basecamp or 5pm or maybe good ol' Google Drive. I'm cool with whatever makes your biscuits rise.

22. If you're working with five to seven people.

23. Link bait is content or a feature on a website that is expressly designed to get users' attention so they click through to another website. There are a variety of ways people are "baited," and one that's particularly effective involves posing a question that can only be answered by clicking through. Being a naturally inquisitive species, humans have a hard time ignoring questions even when we're not deeply interested in the answer. An example: A headline that reads "Kanye and Kim named their baby *what*?!" would likely arouse your attention, at least momentarily, because you want to close the loop on the question posed.

24. While there are many variations of this exercise designed to better understand a customer, the origin of this particular Empathy Map technique comes from XPlane, a visual thinking company that often refers to this as the "Big Head" game.

25. These categories are detailed in an exercise called "Five Human Factors," from Vijay Kumar's book, *101 Design Methods: A Structured Approach for Driving Innovation in Your Organization.*

26. You may have noticed that I didn't bring up Adjectives. This is because the collision of Adjectives with each other rarely, if ever, yields a tangible innovation. A good way to bring Adjectives into the H.I.T. game is to mix them in at random with products or services the group designs. For example, if "singing parachute" was an invention, throw in the Adjective "cold" to see how that might change the innovation.

27. Break and Build is a technique described on p. 94 in Edward de Bono's book *Creativity Workout: 62 Exercises to Unlock Your Most Creative Ideas.*

28. This is a framing question posited by Harvard Business School professor Clayton Christensen in his now-famous "Milkshake Marketing" talk.

29. I may be jumping the gun here, but I want to talk for a moment to my readers who are paying close attention. Could you hypothetically use Project Mindmap and Forced Ranking to achieve the goal of the Decision-Making Meeting? You bet your ass you could. The inclusion of the Gameplan in the first sequence is what makes that sequence work for *Planning* Meetings. But you can and should repurpose any games you see to accomplish whatever goal your meeting is pursuing. This will become clearer and clearer as you keep going.

30. Many of these Infodoodle experiences can be scaled to work with humongous groups. All it takes is a bit of imagination and some restructuring of the activity to make the same visual thinking possible. For example, you may need a higher number of breakout groups, and you may need to ask them to doodle their own matrices. They may need to work tabletop size (with smaller sticky notes) so the room can accommodate more work. It's almost all adjustable, my friends. We just have to commit to the shuffle.

31. I would like to say George W. Bush gave us this number, but really *Saturday Night Live*'s Celebrity Jeopardy with Keanu Reeves gave us this number.

32. "Done" can mean either individually done (since some people work faster than others or have fewer ideas or less interest) or it can mean *all* done in that you let everyone keep working, or at least have them stay seated, until you call time. You decide how "done" you like it.

33. The assumption is that there will be quality content simply because people are trying. There will also be less-than-quality content interspersed, but that's not of concern at this stage.

34. I know you think "sistren" isn't a word. Oh, but it is. Defunct and used only to cement social awkwardness, but it is a word, my brethren.

35. This refers generally to internal capacity, but it may also encapsulate the capacity of established organizational partners or suppliers.

36. Depending on the actual content, it may be worthwhile to plot the opportunities themselves because, hypothetically, an organization could choose to pursue individual opportunities inside of a topic area and not wholly dedicate itself to that topic. For example, if the topic were "Breast Cancer Research," an organization could pursue a walk-a-thon to raise money for that cause but not necessarily dedicate a major focus of the organization to it.

37. If you're from a foreign culture, I'll clarify this esoteric linguistic reference. Americans (and I'm sure our English-speaking cohorts elsewhere) often say that to

assume is to make an ass out of you and me. We think this is a particularly clever adage since it has a home in the spelling of the word itself. Assume = Ass + U + Me. Hardy-har-har.

38. The idea of proof itself can get messy quickly. If one examines beliefs, "facts," evidence, or experience closely enough, the idea of indisputable proof of anything can get very fuzzy indeed. For this exercise, we'll keep it pragmatic.

39. An exception worth noting is if you were designing for a weekly status update. In that case, you could hypothetically conduct this process in five to ten minutes because the messages are probably second nature to you and your team and you can just snap, crackle, pop the sequence.

40. I want my nerd credentials. In the Harry Potter books, the Hover Charm is used to levitate objects and move them wherever you'd like.

41. "Bill Gates: Mosquitos, malaria, and education": http://www.ted.com/talks/bill_gates_unplugged.html.

42. Because of the way the brain physically evolved, gravity itself is working against easy access to our brain's rational centers. The brain must send blood (which includes glucose and oxygen) to any part of itself it wants to activate. The sheer location of where we might say "logos" resides makes it taxing to send blood to and taxing to sustain the supply there for long periods of time.

43. The book I mentioned as inspiration for this section, *Resonate: Present Visual Stories that Transform Audiences,* describes five types of S.T.A.R. moments: memorable dramatizations, repeatable sound bites, evocative visuals, emotive storytelling, shocking statistics. Examples to illuminate them, in order: Steve Jobs using the "reveal" for each new Apple product; Johnnie Cochran insisting that if the glove doesn't fit, you must acquit; Kevin Carter's gut-wrenching photograph of a starving child next to a vulture; Jill Bolte Taylor's TED talk where she tells the story of her stroke (and uses a real human brain as a prop—double S.T.A.R. moment for that!); and the Nike Foundation's animated video "The Girl Effect," where they state that "when a girl turns twelve and lives in poverty, her future is out of her control." All of those were powerful, unforgettable moments that changed the way society perceived a person or an issue. If you can incorporate a S.T.A.R. moment into your presentation, even one that's less dramatic than these, give yourself a pat. You've done well.

44. Many organizations, of course, institutionalize review systems and feedback forms and databases that attempt to minimize subjectivity or inconsistency in performance review. Whether the Feedback Meeting is run in a boutique company or a global firm, the methods of gathering and "grading" employee information need to be perceived as legitimate by the employee. Otherwise, insights on behavior can be dismissed as errors in the system.

CREDITS